norman

gorbaty

works

of a

modern

master

essay

by

donald

kuspit

norman

gorbaty

works

of a

modern

master

QCC Art Gallery
The City University of New York

North American Thought Combine, Incorporated

This publication accompanies the exhibition
Norman Gorbaty: Works of a Modern Master.

Exhibition Dates:

The Tremaine Gallery at The Hotchkiss School

Lakeville, Connecticut

October 25th - December 17th, 2008

QCC Art Gallery/ CUNY

Bayside, New York

February 13th - April 3rd, 2009

Curator: Ben Gorbaty

Editors: Shelley Kaiser-Gorbaty / Ben Gorbaty

Book Design: Andrew Patapis Design, New York, NY

Design Assistant: Michelle LaRocca

Design Consultant: Norman Gorbaty

Printer: Editorial MIC, León, Spain

Photo Credits: Miggs Burroughs, Shelley Kaiser-Gorbaty, Chuck Kintzing, Derek Stanton

ISBN: 978-0-976475-67-5

LCCN: 2009920361

Library of Congress Cataloging-in-Publication Data

Kuspit, Donald B. (Donald Burton), 1935-

Norman Gorbaty: works of a modern master / essay by Donald Kuspit. -- 1st ed. 196 p. 26 x 28,5 cm.

Publication accompanying an exhibition held at the QCC Art Gallery,

the City University of New York, Bayside, N.Y., Feb. 13-Apr. 14, 2009.

ISBN 978-0-9764756-7-5 (alk. paper)

1. Gorbaty, Norman--Exhibitions. I. Gorbaty, Norman. II. QCC Art Gallery. III. Title.

N6537.G638A4 2009

709.2--dc22 2009000560

Published by QCC Art Gallery Press and North American Thought Combine, Inc., 2009

This catalogue was made possible through the generosity and friendship of Bernie Fox in memory of his wife Myra

contents

who
made
this
happen

My unbelievable son Ben and his wife Shelley, for their never end-ing commitment to make this happen. I cautioned them—argued with them to not take on the task of making me known—to no avail. I would like to forget the bitter clashes, the arguments, but they too are part of the working experience. If not for them you would not be reading this book and experiencing my work. I would still be hiding my light under a bushel. It is hard for me to out-wardly express my love for them, but I do so, for changing my life.

Faustino Quintanilla and Charlie Noyes who first took note of my work; who expressed their excitement of discovery and the need to show it to the world. They cast aside all problems with sin-gle–minded determination to present my work. I may have shown little emotion but I am humbled by their belief in me.

My close friend Bernie Fox, for his council, good advice and gen-erosity throughout the "Gorbaty Project." He has been with us from the beginning. He makes things happen! As well, we are indebted to Bernie, who without hesitation, undertook the finan-cial support needed to produce this catalogue. It was offered in honor of his late wife Myra, whom we loved very much.

ng

how

it

came

about

by

faustino

quintanilla

I was both dumbfounded and delighted. I felt like Howard Carter, who on first spying the inside of Tutankhamun's tomb, when questioned "Can you see anything" replied in awe "yes, wonderful things."

My excitement was shared by Charles Noyes, Co–Director of the Tremaine Gallery at the Hotchkiss School. We agreed to work together to make Norman's work known to the world. A small gem of a show was first mounted by Charlie and Ben Gorbaty at the Tremaine Gallery. Ours at the QCC Art Gallery is the second show, substantially larger presenting examples of drawing, pastel, painting and sculpture.

It is an honor for me to be part of the reintroduction, to the world, of the American artist, Norman Gorbaty, by bringing to light a selection of his work, never seen, amassed over more than fifty years. There is so much to be learned from this extraordinary talent, craftsmanship and dedication to the arts during these "hidden" years. The body of the work presented in this exhibition, as Stuart Shedity reflects in 1995 exhibit catalogue "Still Working" confirms he is one of those artists "doing their best and most resonant work later in life."

The great benefit that an artist's sensibility can draw from his encounter with the masters, as a directive,[i] the continuum of impeccable pursuit of craftsmanship, is to glimpse into his consciousness not as a point of culmination, but as a seed that allows him to develop. Anchored in his graphic training on one side of his creative spirit on the other, Norman's creations spring from an inner necessity and shed their own light.

A rhythmically articulate network of lines shown in his work longs to control you, not so much as the object, but as his excitement for them. Serpentine lines of restless pen ink strokes occupy Norman's well–constructed, lyrical compositions, perceptive of moments in his own existence, put the meaning of his art in a new

Van Gogh–like fashion. His work projects a pragmatic expression and awareness of the experience of self–interpretation. His compositions are like journals bearing a unique spiritual, vital force containing the fundamentals of art. Rarely found in the work of his contemporaries is the struggle, in which he takes us to places and provides a sage, inside view from his own beginning and where he would like us to be. The place to seek reality—composition or form—is not to assume a metaphysical formula, but to reflect on the analysis of the metaphysical.

His sculptures are spiritual or esoteric hermeneutics predisposed to discover—in his six days of creation of the spiritual man—the secret that explains the present condition of man. Revealed as a drama of knowledge, a dislocation of the conscience, the decline of prospective and cognitive powers, all of which cut off the human being from his presence in a higher universe and imprison him to his fate of solitary presence is organized in topographical levels and sweeping forms incorporating a mixture of emotions that forge for themselves an art of living.[ii]

Norman Gorbaty throughout his oeuvre, holds nothing back to fulfill his purpose silently and makes no claim to selfless action to attain fulfillment—the path of a true Modern Master.

Faustino Quintanilla,

Executive Director QCC Art Gallery / CUNY, received a B.A. in philosophy from the Monastery of Santa Maria, Burgos (Spain), an M.A. in theology from the Pontifical University , Rome ; a B.A. in art from Wagner College , and an M.F.A. from Pratt Institute. Currently is also adjunct assistant professor of art (printmaking) at the College of Staten Island, CUNY. In 1989 he was selected to represent the United States in a show of contemporary art at Salon des Nations, Paris

.

[i] *"Wherever the master is whom you prefer, this must only by a directive for you. Otherwise you will never be anything but an imitator." John Rewald, Paul Cézanne, Letters[ii]. London, 1941, p241. (Letter to Carmoin, 9 December 1904.)*

[ii] *"They have to forge for themselves an art of living through the times of catastrophe, in order to be reborn, and them fight openly against the death-instinct which is a work in our time" Albert Camus, The Stranger, Random House-Vintage Books, 1946. P. 152*

coming

to

know

the

artist

by

charles

d.

noyes

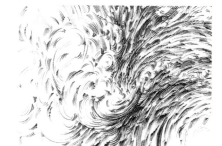

1. *Wave No. 2*

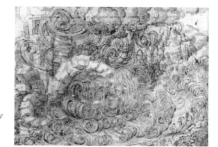

2. *Tempest Study
 Leonardo
 Da Vinci*

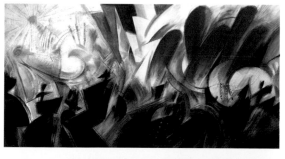

3. *Parade*

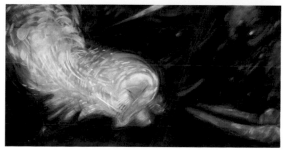

4. *Flyer And Catcher*

On a gray, damp February afternoon in 2008 I sat in my deserted office and opened an innocuous padded mailing envelope. Inside were three carefully packaged books featuring the various art works of Norman Gorbaty. Artists are continually soliciting the Tremaine Gallery for possible exhibition; I cracked the first volume in exercise of my due diligence as one of the gallery's directors. I'd never heard of Norman Gorbaty, but the images that confronted me as I flipped through the pages thrilled me at once. There were sweeping pen and ink drawings[1] in warm, rich sepia tones that captured the energy and pulse of Da Vinci's explosive tempest studies,[2] followed by quieter, spare compositions of distant cityscapes and delicately wooded copses. Other volumes revealed riotous pastel drawings of throbbing parade phalanxes[3] and helter-skelter circus scenes,[4] voluptuous figure work in both luminous color and carved walnut,[5] and energetically painted canvases of rippling light, color and texture.[6] I saw influences of Cezanne's late figurative work, Marc's fragmentation and coloration,[7] and Matisse's soulful brevity and wit.[8] I saw a remarkable breadth of subject matter, media and technique, all guided by a masterful, sensitive hand and a brilliant eye. Who was this Norman Gorbaty, and why had I never before seen his work or read his name?

I perused all three books quickly and carefully, and then immediately phoned the number on the cover letter. Ben Gorbaty, the artist's son and the gentleman responsible for organizing and promoting his father's vast oeuvre, answered the phone after three rings. And I'm afraid that I gushed for the next five minutes. Where has all of this incredible work been all these years? When might we schedule a show here at the Tremaine Gallery? When would I be able to meet with the artist? Indeed, I was inspired by the volume, variety and quality of Norman Gorbaty's work, but I was also intrigued by the history behind it all. It almost reads like

14

the plot line of a serial novel: A brilliant young art student, lauded by many as the next best talent to rock the art establishment, opts to sidestep his fine art career for a more stable and secure livelihood in commercial graphics. He steadily climbs the ladder of success, a shining star in a competitive industry full of stars, and eventually opens his own thriving design studio. He is known to everyone as the innovative and successful ad man and graphics designer—credits for major motion pictures, museum posters, magazine covers and book illustrations. But all the while he is leading another life. Still passionately devoted to his drawing, painting and carving, year after year he toils away in his private world of wood shavings, oil pigments and pastel dust. Evenings and weekends find him sequestered in his studio quietly pursuing his first love, creating images and objects of tremendous beauty and intensity. Only after fifty years does this remarkable artist, now in the twilight of his ad career, step out into the light with his paintings, drawings and sculpture to meet the scrutiny of the public eye. This scenario may sound like a work of fiction, but it's all true. Save for family, close friends and the artist himself, no one has seen a comprehensive display of Gorbaty's art since he participated in an exhibition of young American printmakers at MoMA in 1954. Throughout his fifty years as a thoroughly vested and successful graphic artist, Gorbaty has never stopped producing his fine art—a staggering body of work including prints, drawings, pastels, paintings, relief carvings and sculpture.

So there I found myself, in the winter of 2008, attempting to plan the first comprehensive exhibition of Norman Gorbaty's fine art in over five decades. I'd been broadsided by a body of work I'd never seen before, and I was tremendously excited about the prospects of a stunning show with an essentially unknown master artist. We set tentative dates for an opening in late October of that same year and arranged for a meeting in early summer to meet

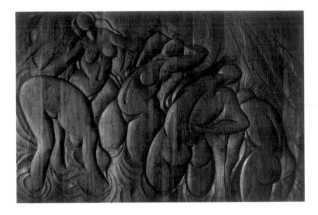

5. Seaside Girls No. 1

6. Trees on Trees

7. lue Horse
Franz Marc

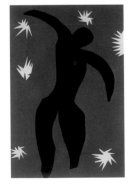

8. Icarus
Henri Matisse

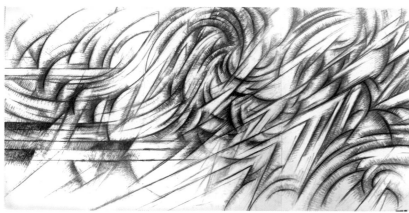

9. *Move*

10. *Giacomo Balla*
 Italian Futurist
 Velocità d'automobile

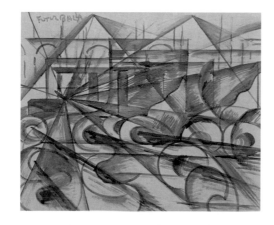

11. *Reclining*
 Nude No. 2

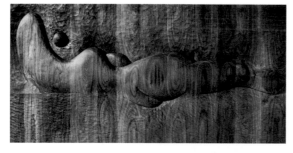

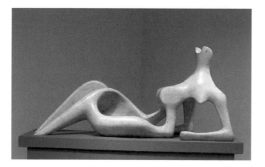

12. *Reclining Figure*
 Henry Moore

with Norman, finalize the scope of the show and select a range of works. My biggest challenge would be winnowing down my selections to create a cohesive and compelling inaugural showing at Tremaine.

I soon realized that the images in the survey books I'd studied barely tipped the scales. I studied hundreds of digital images and additional images in print, and I read the artist's own musings on his approach to making art. The well was rich and deep. Norman Gorbaty's work both dazzles in its unfettered expression and amazes in its remarkable breadth. Many of his charcoal and pastel images embrace the kinetic dynamism and emotive power of the Italian Futurists,[9,10] while his spare still life images and landscape drawings in pen and ink hint of Rembrandt's gentle hand and eye for nuance. Figurative relief carvings in polished walnut nod to both the sensuousness of Constantin Brancusi and the reductive essence of Henry Moore.[11,12] Visions of J.M.W. Turner[13,14] rumble to the surface in some of his more robust canvases. His diverse print works combine both the whimsy of Picasso and a graphic designer's love for daring form and space relationships. In all subjects and media, however, Gorbaty builds on a solid foundation of drawing and honors the expressive soul of the line. He understands and thoughtfully exploits the volumes a single responsive stroke can speak. Drawing is at the core of it all. States the artist, "When I refer to 'drawing' I don't just mean the physical works on paper or the finished piece. I am also referring to the process I use in the actual 'doing' of the art. I make a mark. That mark tells me where the next mark should go and so on until the piece begins to have a life of its own. It begins to tell me what it wants to be. It is for me to recognize what it wants to be and help it to become that." It is this devotion to drawing and responsive process that resonates most profoundly.

When I first met Norman Gorbaty he struck me as an interesting

mix of opposites. He was open and direct, wry and witty in conversation, and almost nonchalant regarding the incredible breadth and quality of his art. Our initial exchanges parried back and forth, bobbing and weaving with sarcasm and good humor, seldom dipping deeper. But once we began looking at work and discussing process and technique in his studio, that surface energy fell away and the voice of the artist emerged. Someone who sees with such sensitivity and precision, someone who has the sensibility and confidence to reduce riotous patterns of shadow and form into several representative stokes of line and color, draws from a place of thoughtful calm and centeredness. This was the voice that surfaced as we lingered over pen and ink drawings, stacks of charcoal studies and countless pastels and paintings. I would ask about a particular technique or influence. Norman would pause, and then answer almost cryptically. He would not readily betray his muse or reveal the intimacies of his process. But I could tell that he enjoyed discussing his work on this level—bypassing the surface trappings and teasing a bit at the soul of each piece.

A cursory glance around Gorbaty's studio[15] reveals myriad passions and pursuits. Tall windows punctuate almost every wall, and even light floods in from the suburban forest that surrounds the space. An overflowing table of bulbous pastels commands the north side of the studio. On top, all around and underneath are plaster casts of horses in rakish poses, carved stele figures tilting precariously and covered with colorful dust, and several wild versions of a bull, reminiscent of Picasso's virile beast, sculpted in plaster, bronze and wood. Additional tables and flat files harbor stacks of drawings and studies. Painted canvases and panels in bunches of four and five are clustered along the walls and among the table legs. The sheer volume, quality and variety of the work defies the notion that one man, one hand, is behind it all.

A double easel supporting an oversized drawing board

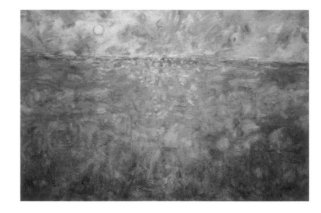

13. Sun Day

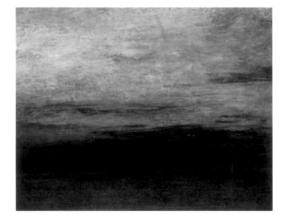

14. Sun Set
JMW Turner

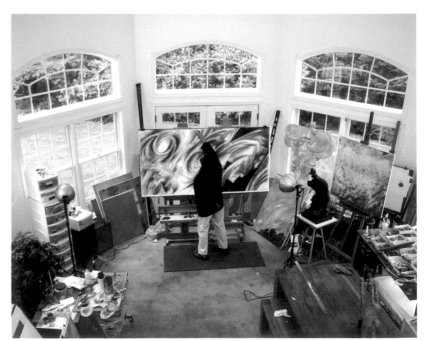

15. Gorbaty in his studio, Great Neck, NY, 2006.

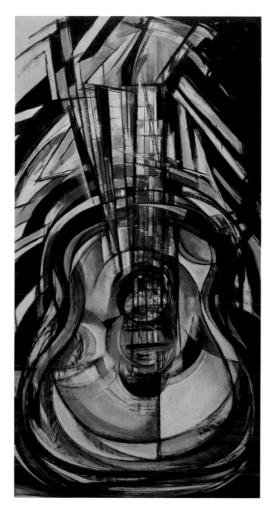

16. Guitar

17. Grapes Away

anchors the room. On it is clipped Norman's most recent pastel image of a guitar[16]—fragmented and shuddering in a profusion of electrified contrast. Concentric waves of line and tone radiate in all directions, dissolving, overlapping and recombining. The riotous image feels like what a guitar is and what it sounds like. In striking juxtaposition, the actual guitar, worn and passive, rests benignly in the corner. "I don't understand music," he claims. "I just know I love it." He will pursue this series of musical instruments until he feels that he's said what he wanted to say. Until it feels resolved and his inclinations are wrung out. Then he will switch his focus to another series already in progress—writhing figures in sequence, a garden view, or simply the desiccated stems of a picked-over grape cluster.[17] Gorbaty often works in series, kneading, massaging and squeezing meaning and vitality out of an unpresuming object or a scene that most of us would not give a second glance. Viewed in sequence, the images reveal an energetic and methodical reduction of detail and form. However complex or intricate the original subject matter, Gorbaty's process typically careens toward a provocative distillation of line, shape and color. Once he has drawn through the various layers of meaning and interpretation, once he has uncovered and celebrated the essence or harmony that first drew his attention, he will pick up and move on.

I find these series most engaging because they offer a small glimpse into the mind of the artist. Studying the images in procession, one can compare the aspects of form and reality that the artist has sacrificed, the elements and ideas that have been exaggerated and celebrated. One is able to form a deeper understanding of and appreciation for the artist's vision and sensibility. For Gorbaty, the thrill and satisfaction are in this pursuit and process of refinement. The material results, while captivating for the viewer, are really quite secondary for the artist. When talking

about a particular painting series, the artist paused and stated that he would be content to paint over the same canvas again and again, appreciating each state, but always pushing on to another responsive layer of color and form—one version, one set of decisions, forever informing the next.

Coming to know Norman Gorbaty and orchestrate an exhibition of his fine art has been a revelation. I am delighted to have been involved in the efforts to bring his work to a broader audience, and I hope that the Tremaine Gallery exhibition will be but the first of many opportunities for the public to revel in Norman Gorbaty's vision. I also wish to recognize the incredible work and dedication of Ben Gorbaty and Shelley Kaiser-Gorbaty. All organization, cataloguing and exhibition preparation are the result of their herculean efforts, passion and devotion. I remain exhilarated and grateful.

Charles D. Noyes

Art Department Head and co-director of The Tremaine Gallery at The Hotchkiss School. Noyes earned his Masters of Art Education at Rhode Island School of Design. He has been teaching drawing, painting and printmaking since 1986. He is an avid outdoorsman and has traveled extensively throughout the world.

the dynamics of norman gorbaty by donald kuspit

Perhaps the dynamics are most evident in Gorbaty's stunning images of waves, pen and brown ink drawings in which he depicts, with amazing verisimilitude, their sweeping movement. He seems to capture them at the moment they crest and break, when they're an intricate conflation of centripetal and centrifugal forces, in *Wave No. 1*[1] more the former, in *Wave No. 2*[2] more the latter. Gorbaty's waves have the same contradictory dynamics as Leonardo's whirlpools:[3] his drawings are more than a match for Leonardo's, both in their excruciating sense of detail and power of concentration. Gorbaty's drawings are as cosmically scaled yet as intimate as Leonardo's. His rapidly flowing water is charged with the same sense of ecstatic turbulence and hypnotic sublimity.

But there's a major difference: Leonardo is a naturalist empiricist, Gorbaty an abstract empiricist. Art, after all, has changed: Gorbaty is a keen observer of nature, but he's also a purist. His drawings read as an accumulation of nuances, grouped in an abstract pattern resembling hatching—the short, tensed strokes, each a sort of extended touch, curved like little bows, that form the brisk waves, are tell-tale signs of its momentum, exquisite gestures that seem to explode from its mysterious depths, dissipating in ripples as they rise to the surface, without losing their strength—as well as uncannily accurate representations of a familiar natural phenomenon. Waves are familiar only to the ordinary eye; to Gorbaty's extraordinary eye, they are demonic and angelic at once—altogether uncanny. They express the ruthless power of elemental nature, made all the more expressive by the power of Gorbaty's hand. Its swiftness keeps up with the swiftness of the elemental flux, mastering it in the act of identifying with it—a triumphant rather than submissive identification. Gorbaty's sure and sensitive touch surfs the waves, navigating their undertow to a safe artistic landing. He is as sure-eyed as a good

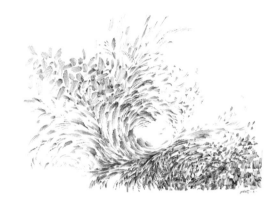

1. *Wave No. 1*

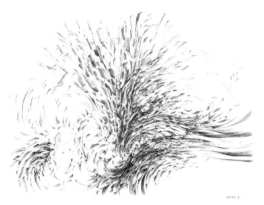

2. *Wave No. 2*

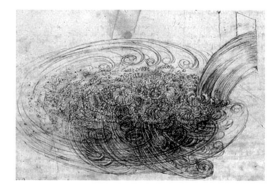

3. *Whirlpools of Water Leonardo Da Vinci*

surfer is sure footed, and the purity of his touch intensifies the waves he sees all around him—for he immerses us in the boundless sea, suggesting what has been called an oceanic feeling—even as it makes the intensity immanent in the current that rhythmically moves the waves manifest.

It is the pursuit of purity—the will to pure form—that enables Gorbaty to render nature with such consummate mastery. He exposes the pure form implicit in its raw matter, paradoxically giving it a refined presence, which even more paradoxically makes it a lived experience, charged with the fullness of being it never has in everyday observation, naively taking appearances for granted. From the beginning, abstraction meant superior consciousness of nature, as Kandinsky and Mondrian argued: consciousness able to abstract its core dynamics from its appearance, resulting in pure art and existential truth. Gorbaty's images of nature are pure art, however "impressionistic" they may seem, reminding us that Impressionism was in fact the prophet of abstract art, as Kandinsky said. I suggest that the empty areas in Gorbaty's drawings are emblematic of pure consciousness, indeed, paradoxically embody it, giving them a depth of meaning they would not otherwise have. Gorbaty's deployment of emptiness gives the drawings a fullness and beauty they would not have if they were simply descriptive. Or if the empty areas were filled in, technically finishing the picture, but leaving it emotionally unfinished. If ripeness is all, Gorbaty finds expressive and formal ripeness in emptiness. No *horror vacui* for him, but rather emptiness as a symbol—even proof—of enigma. The rare ability to make esthetic use of empty space—to make empty space seem full of mysterious meaning—to make the paper's blankness evocative of the unseen, the inevitable incompleteness of seeing, even of the permanently invisible, function as pictorial space flooded with sublime light, pure whiteness—is the sign of a true drawing master.

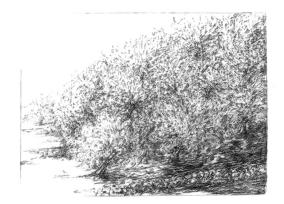

4. Olive Trees

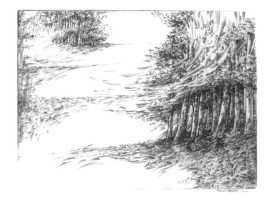

5. Stranger

6. Paris

7. Rome

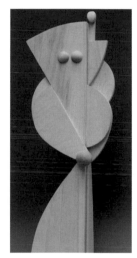

8. Female Nude

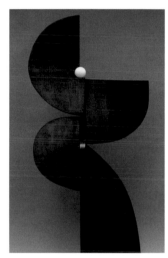

9. Modern Dancer

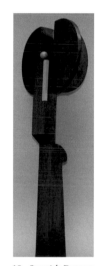

10. Spanish Dancer

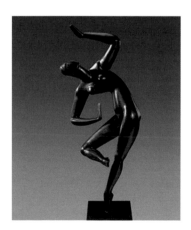

11. Blue Dancer
Alexander Archipenko

There may be an apocalyptic wind blowing in *Olive Trees*[4] and *Stranger*,[5] but the telltale signs of their aesthetic purity are the large areas of untouched paper, paradoxically transformed into experienced space because no line has darkened their whiteness, bringing it down to earth. If they were filled in with detail—even the finest detail of which Gorbaty is capable—the drawings would be less esthetically consummate. Transformed by being untouched, the vacuums of space give Gorbaty's drawings ethereal freshness, beauty, and profundity, making them masterpieces rather than mere records. They acquire an abstract aura epitomizing the dynamic core of nature. The fluidity of Gorbaty's handling adds to the wind's fluidity, convincing us that we feel it in all its immediacy, as he does. *Trees Up*, *Florence*, *Paris*,[6] *Rome*,[7] and *Landscape Venice* make particularly daring use of the pellucid whiteness of the paper. It conveys the enormous space encapsulated in the picture, as well as the light flooding the space, so that it seems the space of the sky. So blinding is the light in the emptiness that the trees and buildings reduce to incidental shadows, sketchily nuancing it with their "touchiness."

Gorbaty is a master of movement, and there is nothing more "moving" to him than the female body, an "expression" of nature irresistible by reason of its complex dynamics. Instead of being straight up and down, like the male body, it is alive with curves. Gorbaty works in wood; such free-standing sculptures as *Female Nude*,[8] *Modern Dancer*,[9] and *Spanish Dancer*,[10] all 2007 and made of pine or ebonized pine, are modernist constructions, as their additive use of geometrical forms makes clear. They have a certain affinity with Archipenko's Cubist dancers,[11] but are much more severely abstract, that is, purely formal inventions. But I think Gorbaty truly comes into his own in his low-relief carvings of the female body. The tension between the low relief, flattening

the body, and the ripe abundance of female flesh, evident in the mass of the buttocks and breasts, as in *Seaside Girls No. 2*, 1990,[12] makes the point clearly. One immediately thinks of Matisse and Lachaise, but their female nudes tend to be either more abstract or more realistic—"primitively" abstract (Matisse) or voluptuously realistic (Lachaise)[13]—than Gorbaty's female nudes, which are an uncanny mix of modernist flatness and Baroque abundance.

Gorbaty's *Reclining Nude No. 1*, 1995[14] is readily comparable to Matisse's *Blue Nude, Memory of Biskra*, 1907,[15] but the buttocks of Gorbaty's nude jut out into space more dramatically, and are more perfectly rounded, suggesting that the nude is more abstract than visceral, however viscerally seductive it may be. The contrast between one small circular breast, placed on her arm as though it was an independent globe, and the other large breast hanging from her torso and cradled in her other arm, makes clear how surreally abstract she is—all the more so because she is headless and her body is broken at the waist, with the upper part turned upside down so that it faces the lower part. *Reclining Nude No. 3*,[16] 1995 is even more to the viscerally surreal abstract point, as her especially prominent buttocks, their flesh overflowing the ledge on which her body rests, makes clear. The fact that the full-bodied nudes are carved in wood—walnut—suggests that they are woodland nymphs. Wood also has its own erotic appeal—its own innate sensuality—which adds to the surreal seductiveness of her body, even as it confirms that it is completely natural and sensual, as nature at its most vital always is, and thus exciting to touch, if only with one's eyes.

Like Gauguin,[17] Gorbaty understands the "savage" power implicit in wood grain—as subtly rhythmic and emotionally evocative as moving water, and as charged with undercurrents—and the haptic power of carved wood. Gorbaty's carving is gestu-

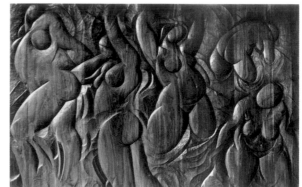

12. Seaside Girls No. 2

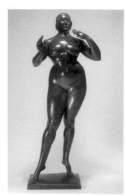

13. Standing Woman
Gaston Lachaise

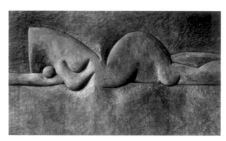

14. Reclining Nude No. 1

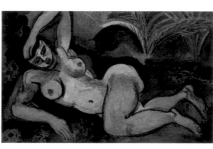

15. Blue Nude
(Memory of Biskra)
Henri Matisse

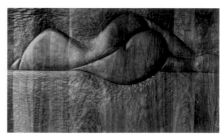

16. Reclining Nude No. 3

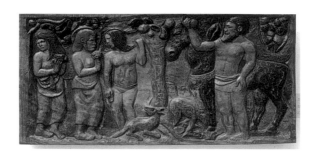

17. Peace
Paul Gauguin

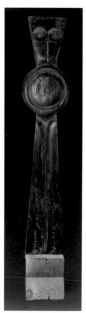

18. Pregnant Woman

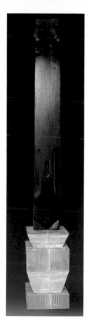

19. Female

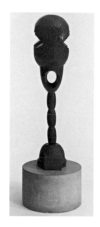

20. Socrates
Constantin Brancusi

rally charged, just as his toned wood, with its atmospherically dark and luminous areas, suggestively transforms his sculpture into a painting. He is clearly trying to collapse—and eloquently finesses—the difference between three-dimensional sculpture (the rounded body reads as sculpture) and two-dimensional painting without denying it. The tension between smooth and rough surface—the pleasurably refined and the painfully raw, in effect between the civilized and the instinctive—adds a patina of depth of meaning to the wood, all the more so because Gorbaty's carving sets the work in process, as it were, suggestive of unconscious process, and makes it more "cutting," and thus suggestive of suffering and hurt, however reverential—a homage to the organic—the carving may be.

Carving brings out the innate plasticity of wood more than modeling, although Gorbaty ingeniously models as he carves, thus collapsing what Adrian Stokes regarded as fundamentally different modes of sculpting—another integrative finessing of the opposites to Gorbaty's modernist credit. "Carving conception," as Stokes calls it, "causes its object, the solid bit of space, to be more spatial still," while a "plastic material" is "freely" modeled, suggesting that space is dynamic and flexible rather than inflexibly fixed "in place," and allowing a more "imaginative communion" with its material than carving a hard material allows.[i] Wood is a solid bit of space, but by reason of its organic nature it is inherently plastic—certainly not as hard, rigid, and intractable, that is, resistant to touch and as hard to work as stone—suggesting that Gorbaty's sculptures render the plasticity of space (by way of the plasticity of the body, indeed, the plasticity self-evident in the curves of the female body) without denying the uncanny solidity of wood.

The basswood *Pregnant Woman*[18] and the cedar wood *Female*,[19] both 2007 have a certain relationship to Brancusi's

totemic sculptures,[20] as their pedestals indicate, but they are all wood, while Brancusi's pedestals are typically of stone, and his figures usually bronzed. Gorbaty is unremittingly organic in comparison, in line with his idea of woman as the embodiment of vital creation, to refer to, *Eve from Adam*,[21] a 2007 sculpture of fir wood. The fantastic *Creation of Eve*, 1977[22] and *Eden*, 1980,[23] both carved in pine wood, makes the point clearly. We are in paradise, and Eve is its perfect flower, her body, with its core dynamics—its stalk-like torso, bulging thighs, and delicate head—suggests. Gorbaty brings out the inherent abstractness of her body without denaturing it, as Brancusi does. Gorbaty implies that nature has as much rights as art, which can never completely dominate her. Art must work in tandem with nature to strike an esthetic balance between them. Nature should not be bent to the will of art, and finally erased from it, which is what occurs in modernist formalism, that is, abstraction for the sake of abstraction, purity for the sake of purity—rather than to articulate the dynamic essence of nature. Gorbaty clearly repudiates "absolute art" however much he uses abstraction to make the rhythms of nature—particularly as embodied by the twists and turns of the female body—esthetically evident.

But not only, as the wildly expressionistic snake in Gorbaty's extraordinary version of *The Temptation*, 1981,[24] the futuristically dynamic *Dog Looking Up*[25] and *Wolf*, both 1994, the Cubistically fragmented *Creation of Adam*, 1975[26] show. These and other works show that Gorbaty uses modernist ideas and methods to breathe fresh life and find new meaning in age-old myths and archetypes. Even death acquires existential import in Gorbaty's *4856 (In Memoriam*[27]), 1992, the most convincing memorial to what in effect amounts to a holocaust—the "more than 14,000 Jews...killed by peasants and crusaders on their way to Jerusalem in the first crusade," as Gorbaty writes. Like all of Gorbaty's low

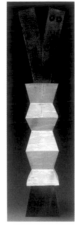

21. *Eve from Adam*

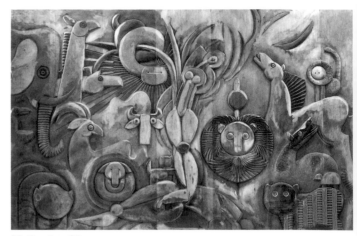

22. *Creation of Eve*

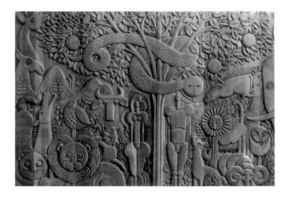

23. *Eden*

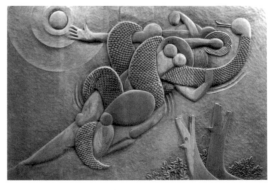

24. *The Temptation*

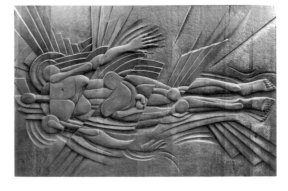

26. *Creation of Adam*

25. *Dog Lokking Up*

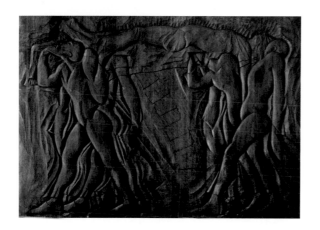

27. *In Memoriam*

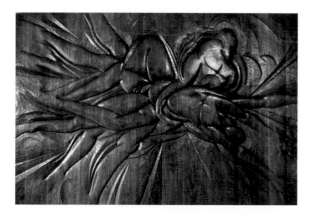

28. *Penial*

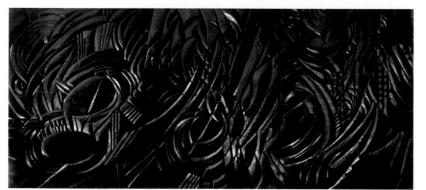

29. *Jazz*

reliefs, it integrates the naked figure, now heroic, and "convulsive" modernist forms. A Jewish theme also appears in *Peniel*, 1989,[28] but the dynamics of the wrestling figures—Jacob and the angel, "face to face" (the meaning of "peniel")—seems more to the point of the relief than its theme. Dynamics are on visionary display in Gorbaty's *Jazz*, 2000,[29] a tour de force of unleashed energy, integrating expressionist and Cubo-futurist ideas of movement.

Gorbaty is a visionary working in an abstract mode—integrating the variety of esthetic innovations that inform abstraction—with no sacrifice of the vitality that only nature can confer. His love of nature is evident in his paintings and pastels—brilliantly colored landscapes—and his use of wood, an organic material emblematic of natural process. His feeling for nature enables him to embrace its dynamic forms without being overwhelmed by them, much the way Jacob wrestled with the angel without being overcome by him. Instead, Jacob was blessed by the angel, just as Gorbaty is artistically blessed.

Donald Kuspit is an American art critic, author and professor of art history and philosophy. He is a contributing editor at Artforum, Sculpture, Tema Celeste and New Art Examiner magazines, and the editor of a series on American Art and Art Criticism for Cambridge University Press. He has been awarded fellowships from the Ford Foundation, the Fulbright Commission, The National Endowment for the Arts, and the Guggenheim Foundation, among others. He has doctorates in art history and philosophy, as well as degrees from Columbia University and Yale University. In addition, he has received an honorary doctorate in fine arts from The New York Academy of Art.

Kuspit is the author of numerous books, articles, exhibition reviews and has lectured at universities and art schools worldwide.

[i] Adrian Stokes, "Stones of Rimini," *The Critical Writings of Adrian Stokes* (London: Thames and Hudson, 1978), I, 235

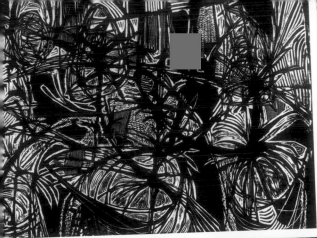
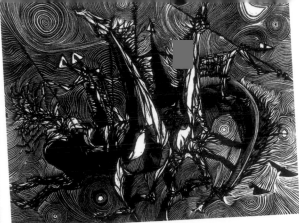

TIME

LANDSLIDE

Prospects for the Second Term

bananas

3/1981 novum
gebrauchsgraphik

Ma

SEX I

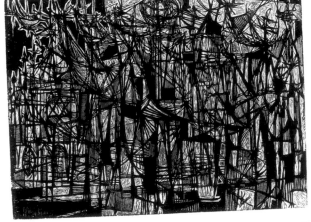
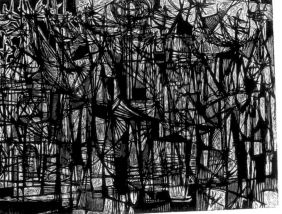

nervous system

respiratory system

cardiovascular system

E

Vitamin E in Human Health

TIME

Sex & the Teenager

RE

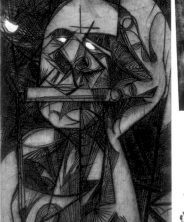

Lew.

GLOBAL SITES & LOGISTICS

A Publication for Global Decision-Makers

from yale to graphic design and back

In 1954 Norman Gorbaty was a promising young artist whose work was included in a modest show of Young American Printmakers at New York's Museum of Modern Art. At Amherst he earned the Heisey Award for design in glass from Steuben and was honored with a scholarship to attend the inaugural session of the newly formed Yale Norfolk Summers Arts School. Upon graduating he received a Simpson fellowship from Amherst and a teaching fellowship from Yale where he enrolled to pursue his MFA. While at Yale, Gorbaty found himself in a rich artistic environment influenced by teachers that included Joseph Albers, Alexi Brodovitch, Leo Leonni, Herbert Matter, Bernard Chaet, Gabor Peterdi and Louis Kahn, as well as students that included Richard Anuszkiewicz, Neil Welliver, William Bailey, Arnie Bittleman and Jay Maisel. During this time at Yale, Gorbaty won the Summer Painting Prize from Joseph Albers and had his prints regularly shown in the prestigious Brooklyn Museum Printmaking Annual. His master's thesis Print Making with a Spoon was published by Reinhold and incorporated in almost its entirety in Gabor Peterdi's authoritative volume Printmaking Methods Old and New. 1954 was also the year that Gorbaty proposed to Joy Marks. They married in 1956 when practical considerations and pressures led him from a career in fine art towards one in graphic design. He honed his skills as a graphic artist working at Benton and Bowles Advertising as the Vice President Art Group Supervisor where he directed the product launch of many now familiar brands including the IBM Selective Typewriter, Pampers and Crest Toothpaste. During this time he was invited to be the Adjunct Proffersor of Advanced Graphic Design at Cooper Union where he taught for almost a decade. Upon leaving Benton and Bowles, Gorbaty opened his own graphic design studio in 1968. His work included credits for major motion pictures, museum posters, magazine covers for Time and US News & World Report,

30

and illustrations for numerous children's books. Gorbaty has received recognition and awards for his work and has been asked to lecture at a host of schools including Yale, Carnegie-Mellon, Minneapolis School of Art and the Kansas City School of Art. As Gorbaty states *"during the close to fifty years doing advertising design one would think there would be little time to do my own art. Not so. Firstly, the tools used were often the same pencils, brushes, pastel. The main difference was one of problem definition and reply. In advertising, the problem was given from the outside world, in personal work you designed your own problems. There were as many hours in the night as in the day affording the opportunity to make furniture and make ship models, geodesic domes for the kids to play on, to make cuttings or grow plants from seed...and do art. Maybe the doing of art was a way of keeping honest, of sticking to the high road—to make a statement of not having surrendered completely to the commercial world. Filling drawers with artwork was perhaps a way of alleviating the guilt felt for having aban-doned a life of art."* Throughout his fifty years as a graphic artist Gorbaty continued to produce fine art amassing a large body of work that includes sculpture, paintings and works on paper. With the passing of Joy, his "Old Beauty" in 2003, Gorbaty no longer had his audience-of-one with whom to share his art. Having accom-plished his goal of providing Joy and their two children with stabil-ity and comfort he again turned his entire focus back to fine art.

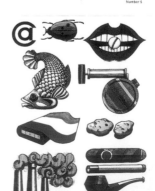

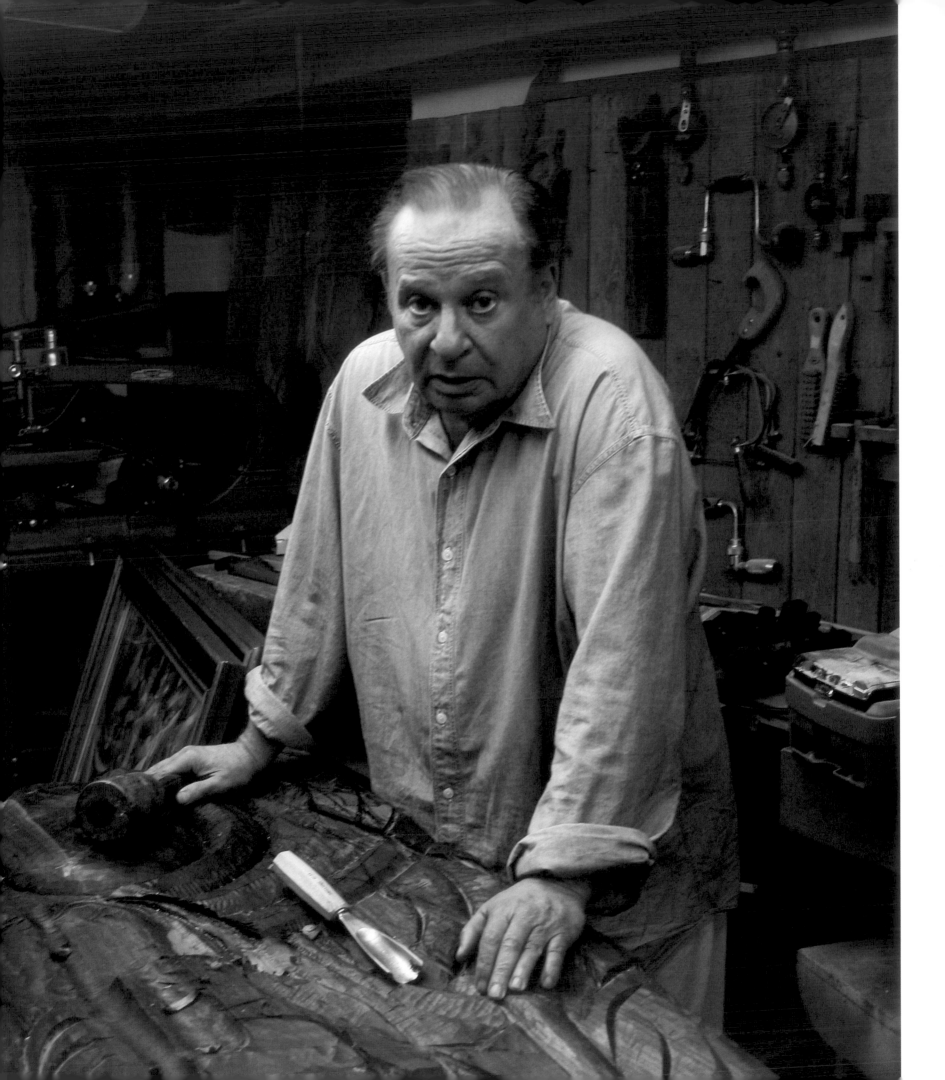

what
i
am
about

1. *Homage*
 Oil on Masonite
 Joseph Albers

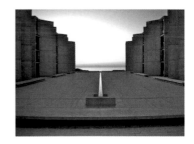

2. *Salk Institute*
 Louis Kahn

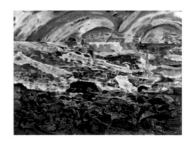

3. *Weather Bird*
 Oil on Canvas
 Bernard Chaet

Opposite Page:
Gorbaty in his basement studio
Great Neck, NY, 2006.

Le but n`est rien; le chemin, c`est tout. – Jules Michelet

*When I think of my work two words come to mind: Movement and Drawing. These concepts are recurring themes that I try to comprehend, study and explore. Yes, drawing is a concept. When I refer to "drawing" I don't just mean the physical works on paper or the finished piece. I am also referring to the process I use in the actual "doing" of the art. Joseph Albers, Louis Kahn and Bernard Chaet greatly influenced this approach while I was at Yale. **Joseph Albers**,[1] director of the Yale Art School, a former student and teacher at the Bauhaus, passed on those principles to students just beginning a journey into the world of art. We learned to see what we could not have seen before. To see the magic of color and form and how they effect each other, through our own eyes. He was the most mesmerizing lecturer I have ever experienced. He was tough. A no nonsense kind of guy. He could make grown men cry. He could command the focus of an entire lecture hall with one finger. From him I learned that in art, one plus one can equal four. The wonder of it all! **Louis Kahn**,[2] lectured in the school of architecture. During breaks he would come down to the basement of the building to schmooze with the design and art students. He said we were dreamers and more receptive to what he was about than most of the architecture students. The love, the humanization of the doing and the making. I learned more about the doing from looking at a brick and asking of it what it wants to be. About a life being born in the doing. About giving integrity to that which is being born, to hear what it wants to be, to honor it—to have dialogue with that which is being created—simply to be able to talk with it. I used to typeset Kahn's poetry for him. I still can see the love in his eyes in looking at the type I had shaped into his poetry. The words were his bricks! **Bernard Chaet**[3] taught drawing and painting at Yale. From him I learned a love for drawing, what simple line could create. Bernie of the magic pencil. He would correct our drawings*

with one mark here, a scratch there, they would come alive. We were so naive as to believe it was not him but his special pencil. Quickly we would run to the nearest art store to get that exact pencil. Alas, in the hands of beginners the pencil would not perform. The magic was not in the instrument but in Bernie. Till this day, when doing an image, I hear Bernie in the background sounding his point of view. Sometimes I accept it, oftentimes I question it, reject it, no matter, after all these years, I still hear him, feel his love for doing lines. I make a mark. That mark tells me where the next mark should go and so on until the piece begins to have a life of its own. It begins to tell me what it wants to be. It is for me to recognize what it wants to be and help it to become that. Sometimes I don't give in and instead force a different direction, it is all part of the conversation between me and the piece. It is this "doing" of the work that I am about. I am fascinated by the motion around us and often try to capture this in my work. There is movement in life as we "do" it. Everything moves. Images are constantly in motion. Whether we are physically moving or our surroundings are moving, or just our eye is moving we sense motion constantly. This movement combines with our differing perspectives of an image to create unique experiences that I artistically explore. Jules Michelet's quote sums up both my journey and my passion for art: The end is nothing, the road is all. When a piece is finished it no longer belongs to me. You can hang it, show it, look at it, turn its face to the wall, say about it what you want, and do with it what you will. But the doing of the work is mine. Only I own the doing. I am most concerned with the doing, but can't hide from that which is done, the "finished" work. Why the need to explore a specific subject—a grape, an egg, music, myth, a biblical thought, a waterfall, a mountain, a tree, death, growth, movement? I confess I don't know. Something strikes my fancy and that's it! The finished images are unfulfilled, no more

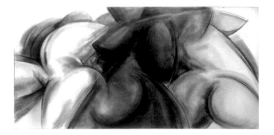

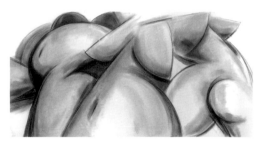

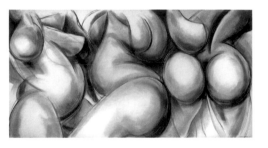

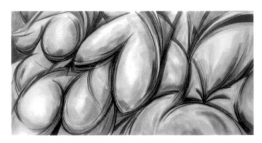

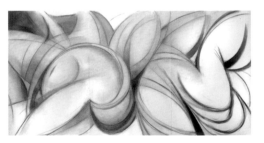

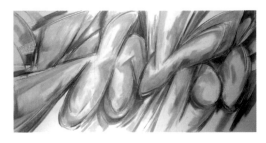

Why the need
to explore
a specific subject?
… I confess
I don't know.
Something
strikes my fancy
and that's it!
The finished
images are
unfulfilled,
no more than
beginnings,
notations for
continued search,
then or at
some later time.

than beginnings, notations for continued search, then or at some later time. Once noted, I am free to go elsewhere knowing they will be future reminders of where to go, to resume the "what ifs" of the unknown uncovered by the yes—for the yesses open doors to the unknown. Yesses are hard, they say "let's try it," let's take a chance, let's go where we have never been before. There are no answers. We can only make reply depending on the context in which we find ourselves in the doing. The context is constantly changing as we are changing as the surround is changing. Everything is moving in this circling merry-go-round.

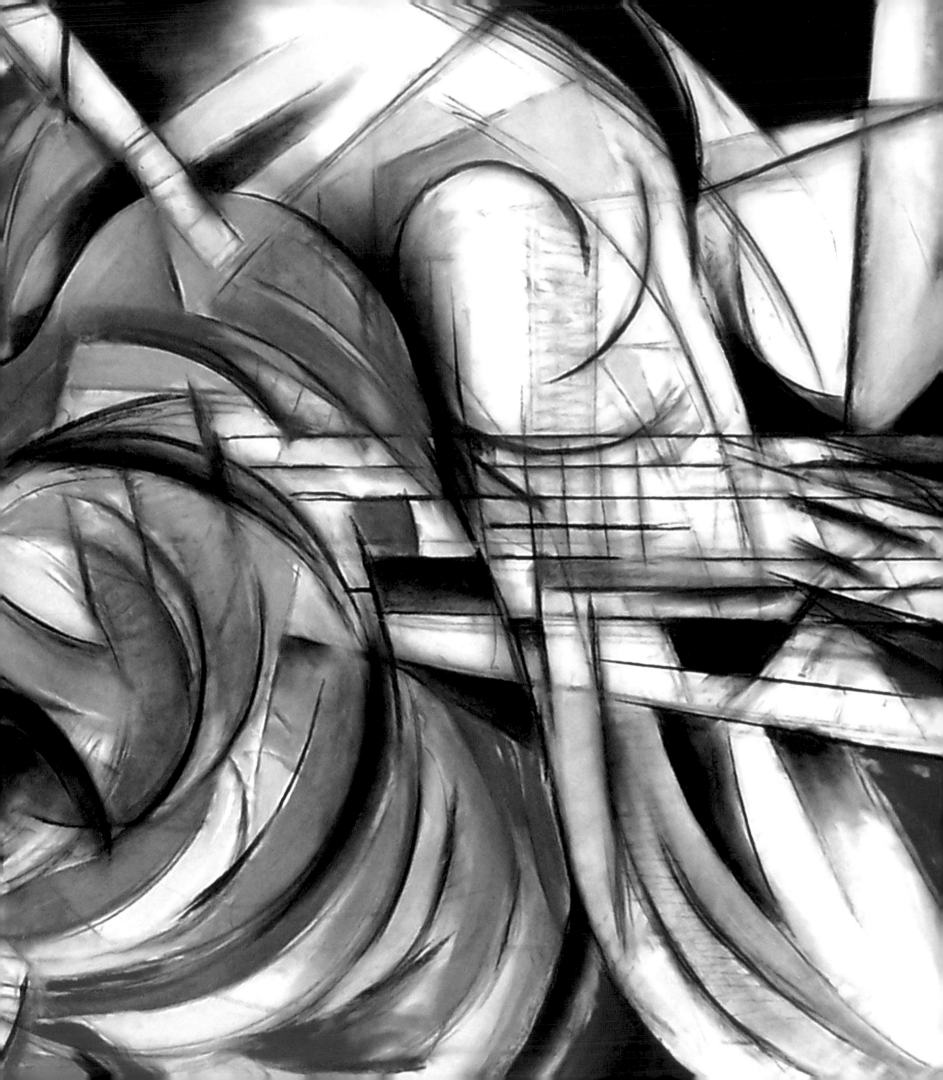

doing

pastel

is

messy

and

dirty

Pastel is a pain in the ass. At first, I hated the medium. Messy….fingers, clothing, face, hair, studio, everything! Then why do pastel? Because the pure pigment in pastel will retain its light longer than any other medium. Degas' pastels are as brilliant today as the day he did them. I was never formally taught how to do pastel. I don't do traditional pastels — portraits, still lifes, landscapes, etc. I do my own thing and use them more like paint. That's why perhaps, when reproduced, most people think they're paintings. Now, I love working with pastel…but it's still a pain in the ass!

Detail:
Django
78" x 40"
Pastel
2005

Following Page:
Parade No.1
40" x 78"
Pastel
2002

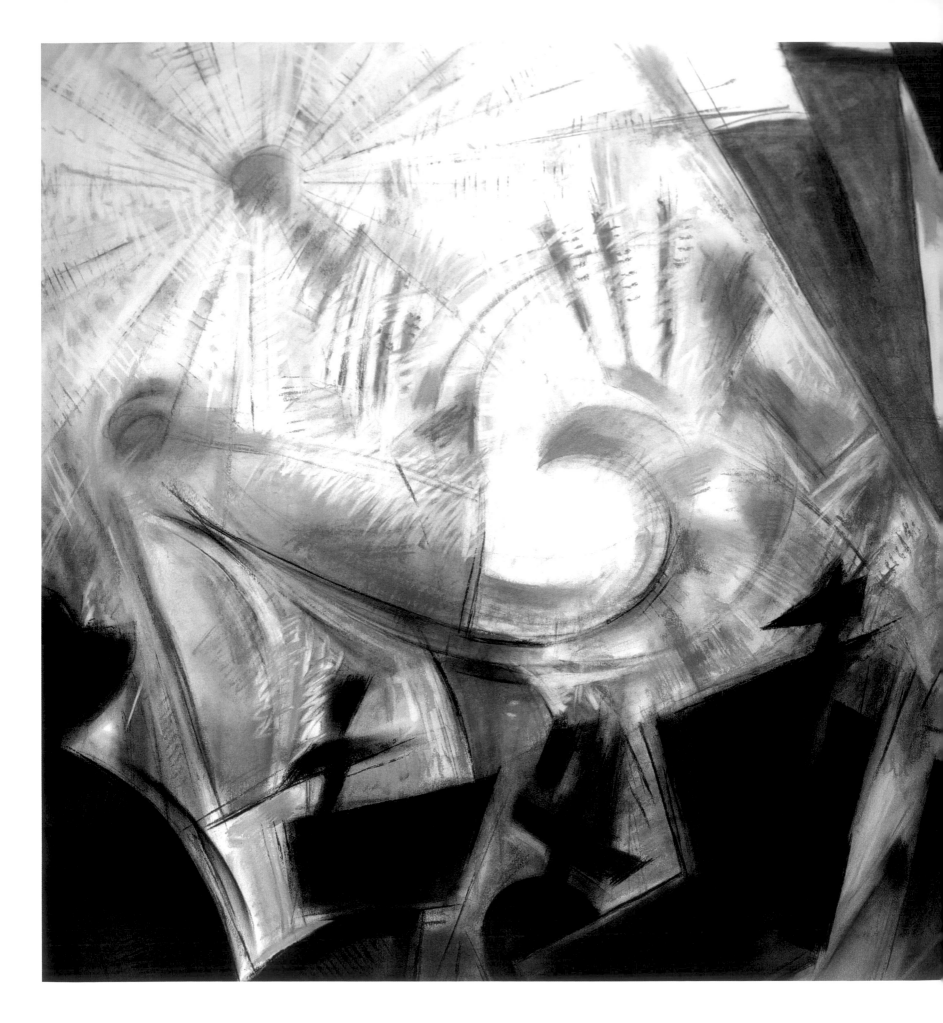

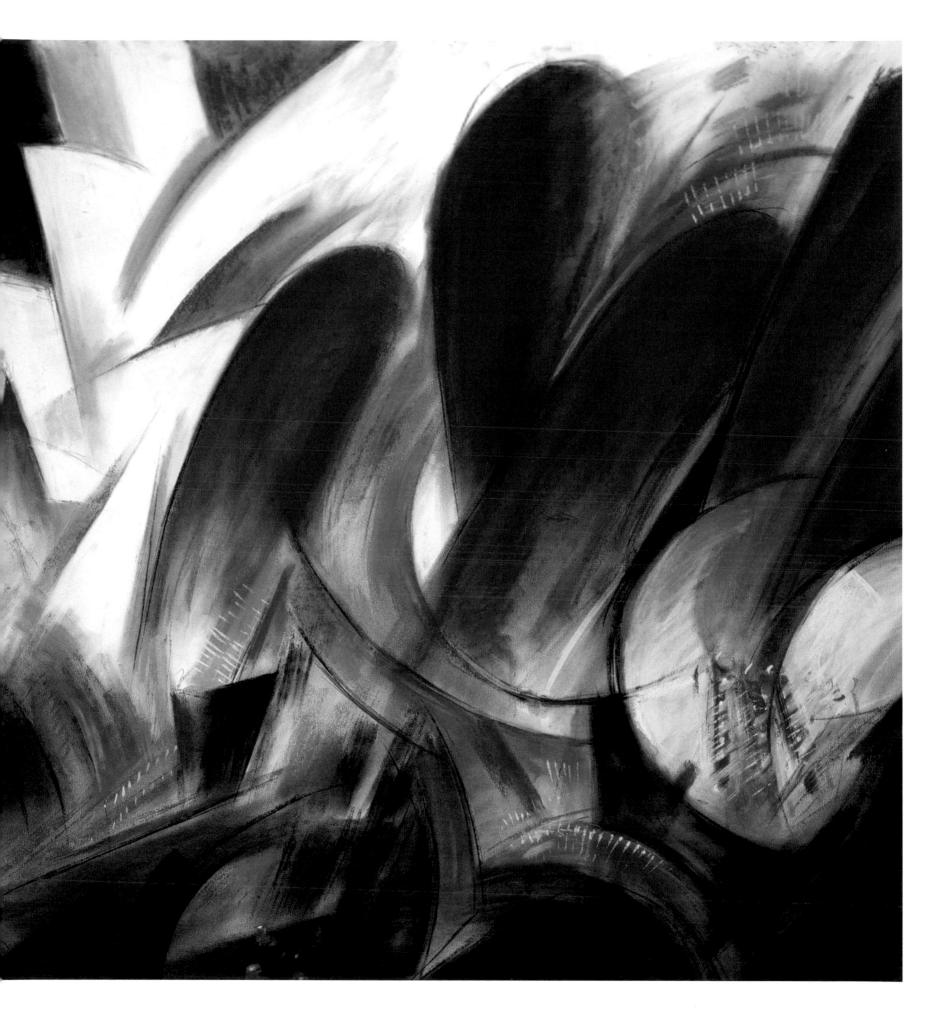

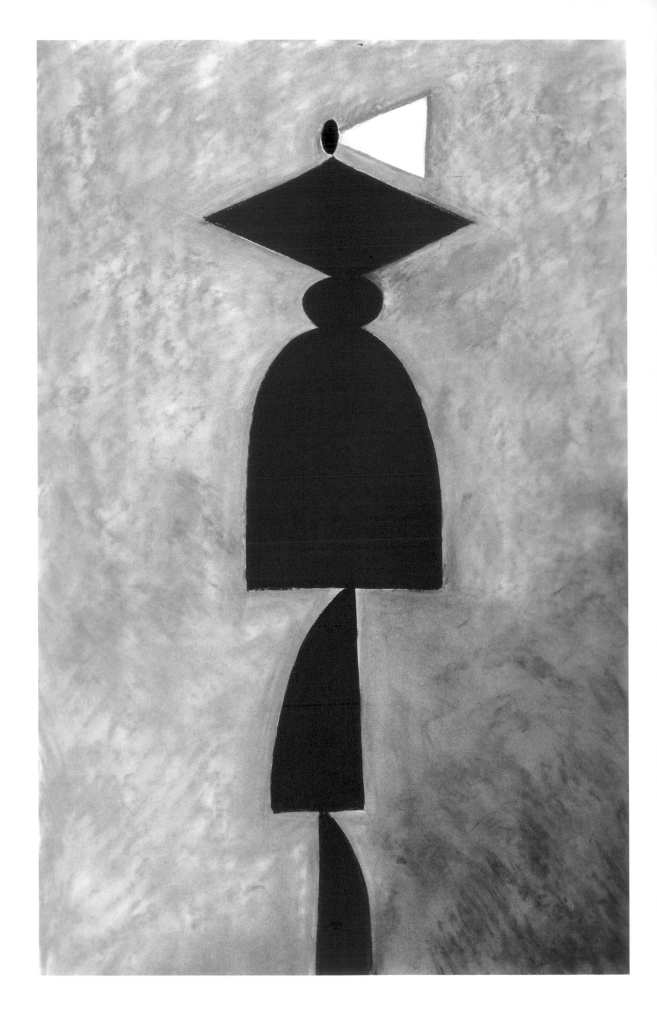

Big Black Lady
40" x 26"
Pastel
1977

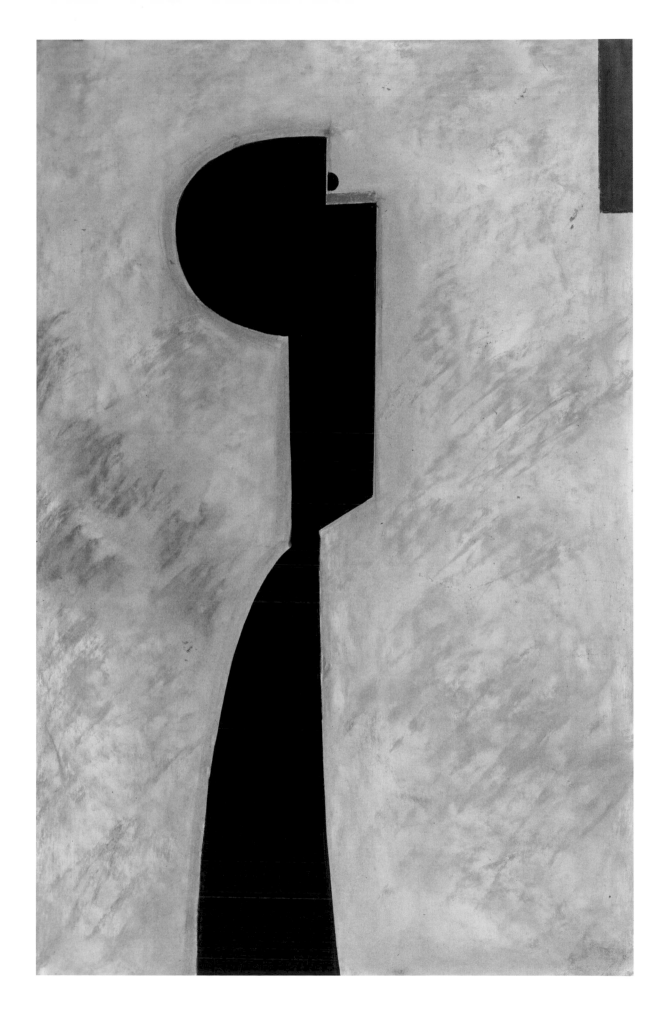

Spanish Dancer

40" x 26"

Pastel

1977

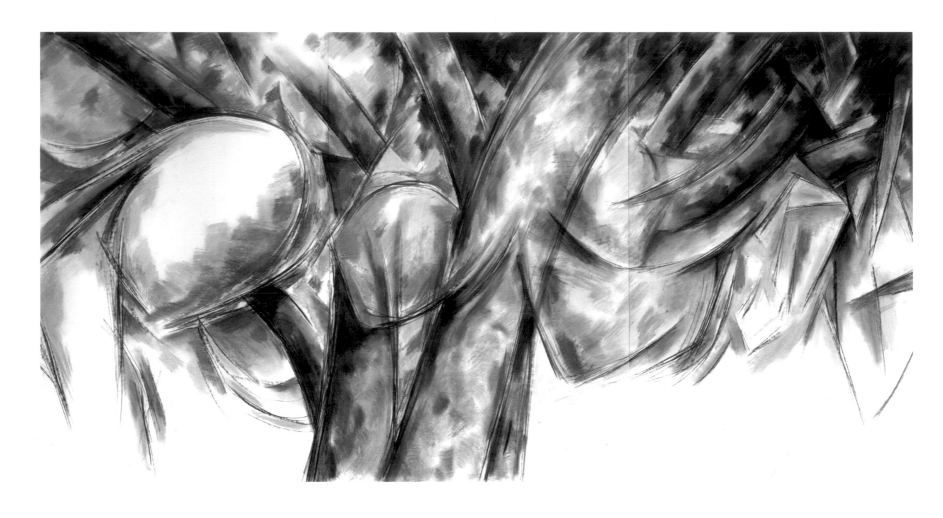

Provence
40" x 78"
Pastel
1978

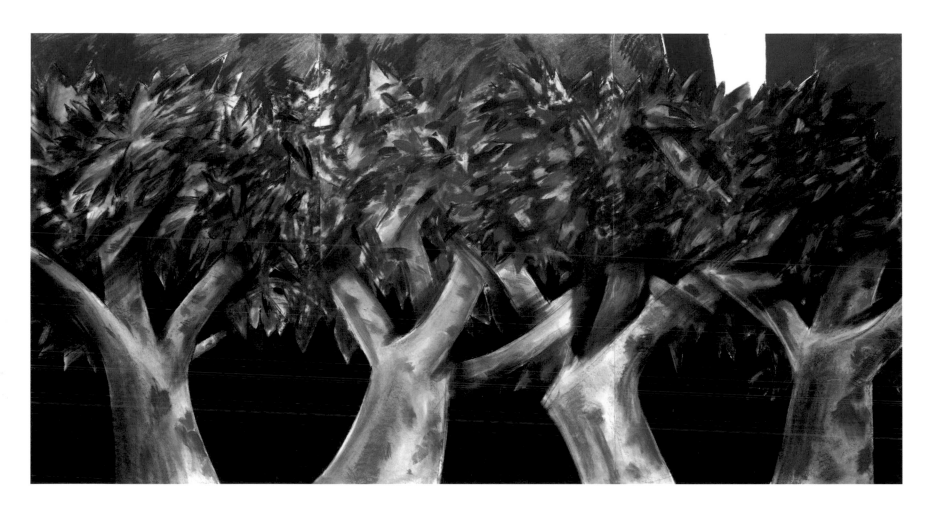

Cannes
40" x 78"
Pastel
1988

Following Page:
Joy's Mountain
40" x 78"
Pastel
2003

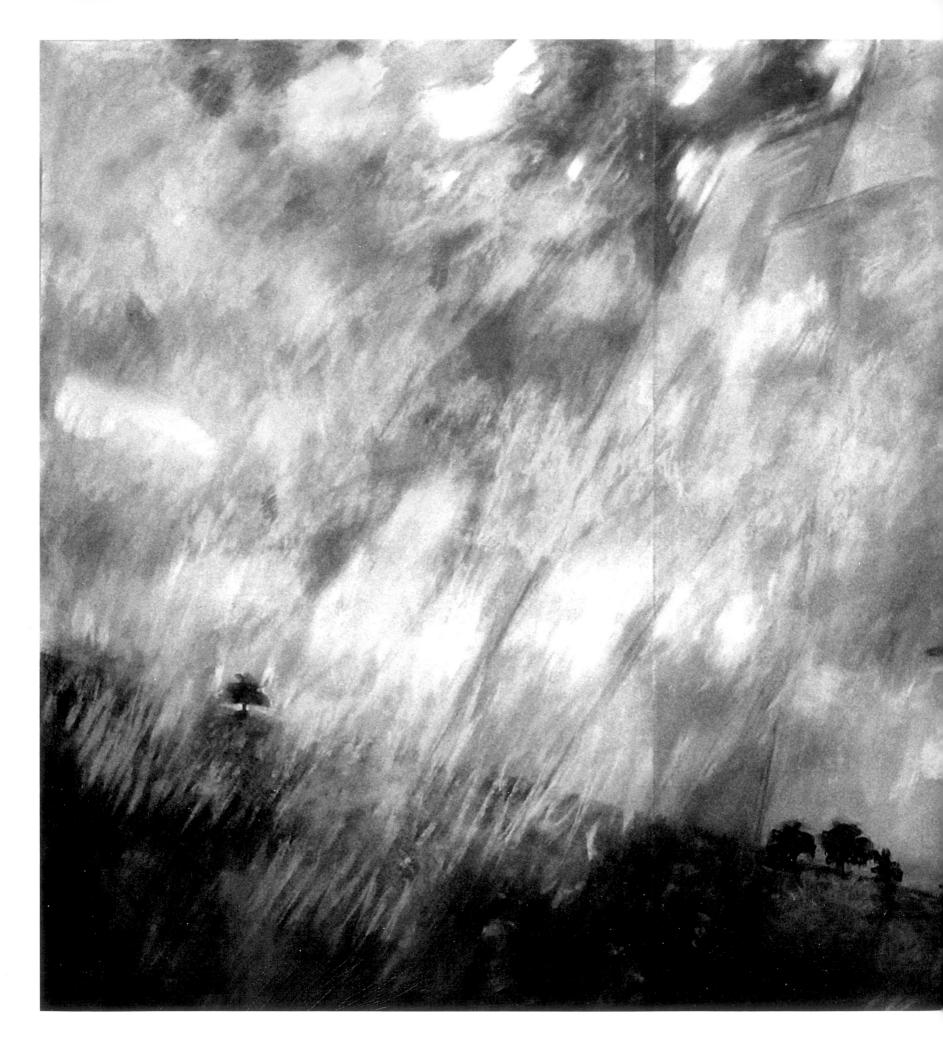

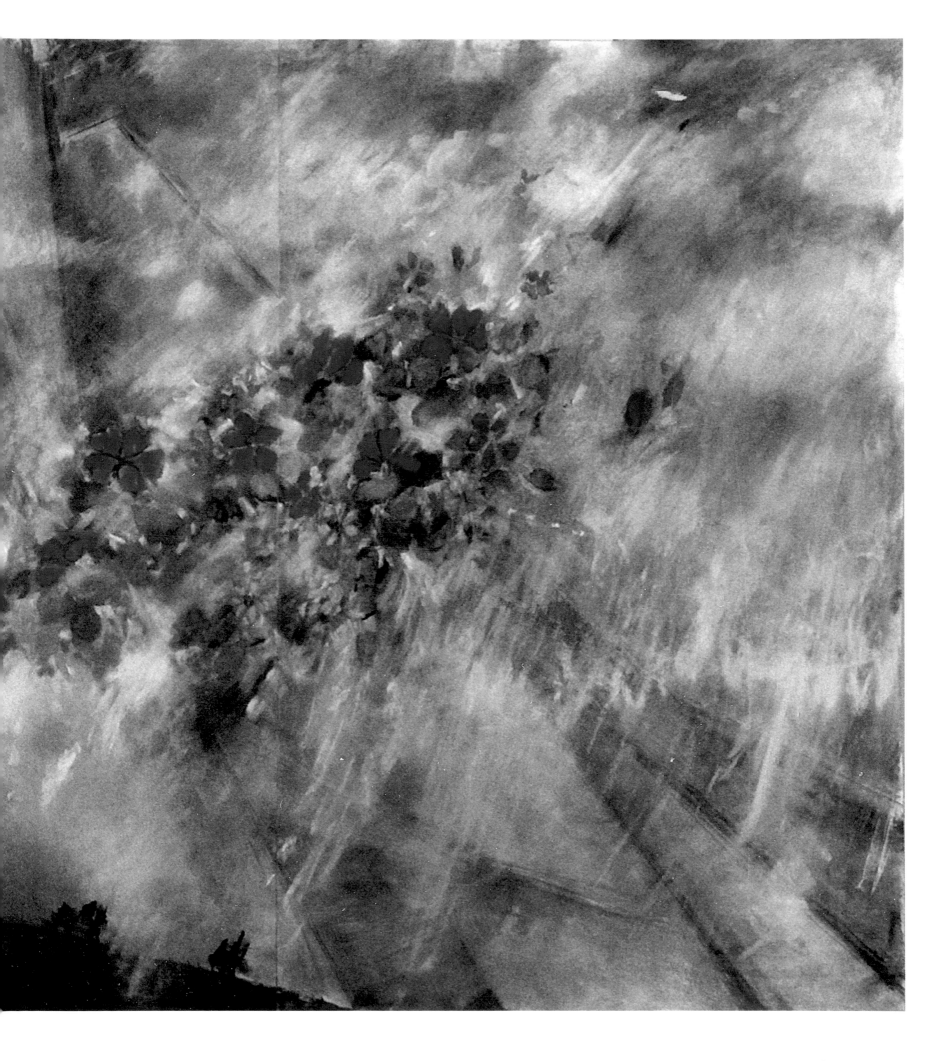

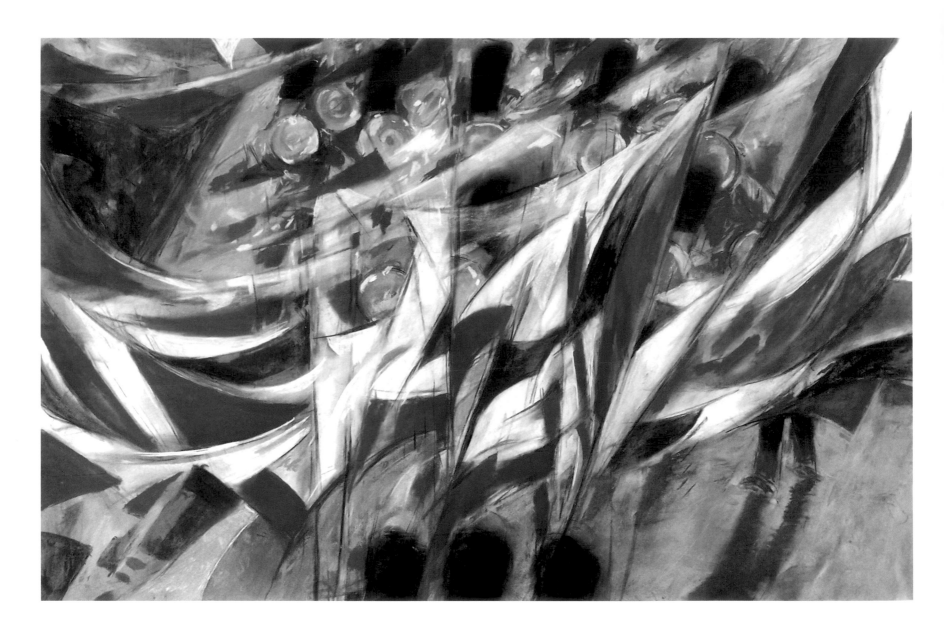

Parade at You
26" x 40"
Pastel
2004

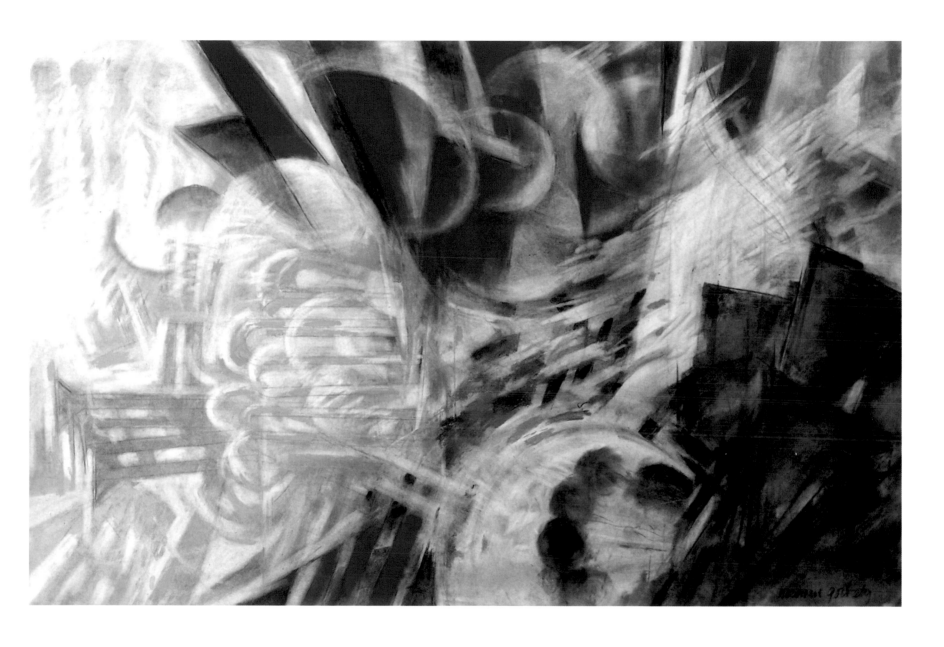

Parade No.2
26" x 40"
Pastel
2002

Following Page:
Spain
40" x 78"
Pastel
1977

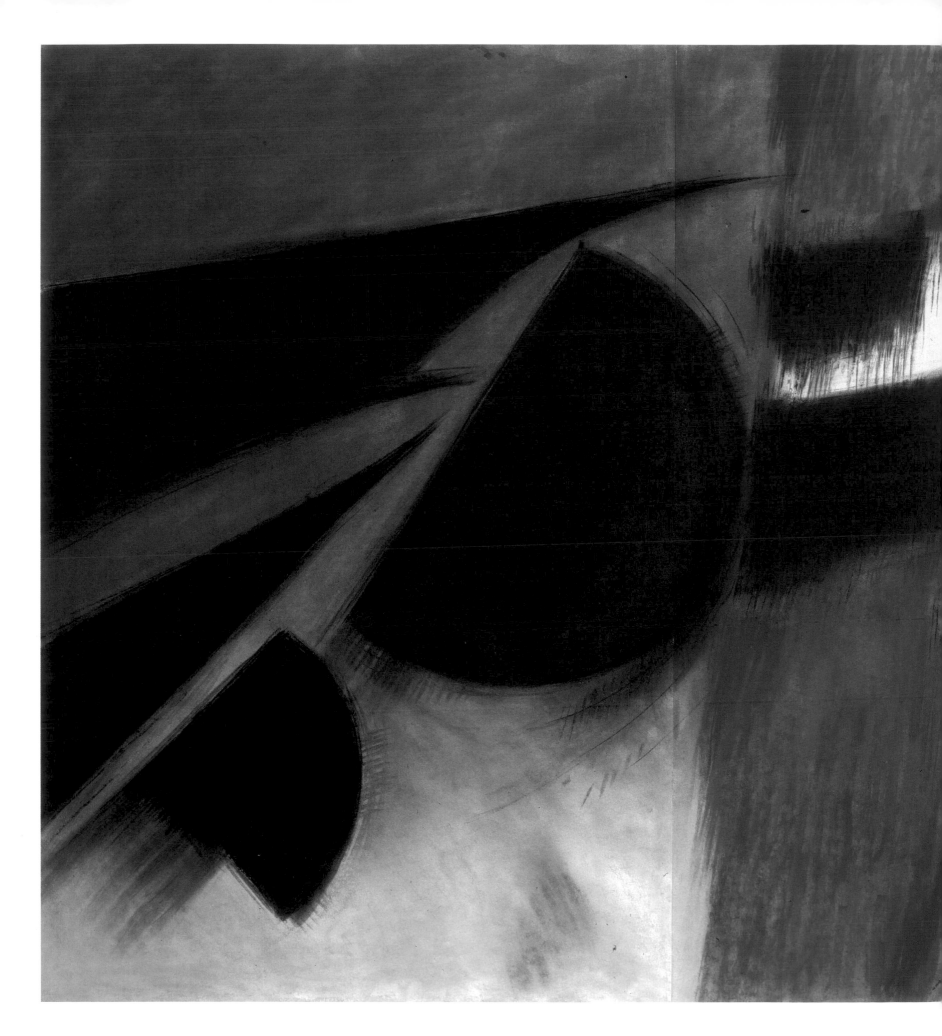

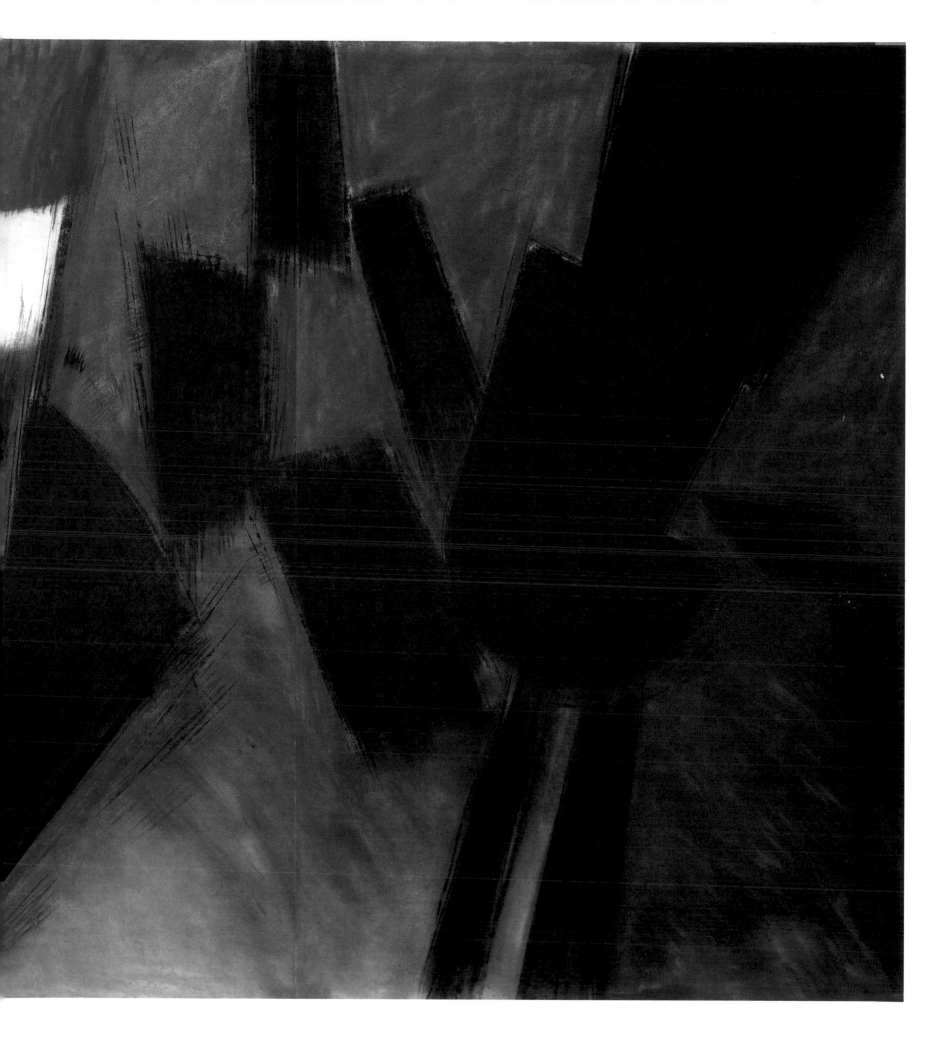

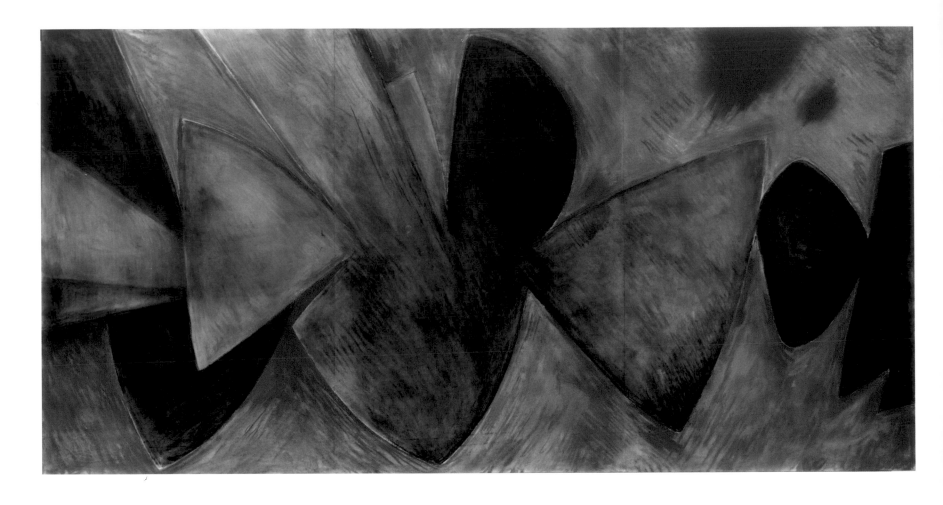

Pink & Green
40" x 78"
Pastel
1998

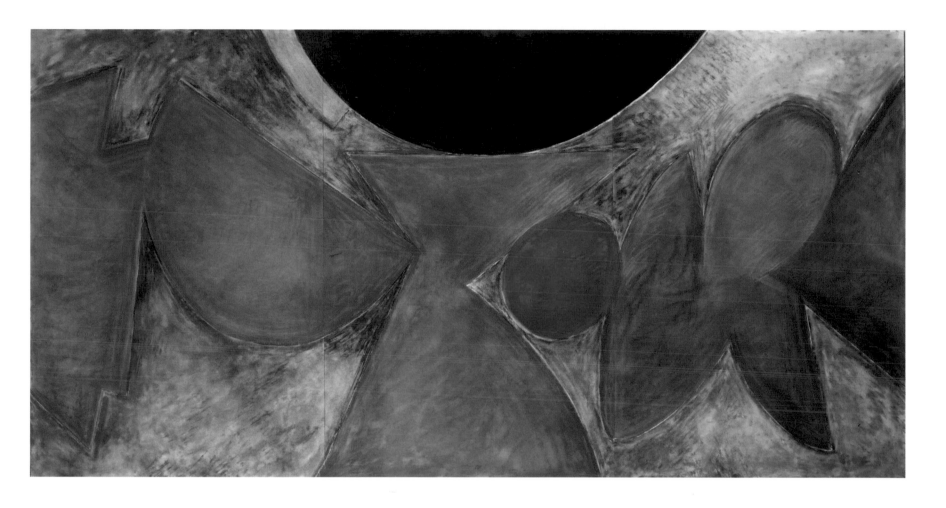

Mexico
40" x 78"
Pastel
1985

Following Page:
Django
78" x 40"
Pastel
2005

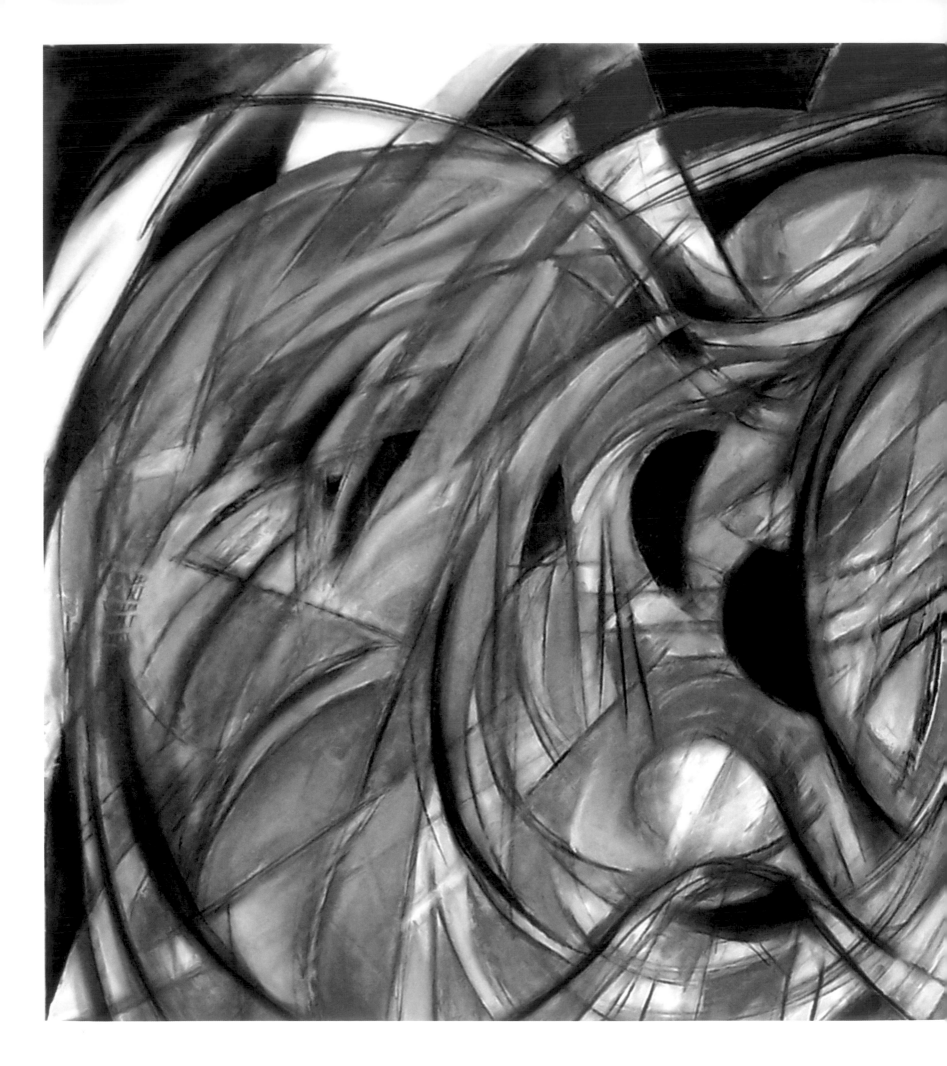

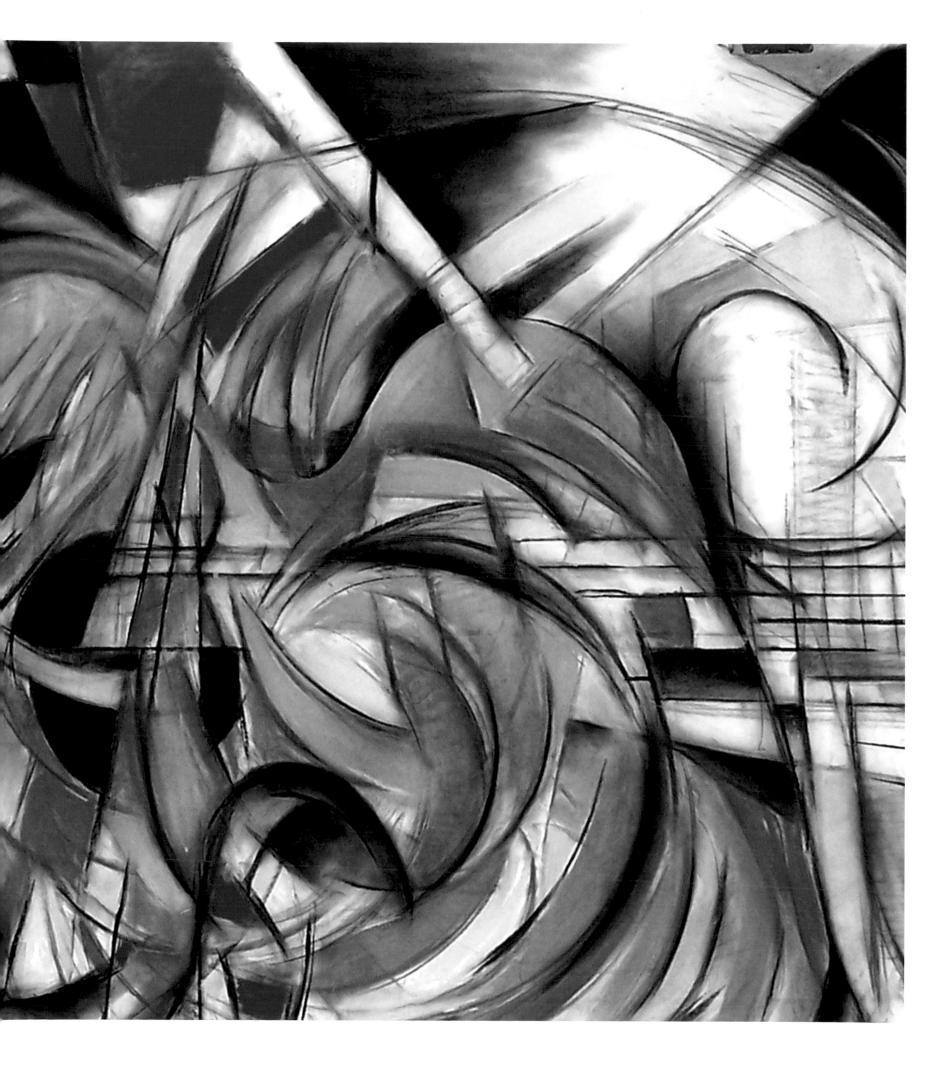

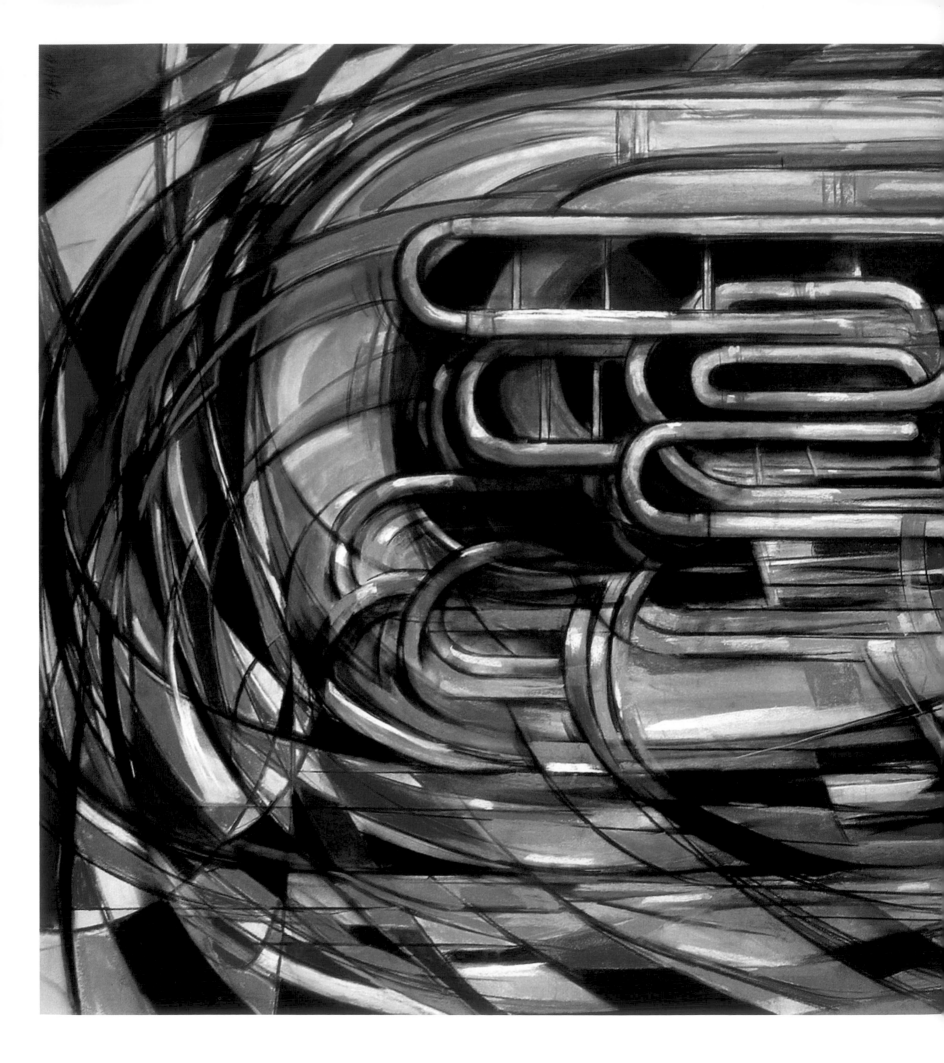

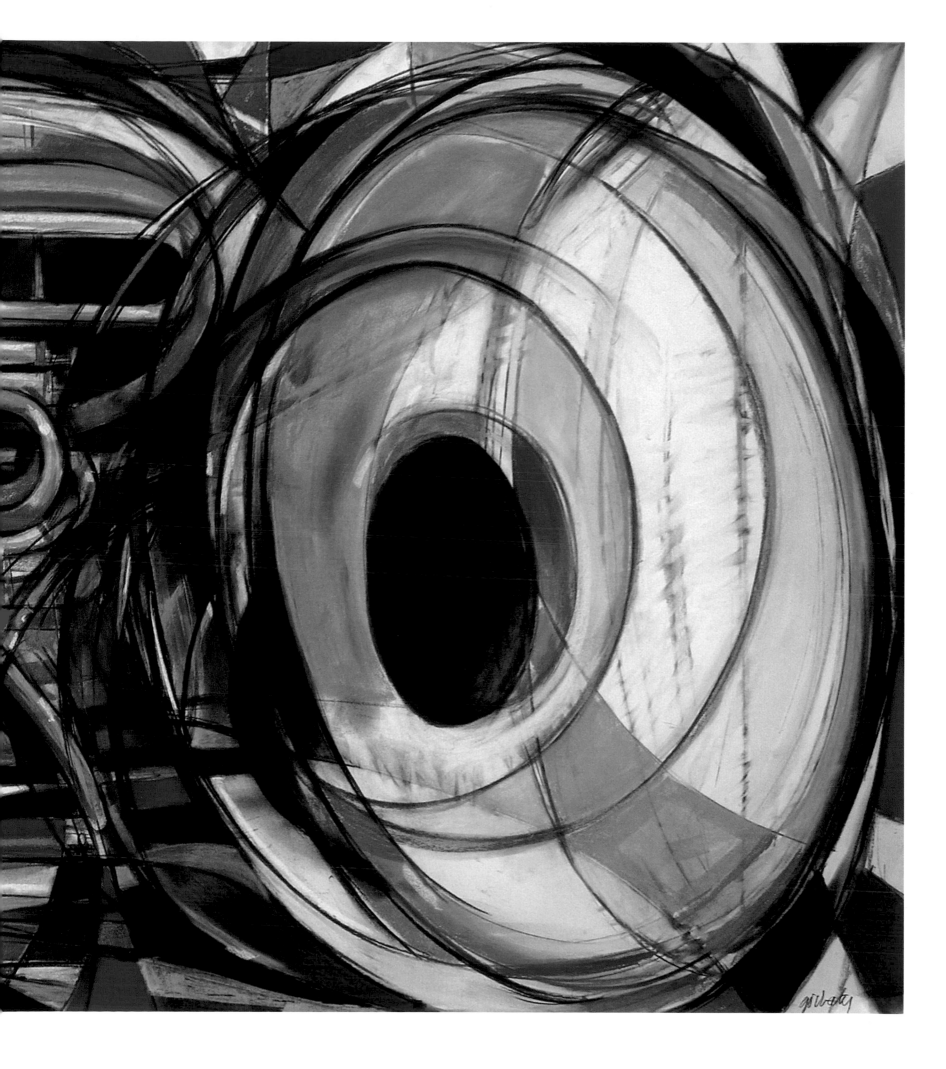

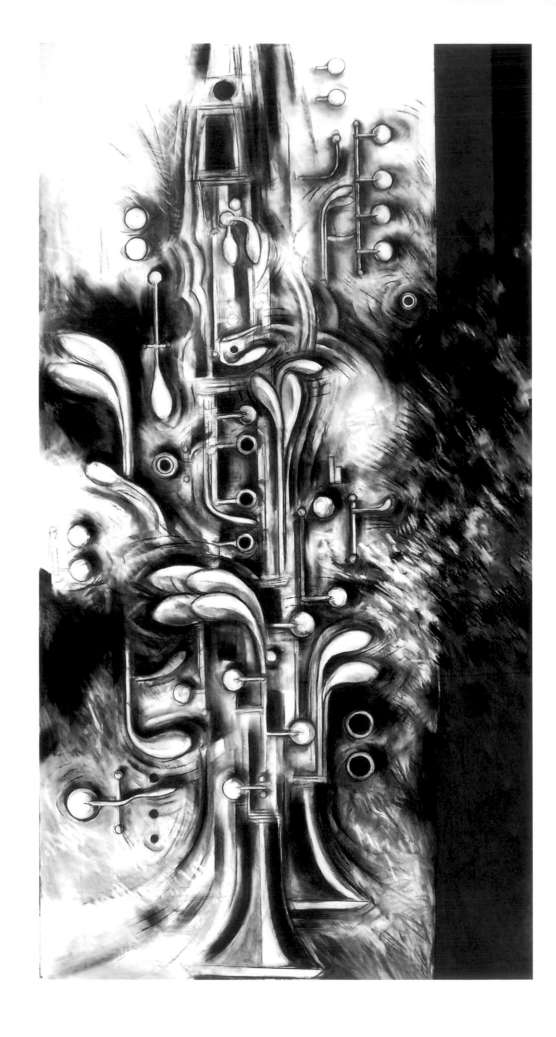

Preceding Pages:

John Phillip's Tuba
78" x 40"
Pastel
2005

Dr. Chow's Clarinet
78" x 40"
Pastel
2005

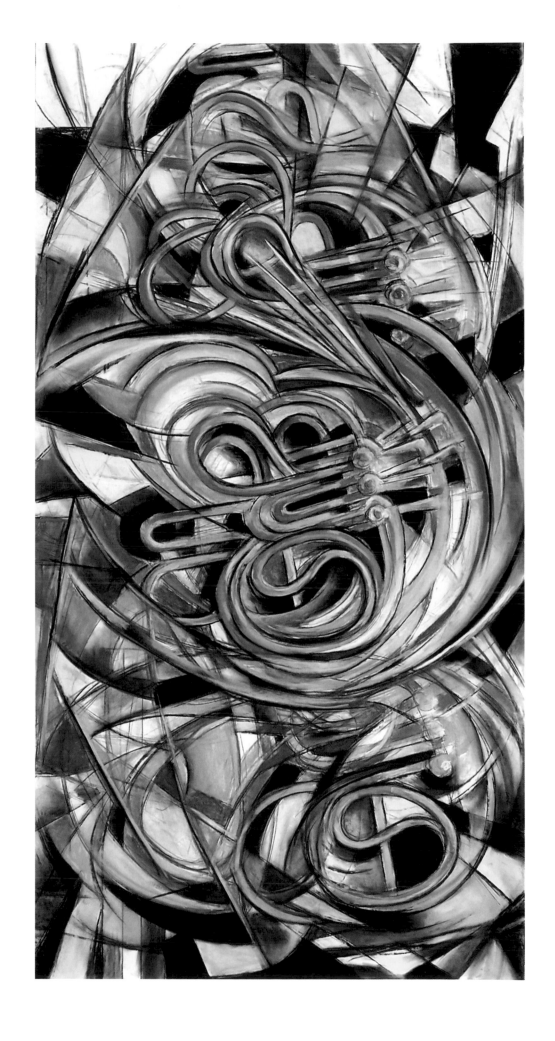

Cor
78" x 40"
Pastel
2005

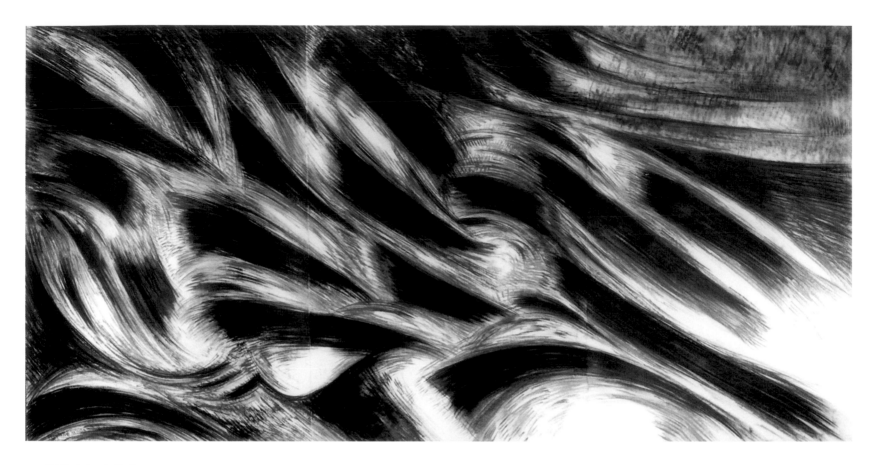

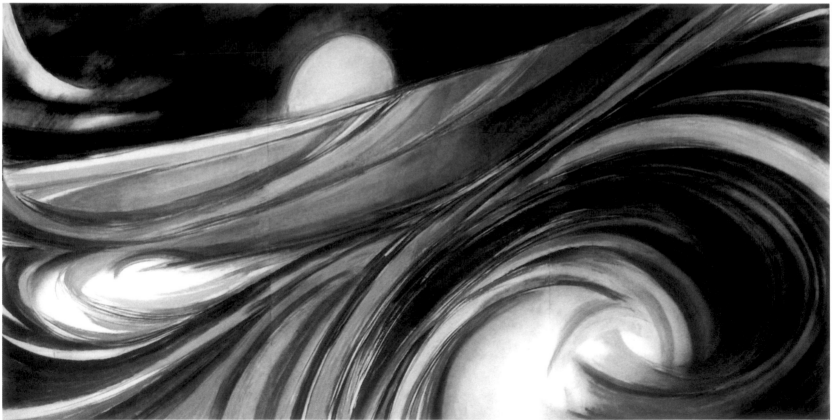

Breaking Waves
40" x 78"
Pastel
1993

Moon Waves
40" x 78"
Pastel
2006

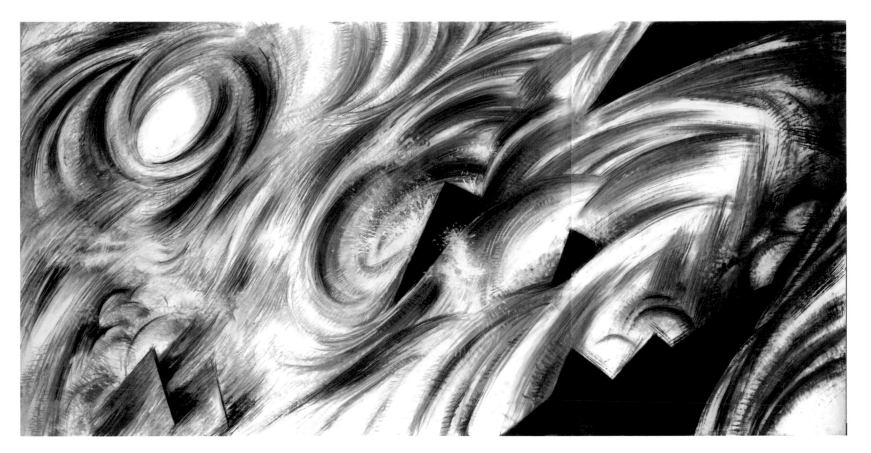

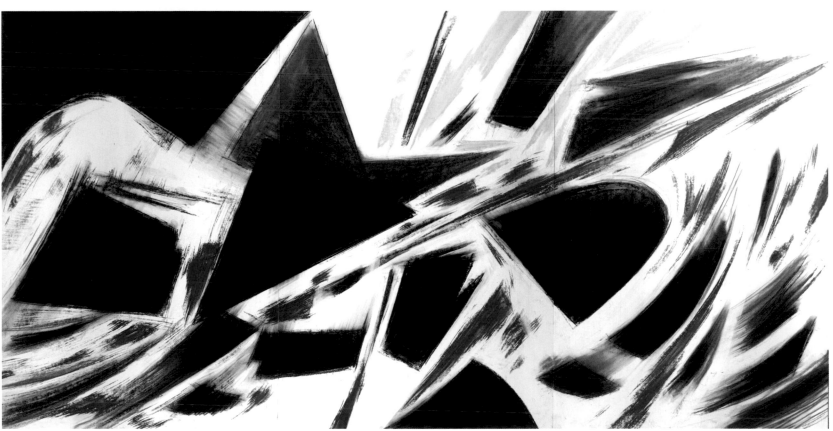

Rush	Rapids
40" x 78"	40" x 78"
Pastel	Pastel
1993	1976

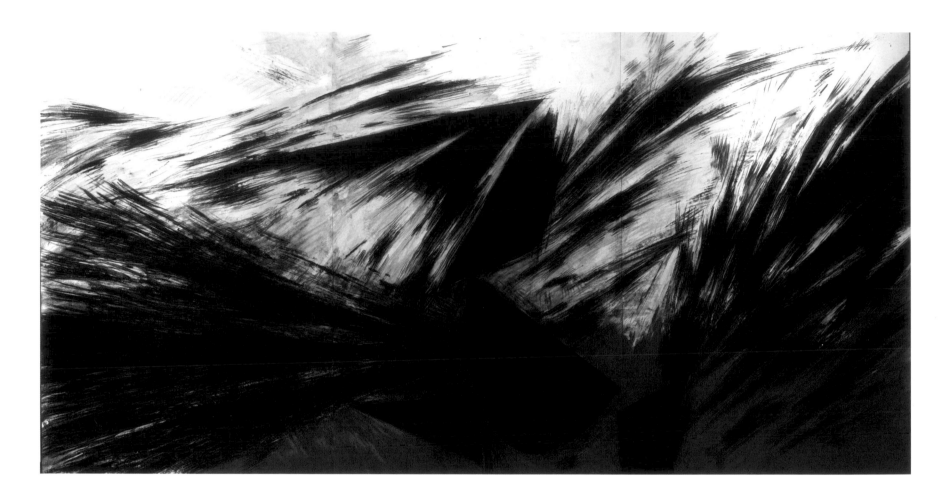

Icarus
40" x 78"
Pastel
1997

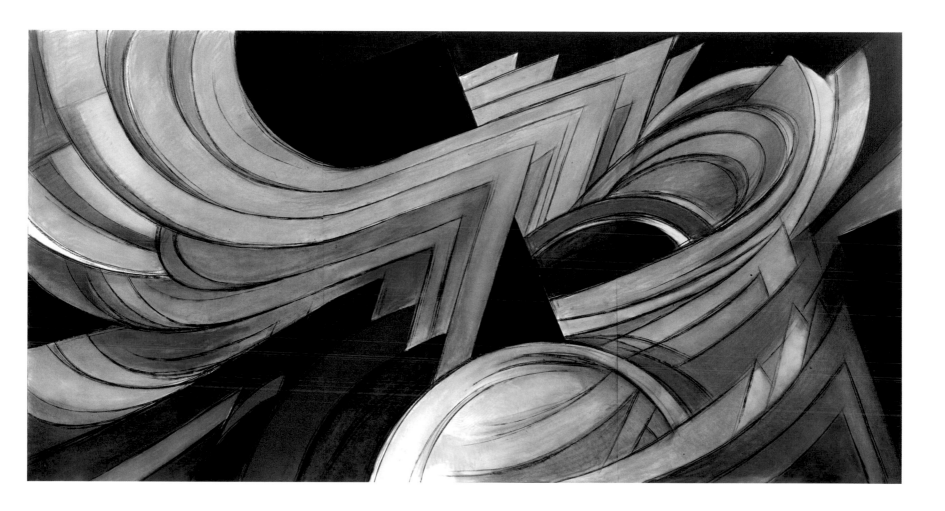

Movement
40" x 78"
Pastel
1997

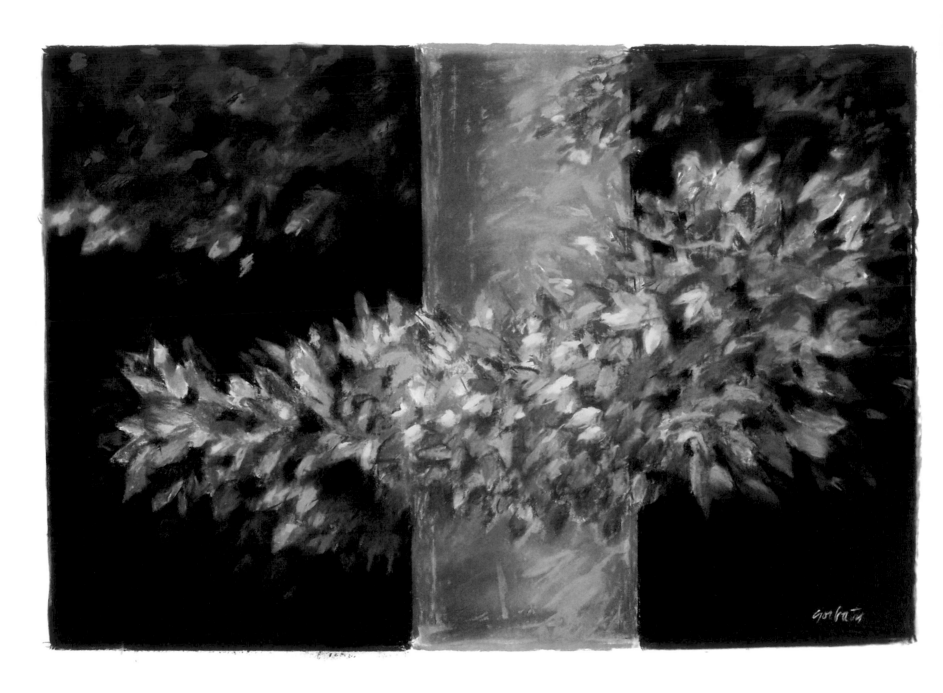

Middle Tree
22" x 32"
Pastel
2005

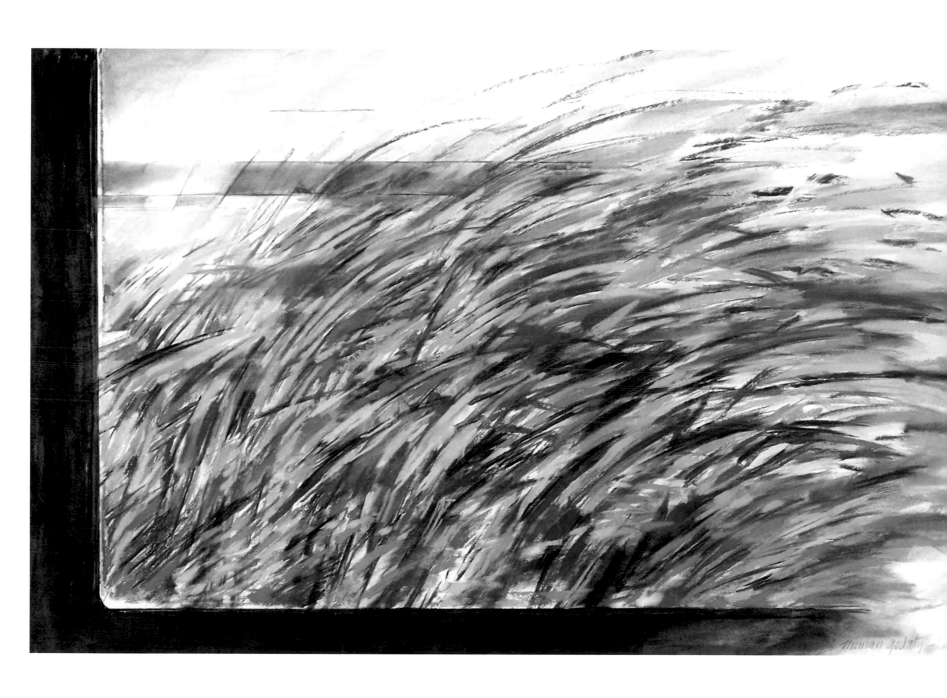

From The Train

26" x 40"

Pastel

1999

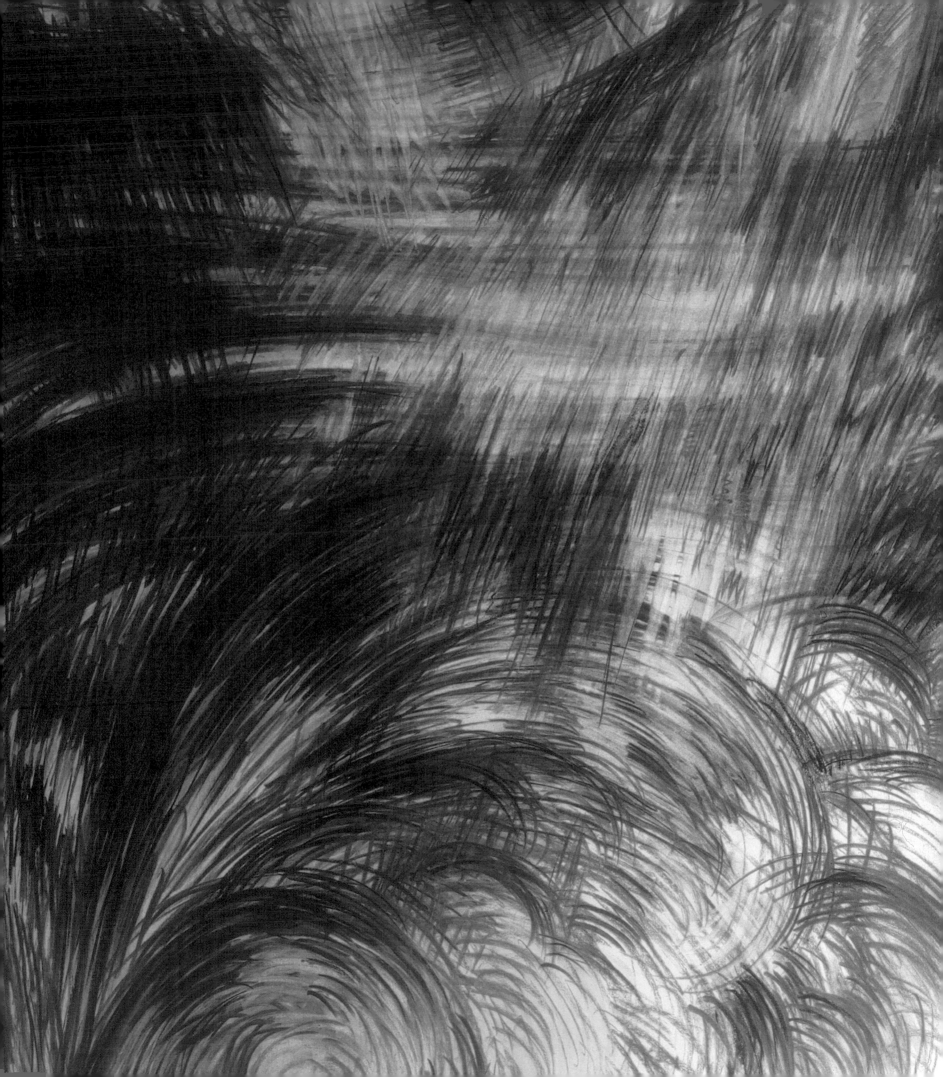

doing

drawing

is

doing

magic

Drawing for me is basic to all forms of the visual arts. In doing drawing one becomes a magician. Symbolically defining three dimensional form in two dimensions. The mark, the line, darkness and light are units of language, as is the word or grammar for communicating feelings, ideas and thought. Drawing can be quick, like a sketch, to catch an idea or more "tickled" as a more complete statement.

Detail:
Maelstrom
40" x 78"
Charcoal
1998

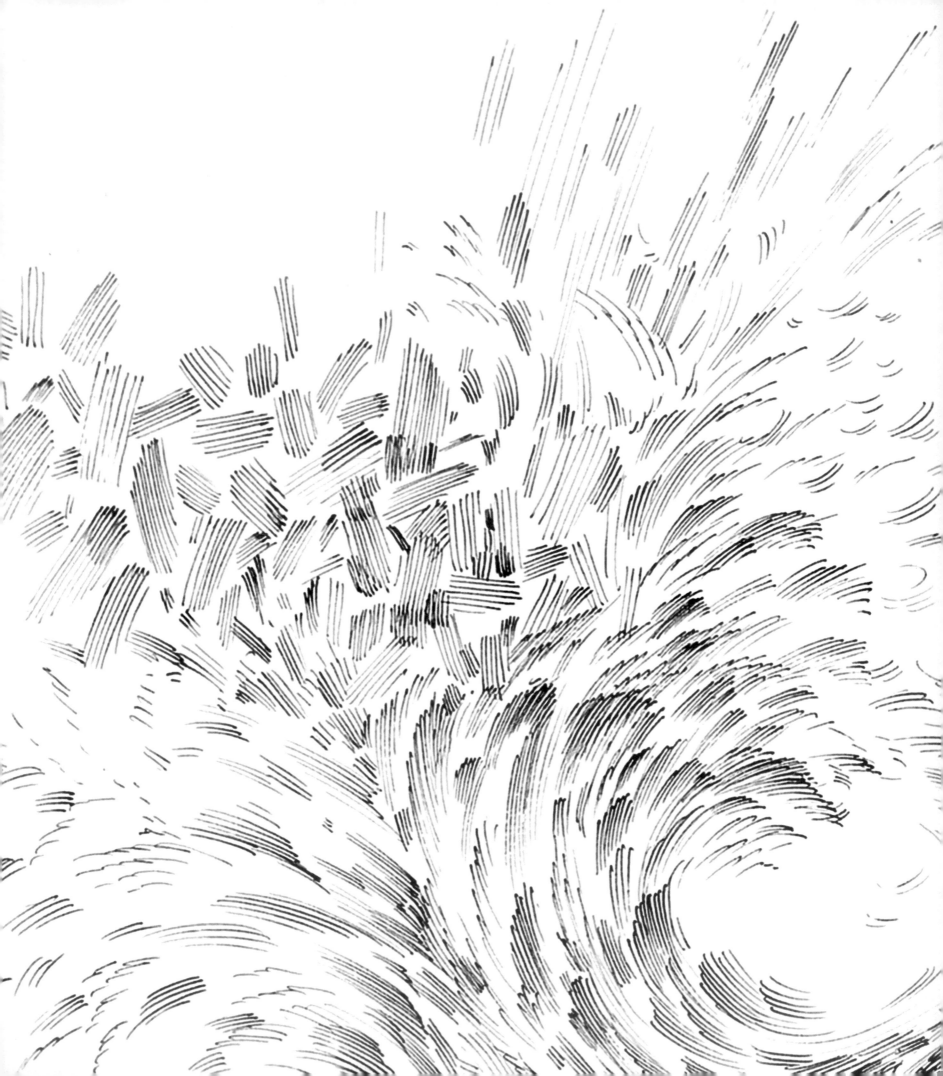

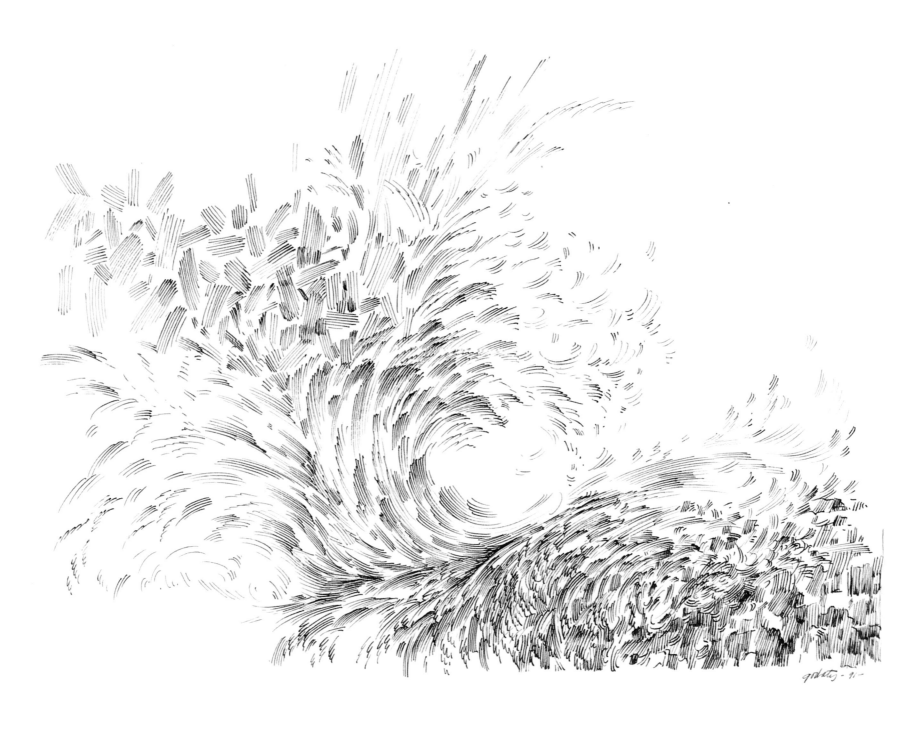

Detail

Wave No. 1

16" x 21"

Pen & Brown Ink

1991

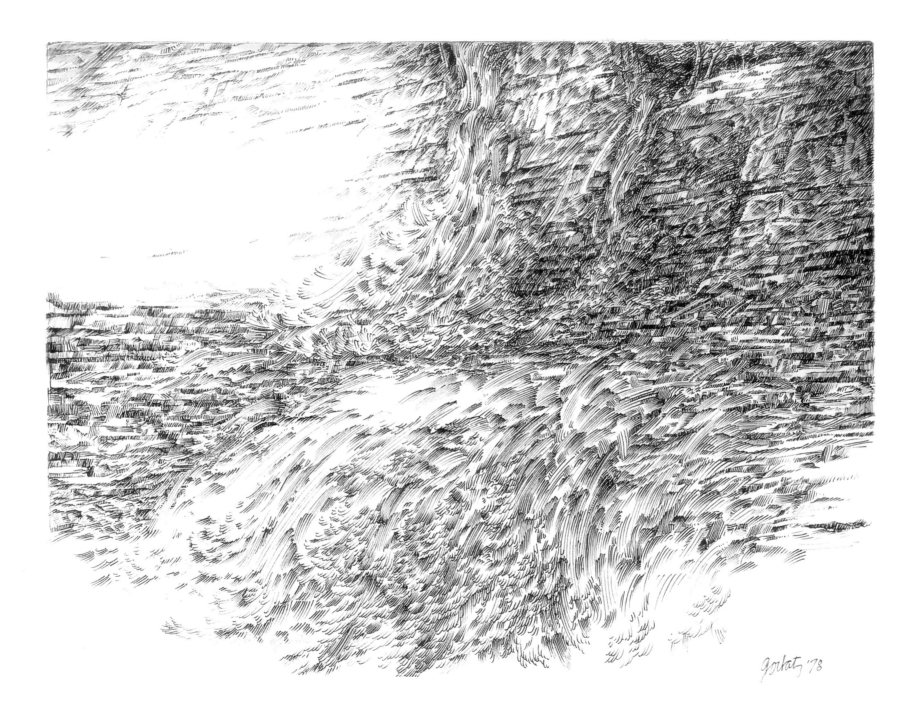

Simon's Falls

16" x 21"

Pen & Brown Ink

1978

Detail

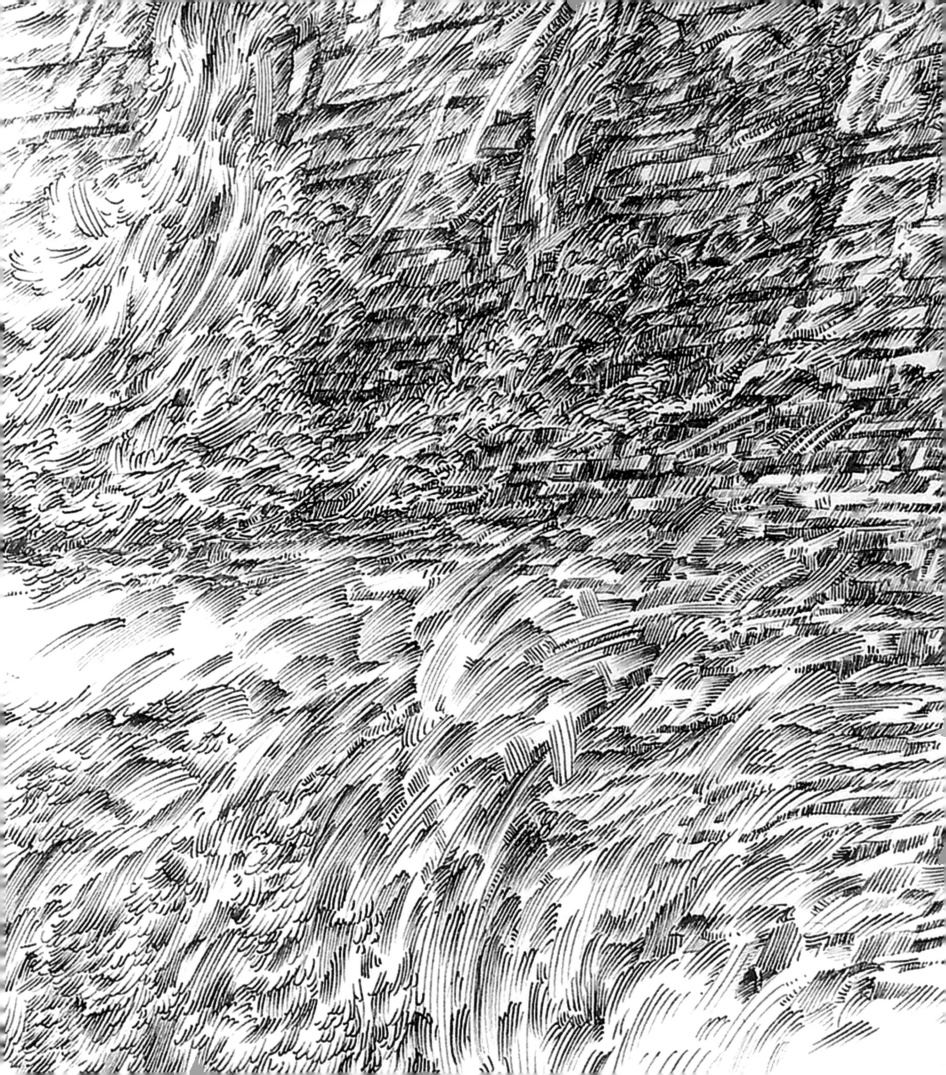

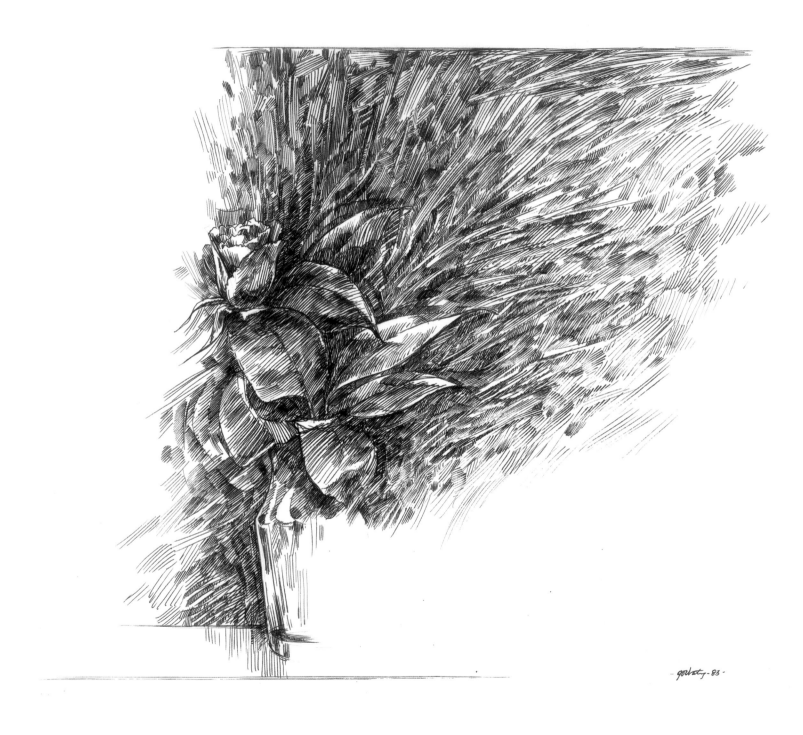

Rose
16" x 21"
Pen & Brown Ink
1983

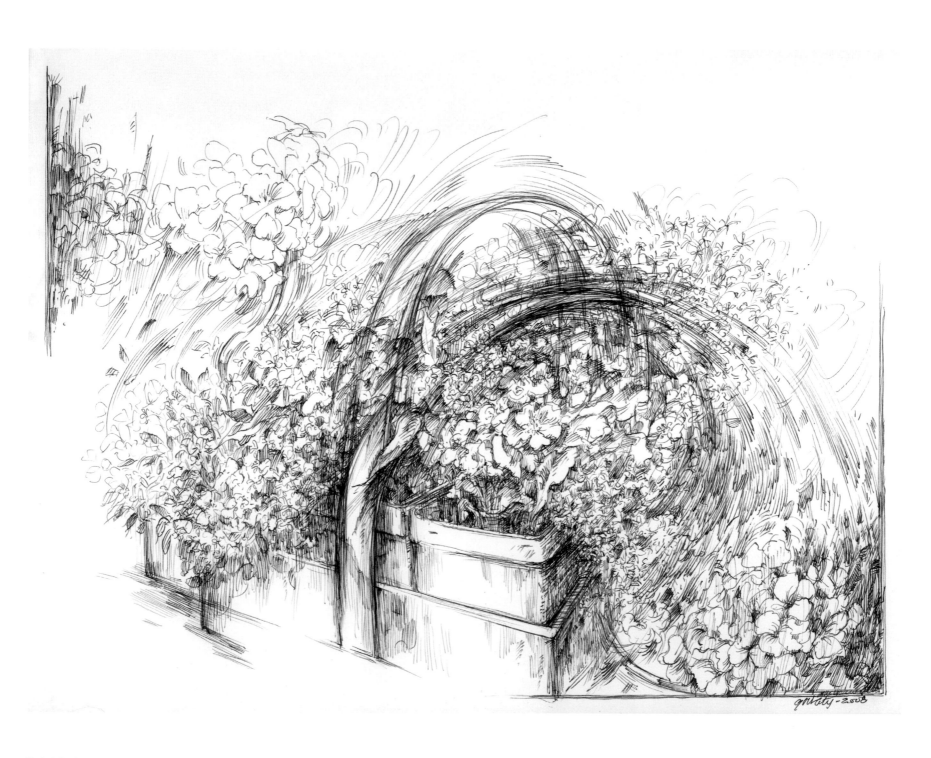

Hariet's Basket
16" x 21"
Pen & Brown Ink
2008

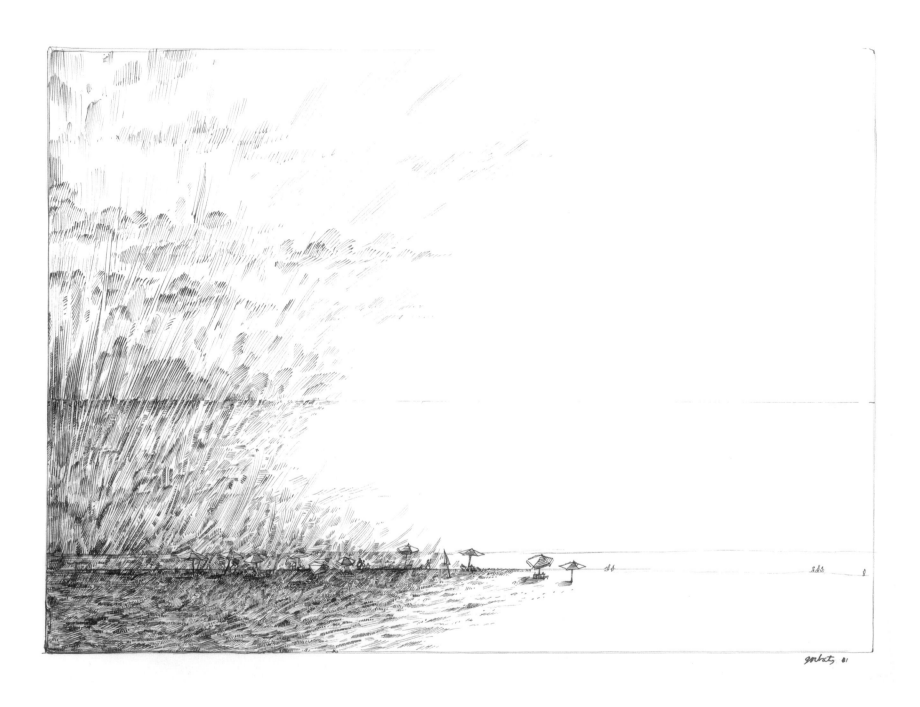

Beach End of Day
16" x 21"
Pen & Brown Ink
1981

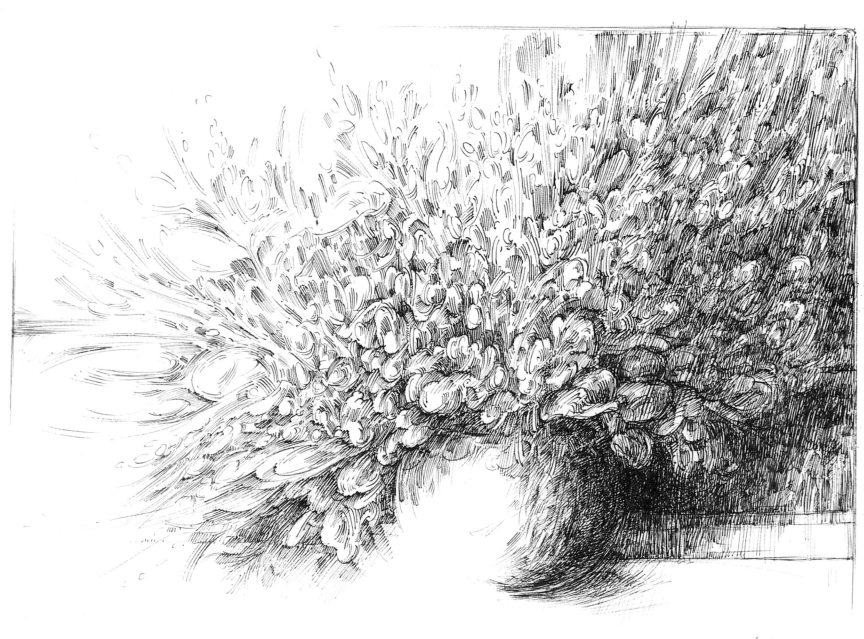

Bowl

16" x 21"

Pen & Brown Ink

1981

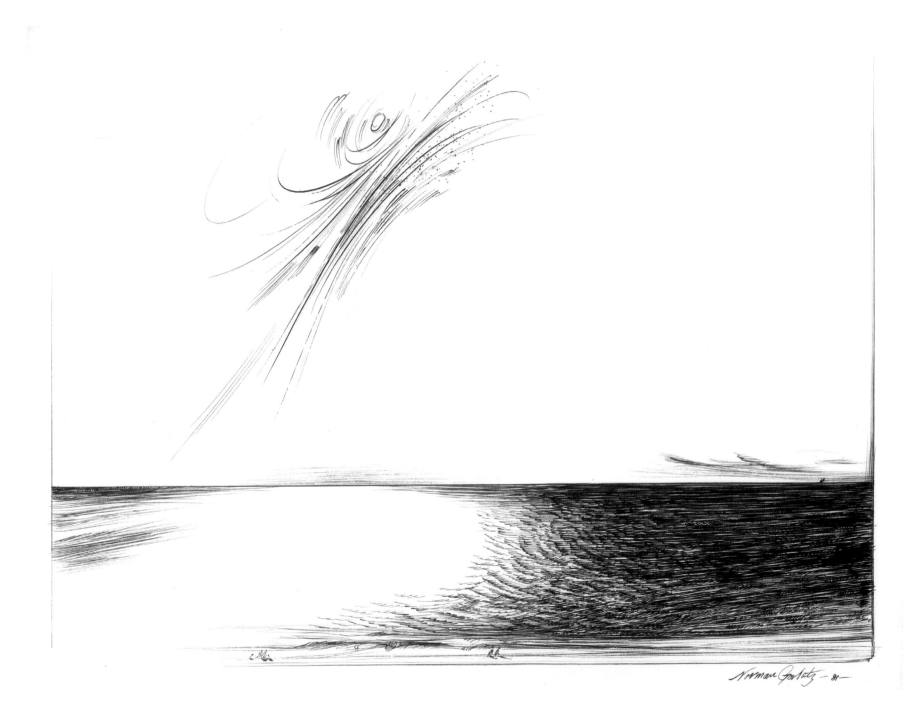

Reflection

16" x 21"

Pen & Brown Ink

1981

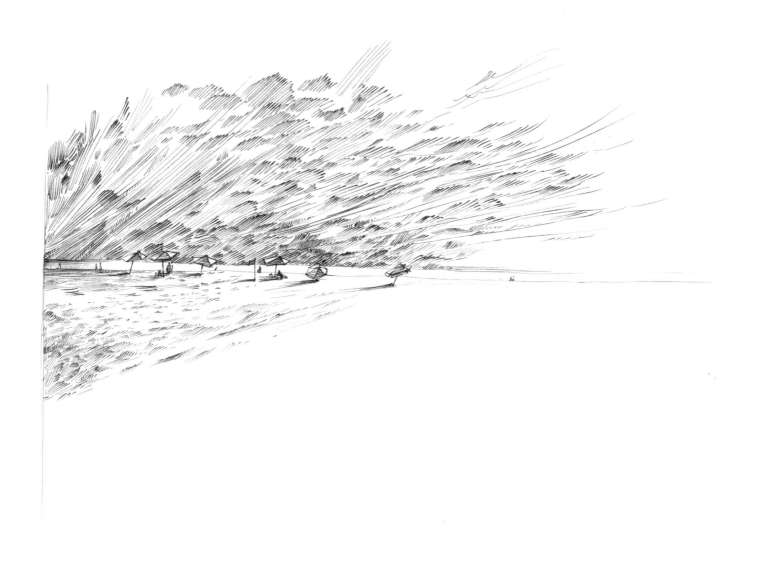

Beach Sunset

16" x 21"

Pen & Brown Ink

1981

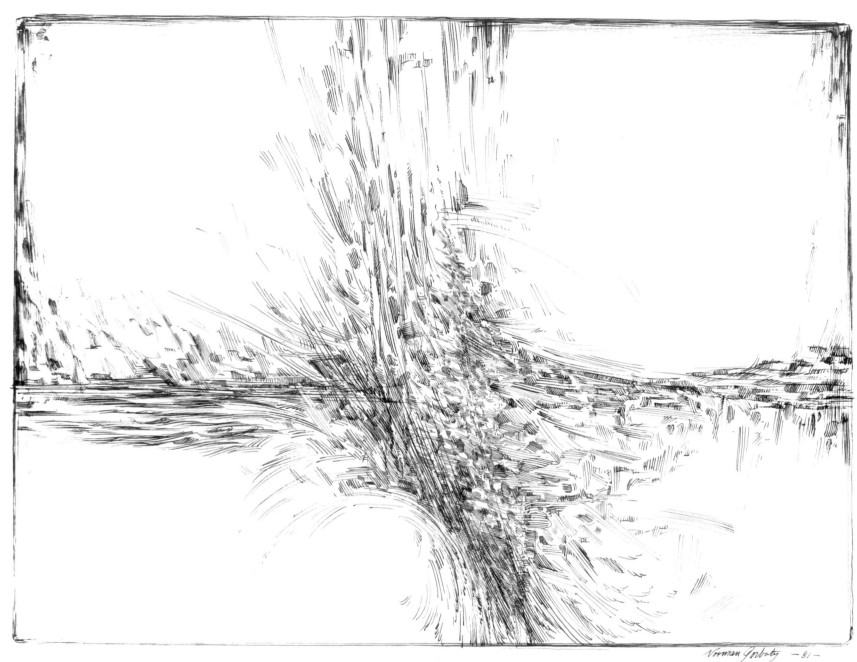

Squeeze

16" x 21"

Pen & Brown Ink

1981

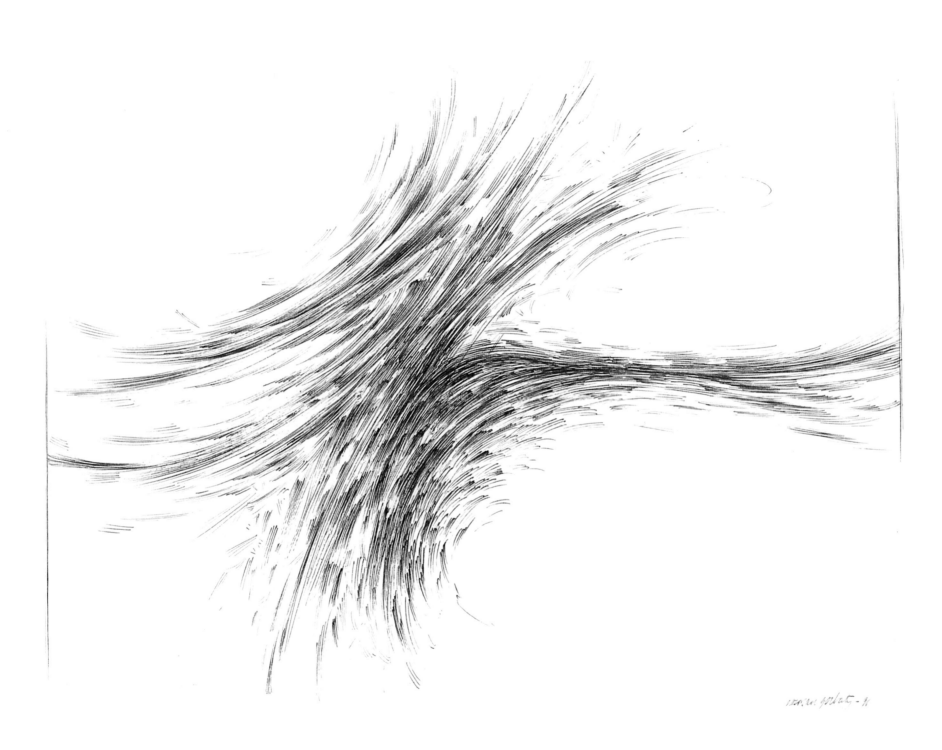

Big Wave
16" x 21"
Pen & Brown Ink
1991

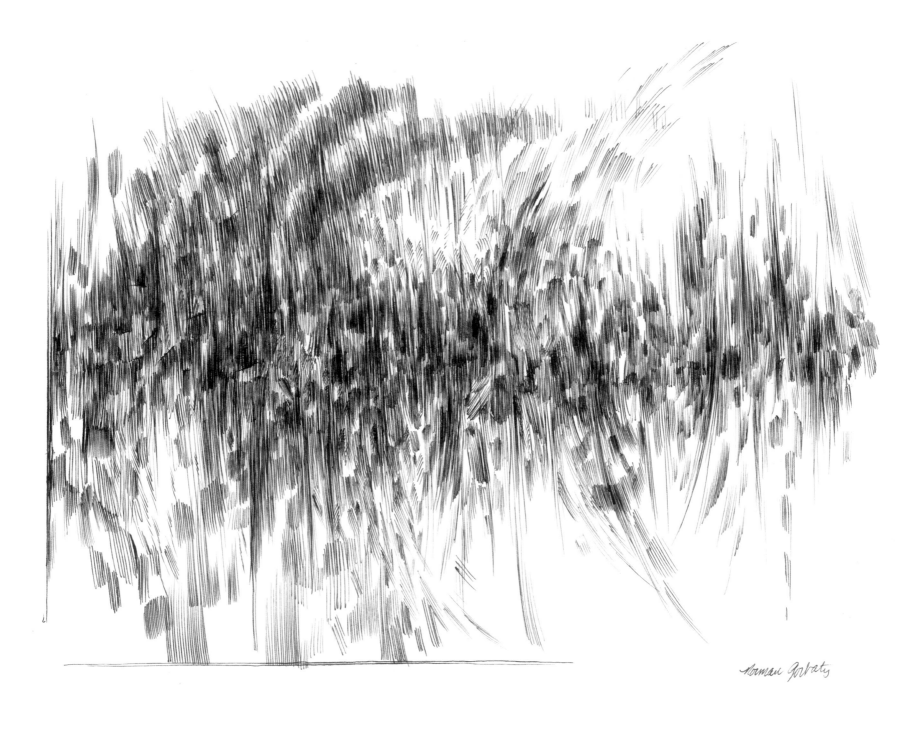

Reeds No. 2

16" x 21"

Pen & Brown ink

1991

Detail

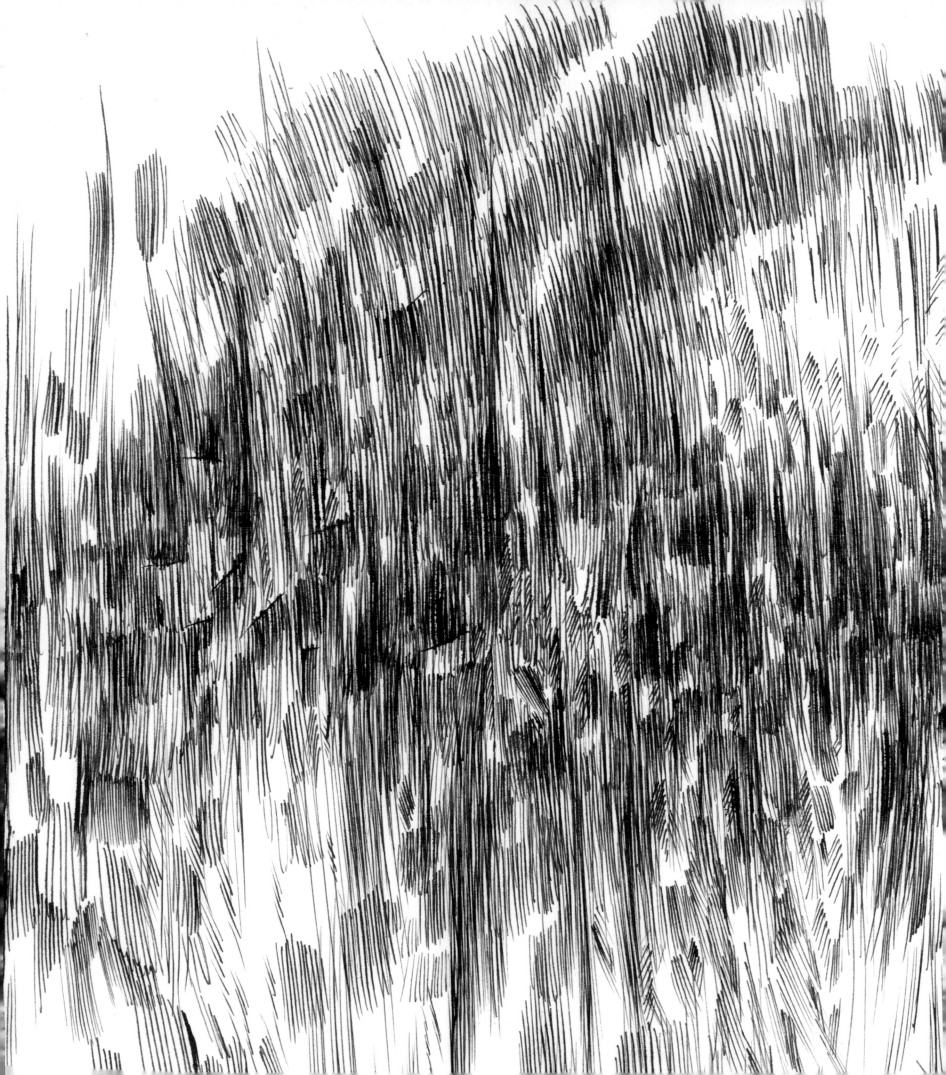

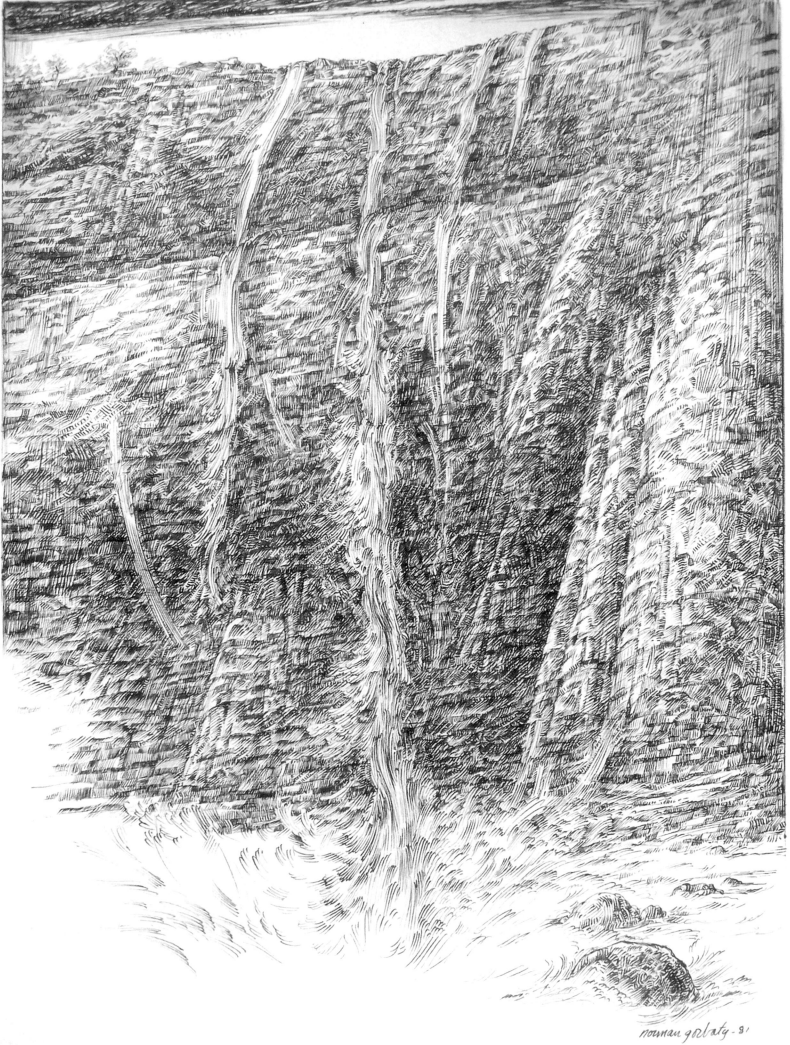

norman gorbaty - 81

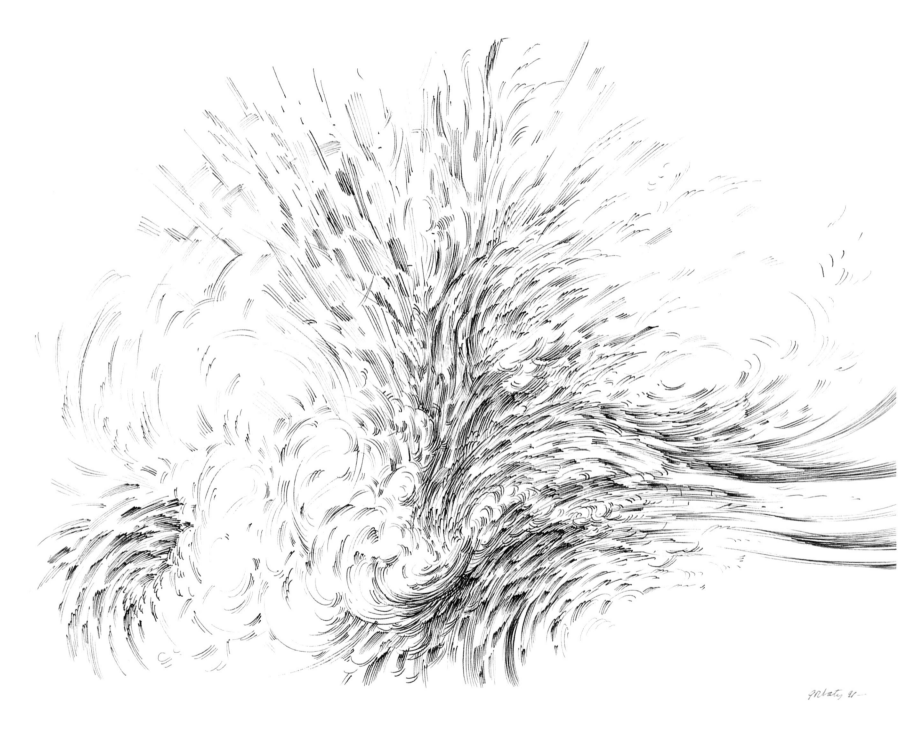

Cascade
16" x 21"
Pen & Brown Ink
1981

Wave No. 2
16" x 21"
Pen & Brown Ink
1981

Following Pages:

Stone Wall Lacoste
20" x 15"
Pen & Brown Ink
1970

Vine Lacoste
20" x 15"
Pen & Brown Ink
1970

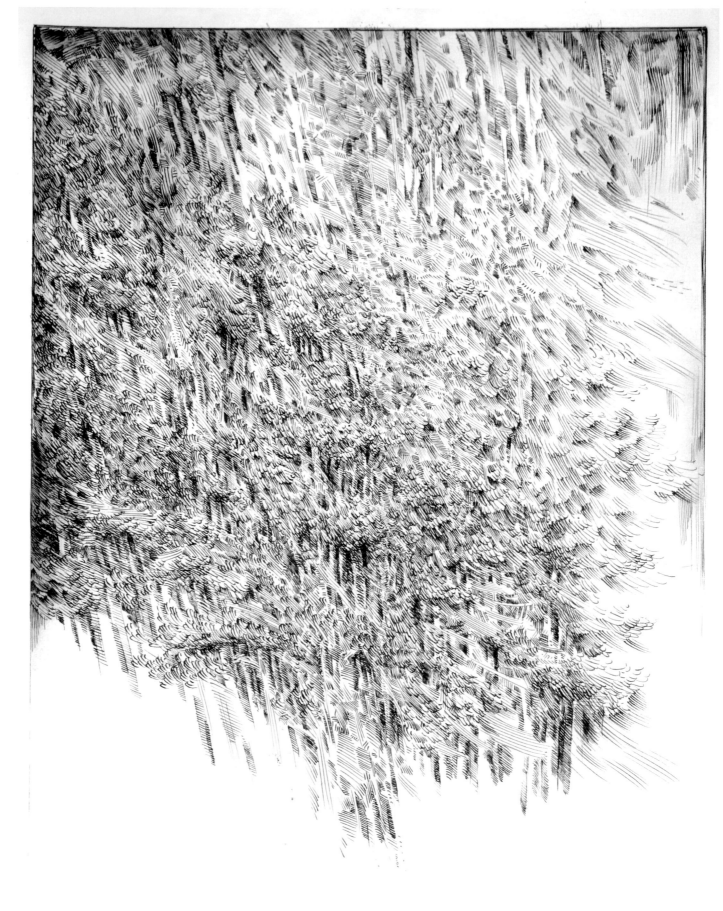

Detail Cliff Trees
 21" x 16"
 Pen & Brown Ink
 1983

Norman A. Welty

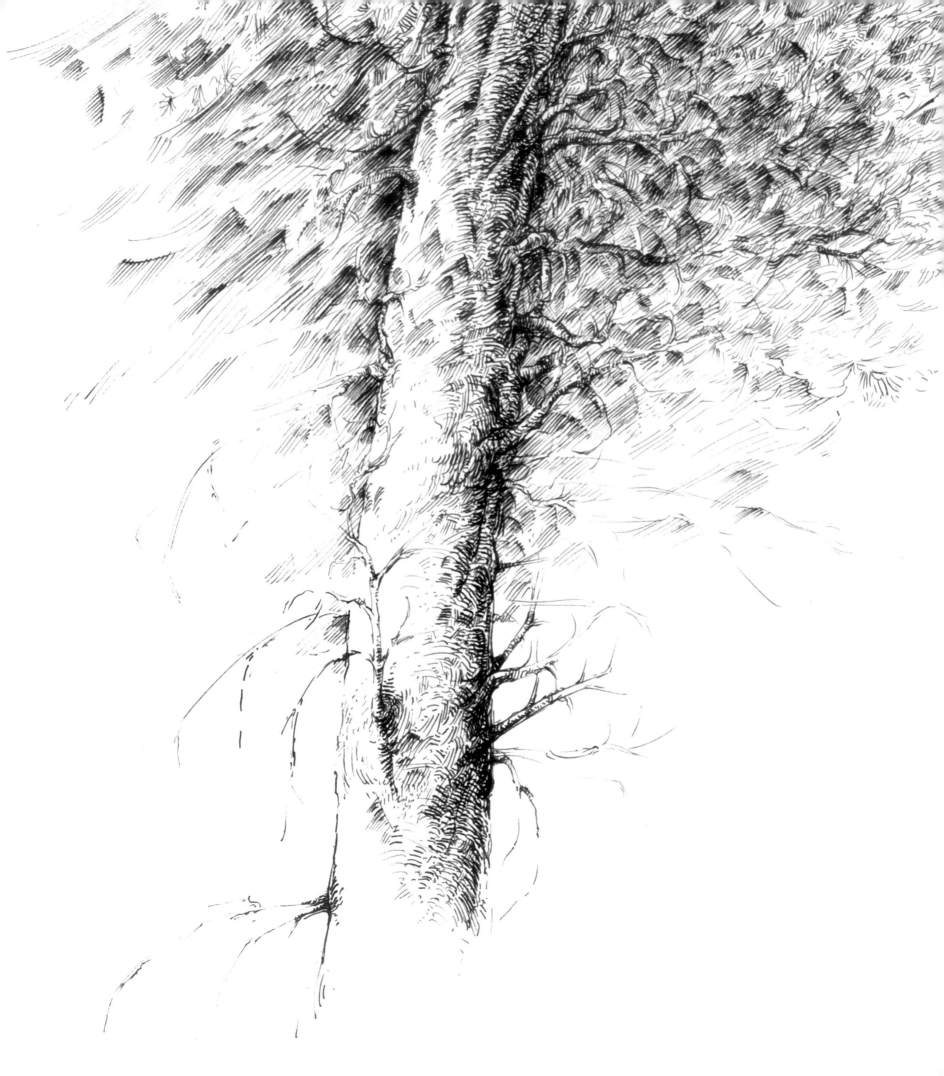

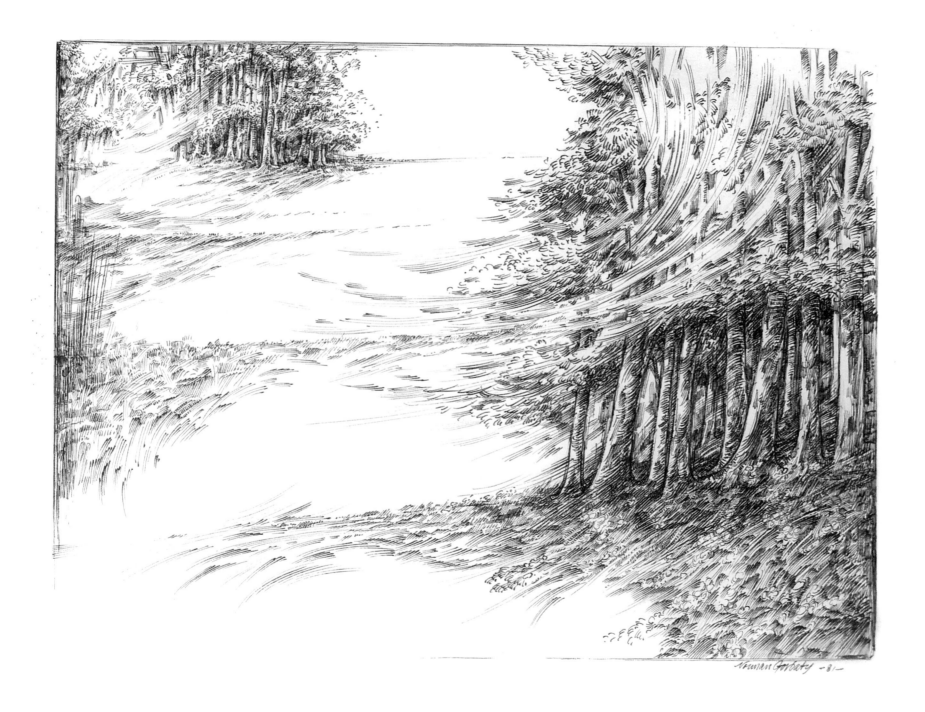

Pine Tree
20" x 15"
Pen & Brown Ink
1971

Stranger
16" x 21"
Pen & Brown Ink
1981

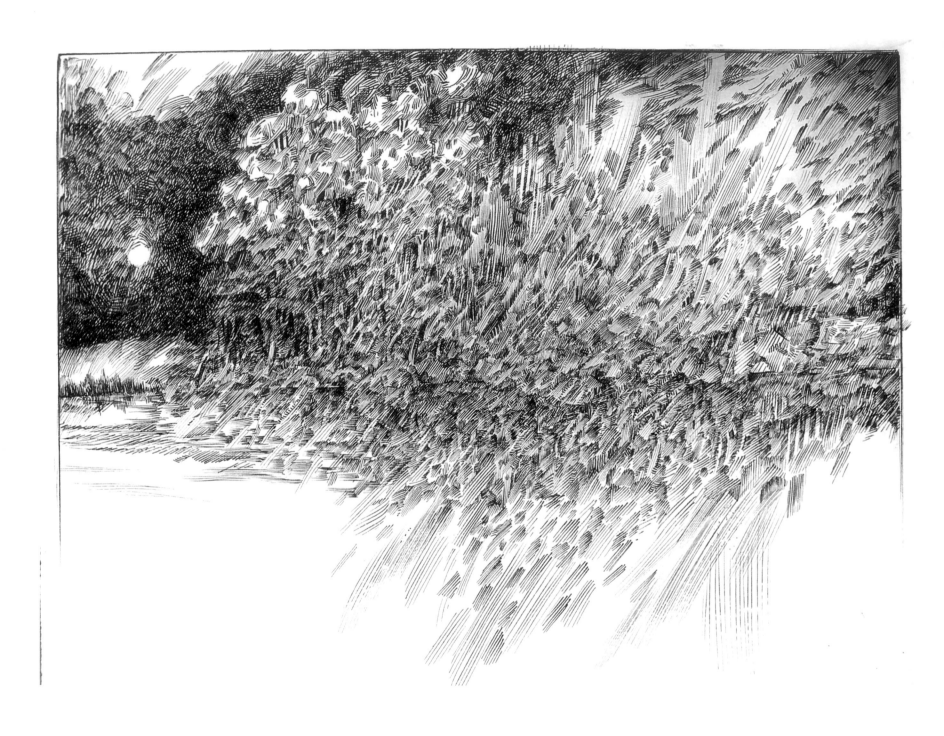

Landscape (Moon)
16" x 21"
Pen & Brown Ink
1982

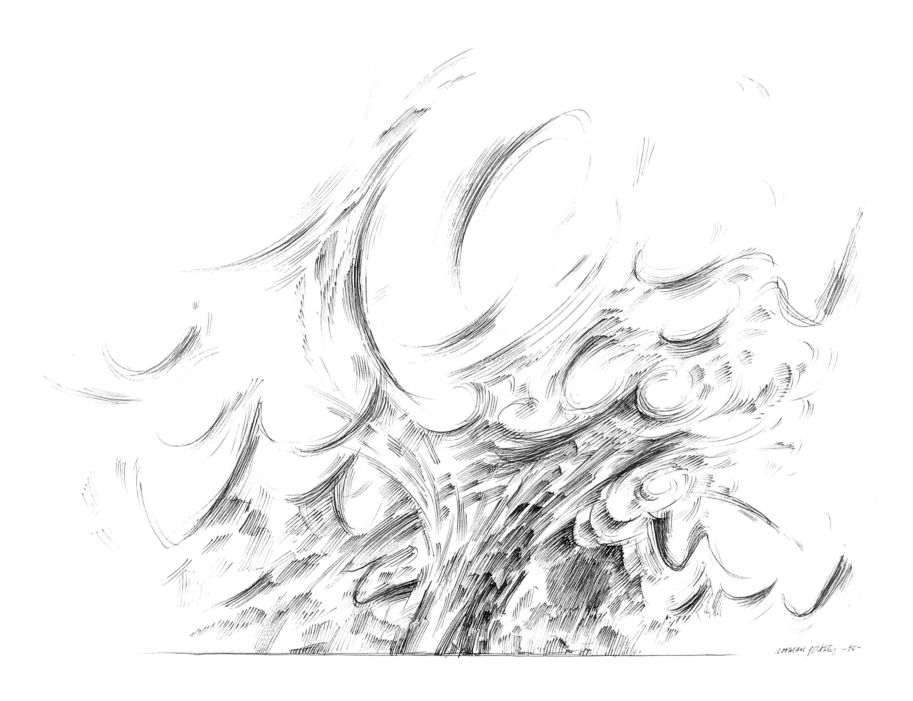

Olive Tree
16" x 21"
Pen & Brown Ink
1995

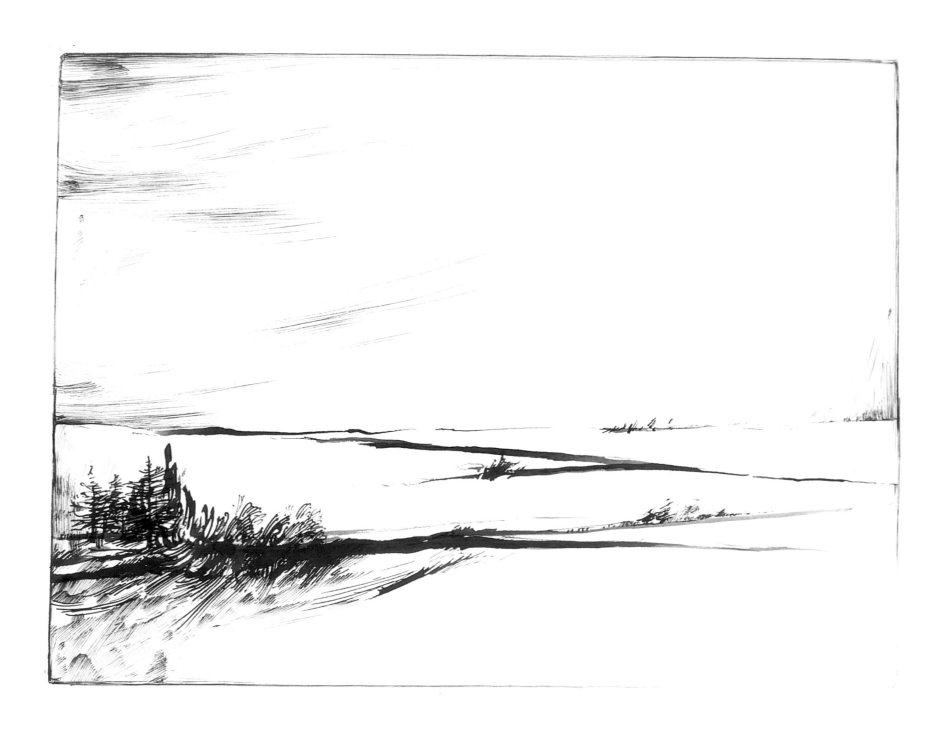

Winter

16" x 21"

Reed Pen Sepia Ink

1958

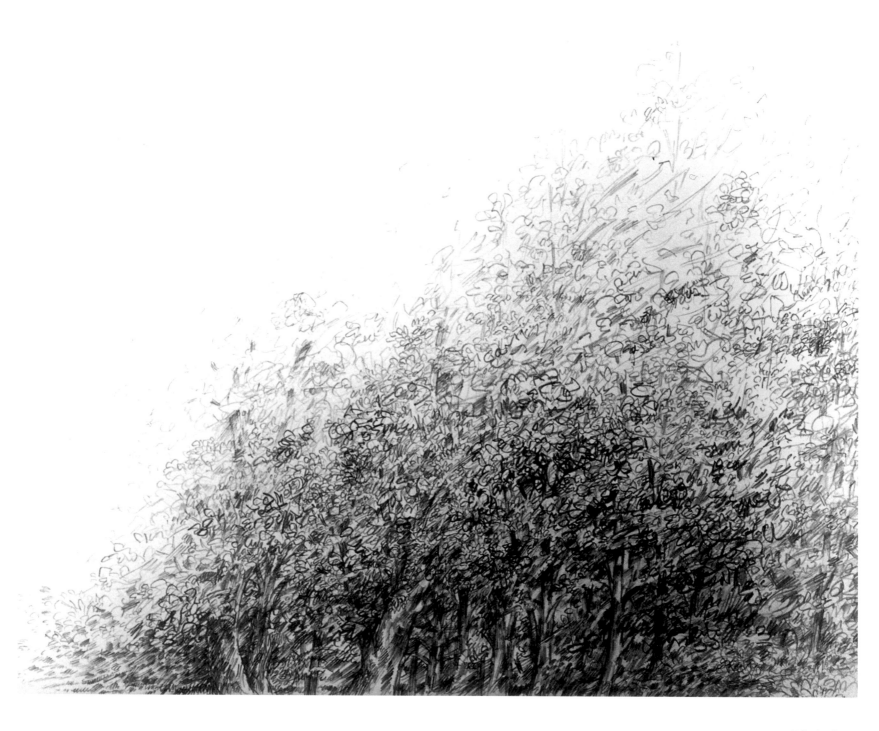

Edge Of The Forest
22" x 30"
Pencil
2005

Following Page:
Movie House
40" x 78"
Charcoal
1990

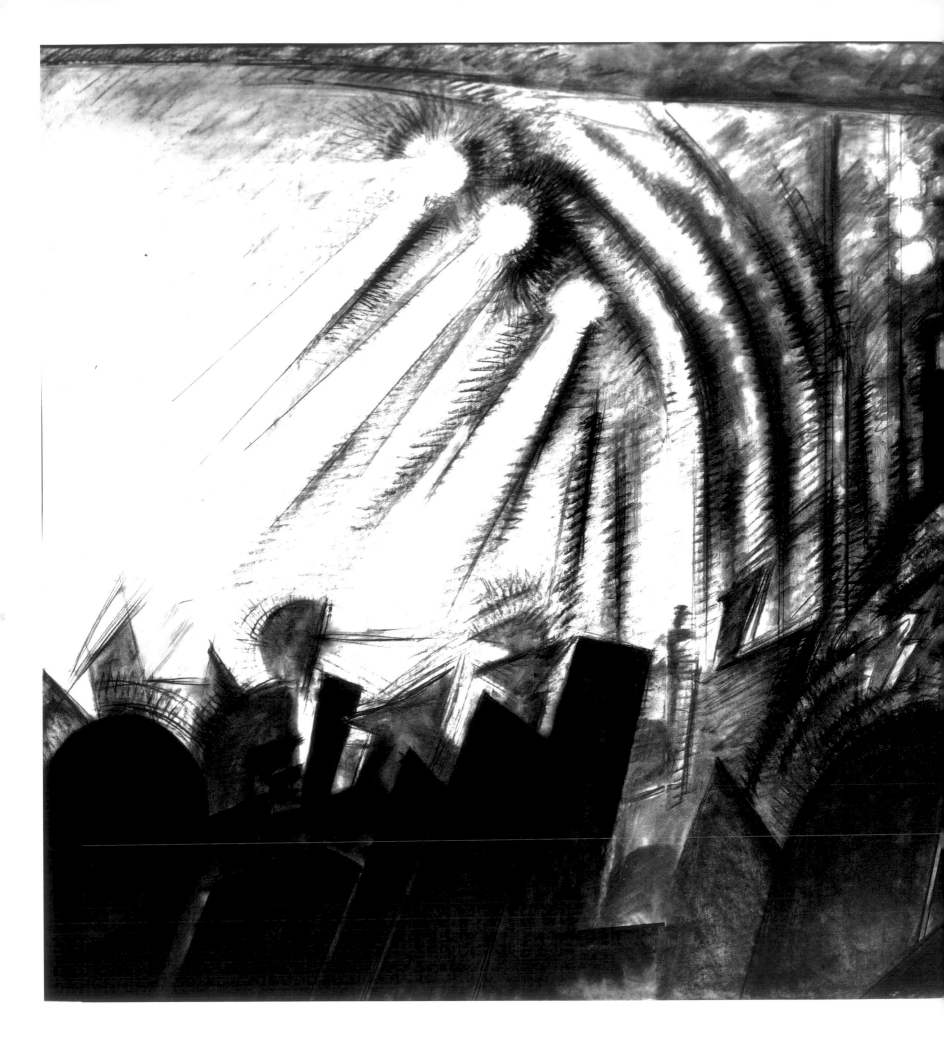

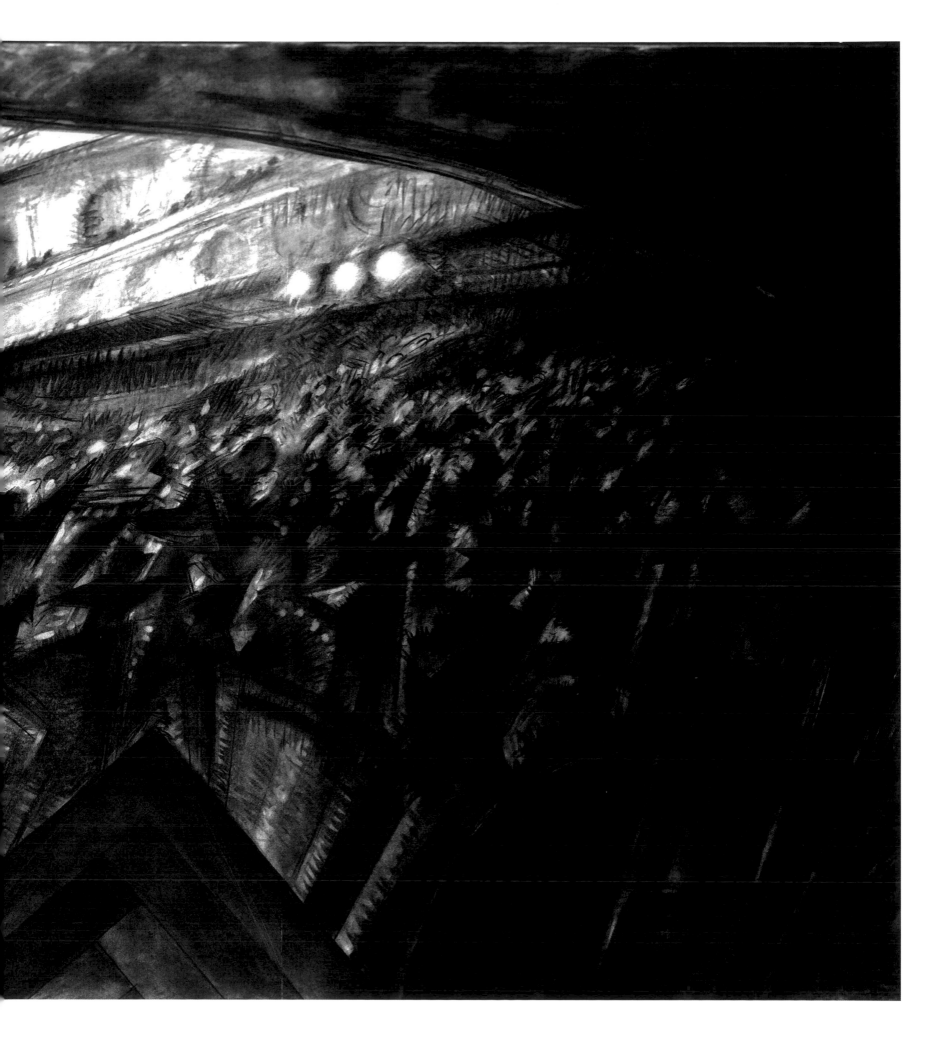

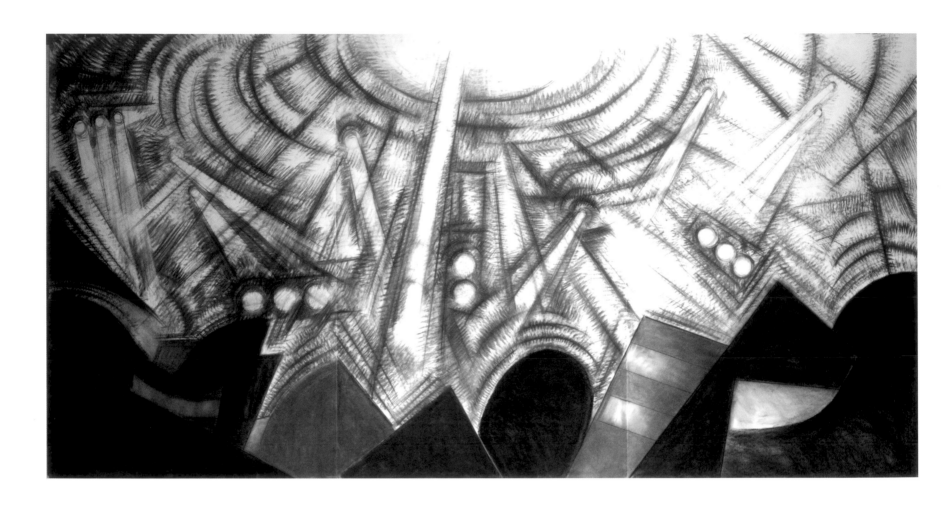

Circus Up
40" x 78"
Charcoal
1990

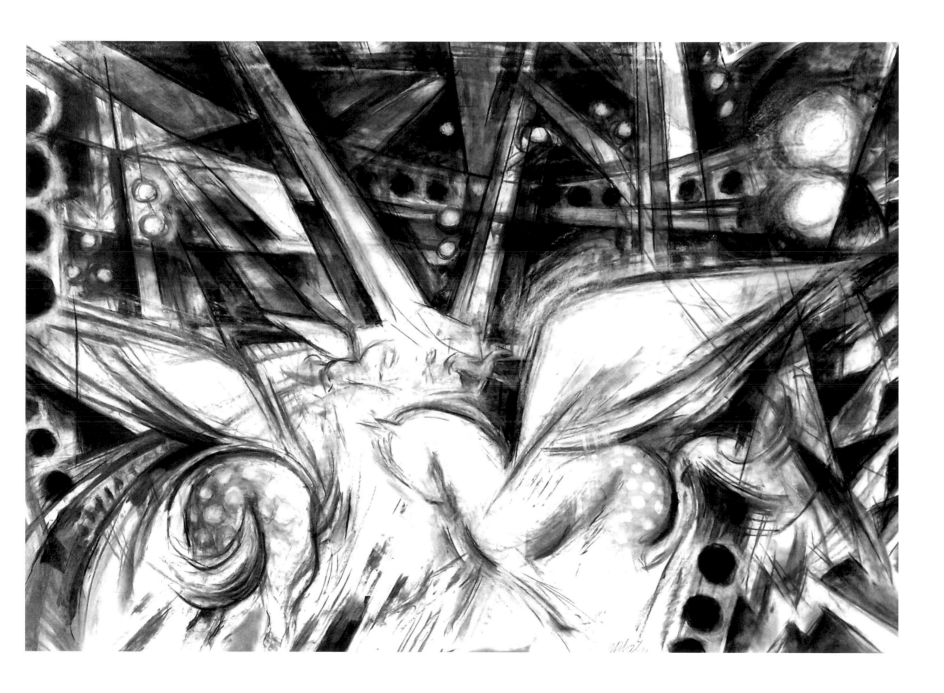

Circus (Horses)

25" x 40"

Charcoal

1995

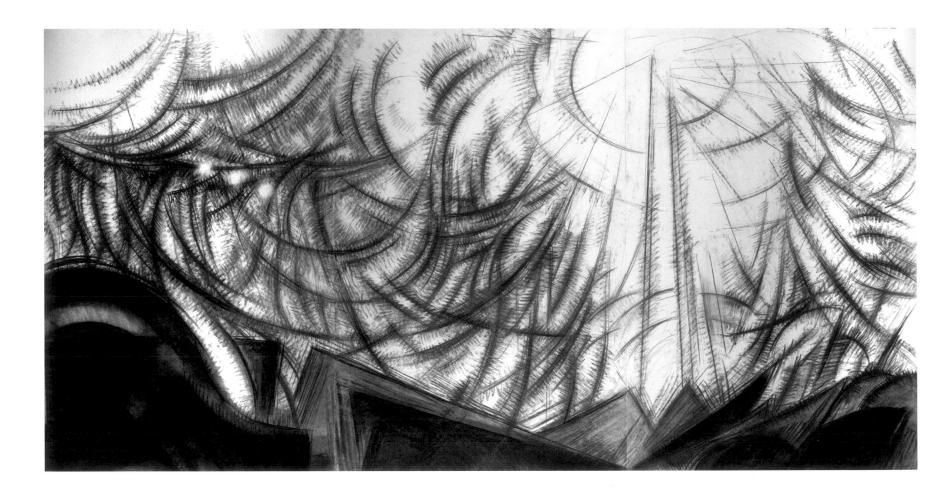

Circus Tent
40" x 78"
Charcoal
1990

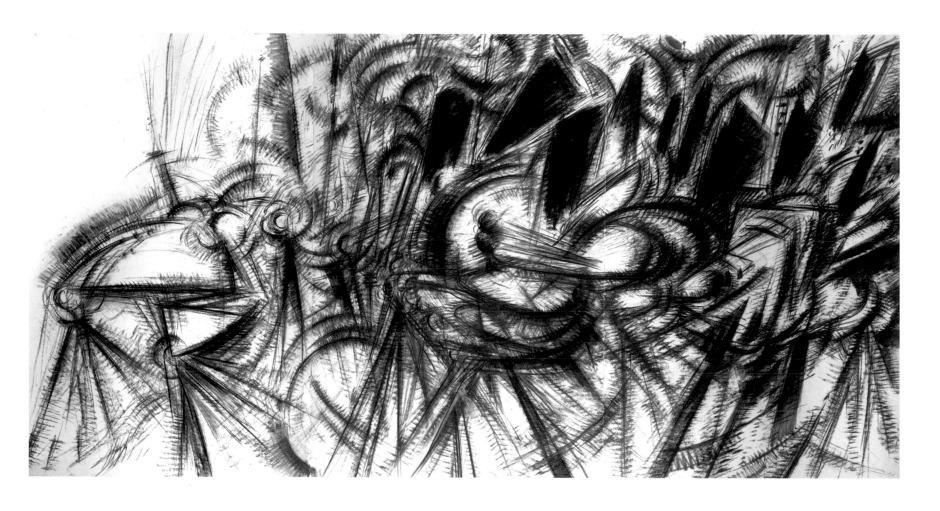

Marching Band No. 2

40" x 78"

Charcoal

2002

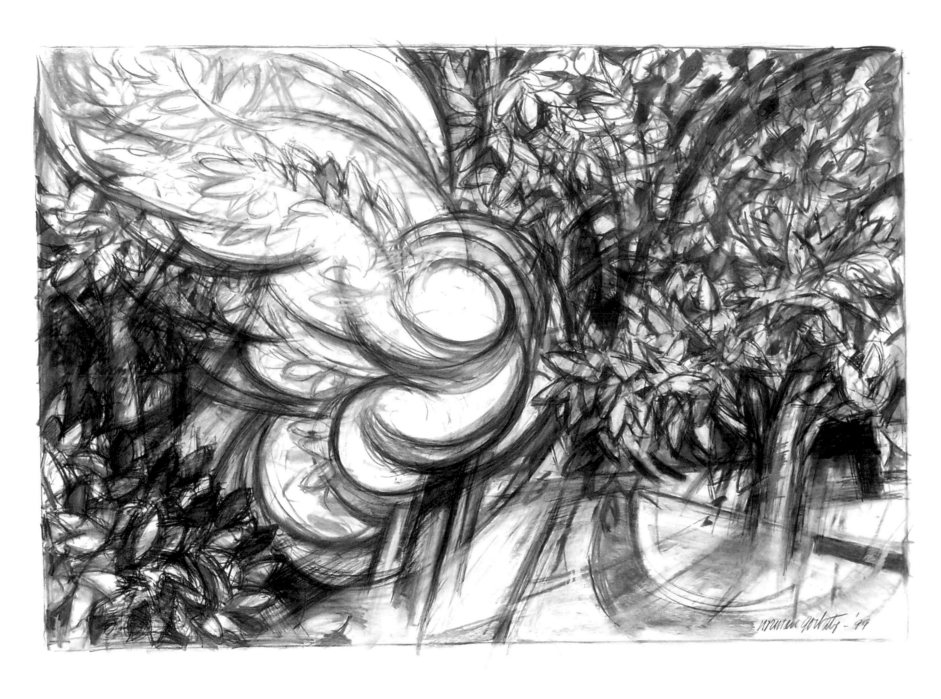

Villa Borghese No. 1

22" x 31 1/2"

Charcoal

1999

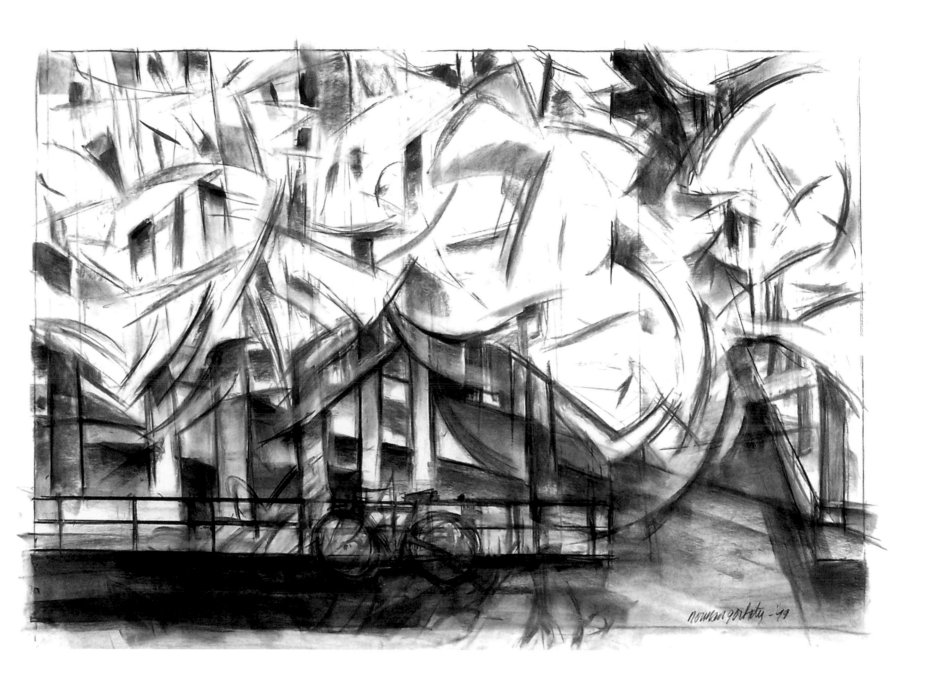

Villa Borghese No.10

22" x 31 1/2"

Charcoal

1999

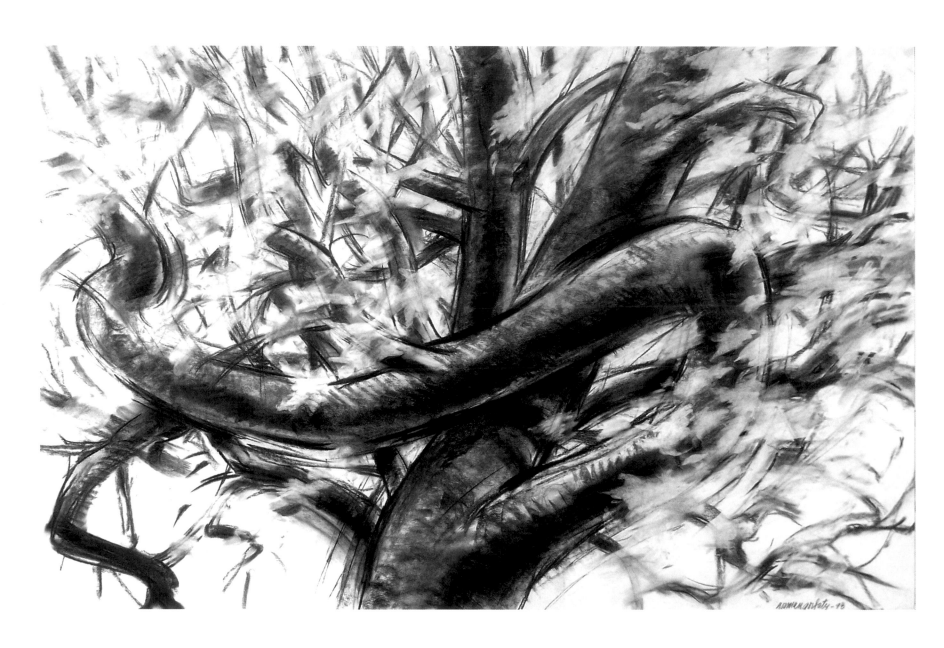

Tree
26" x 40"
Charcoal
1998

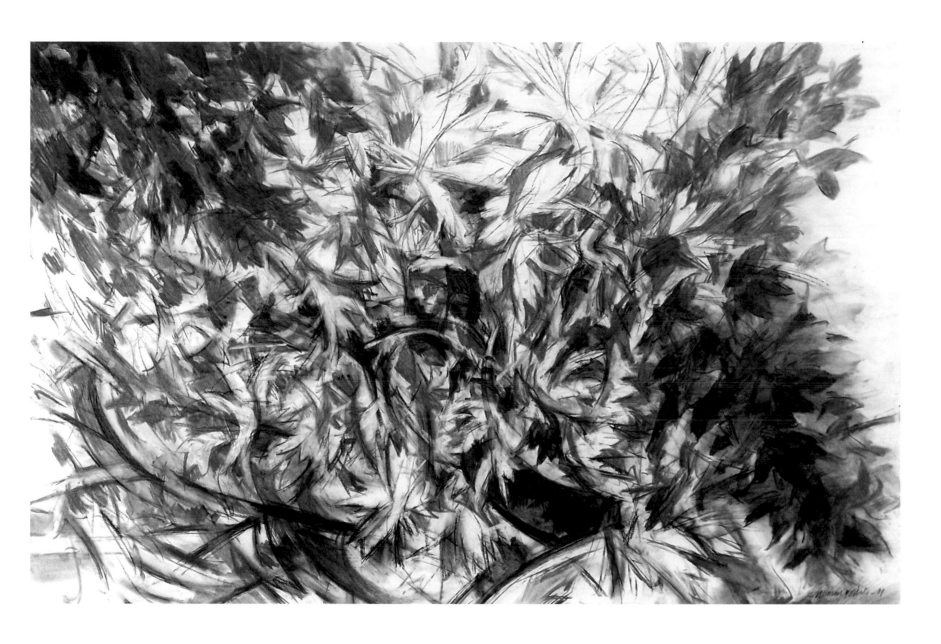

Leaves

26" x 40"

Charcoal

1999

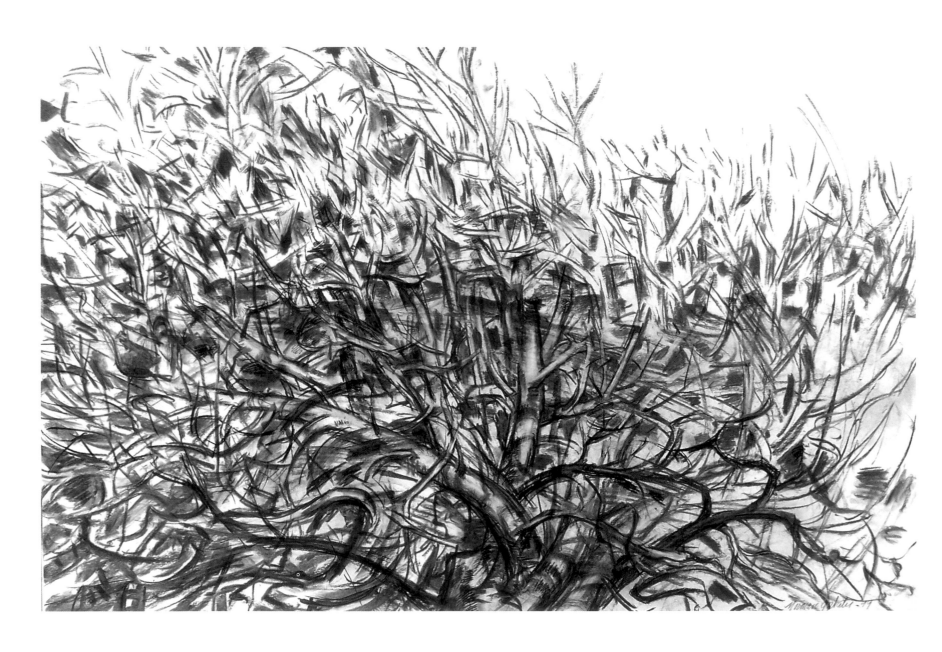

Blowing Tree
23" x 35"
Charcoal
1999

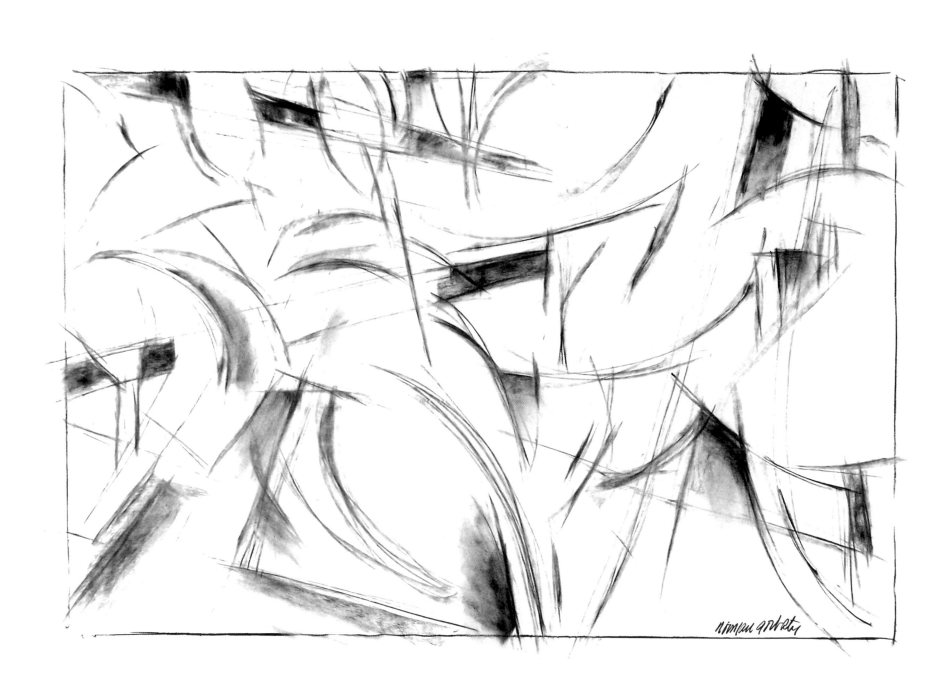

Villa Borghese No.2
22" x 31 1/2"
Charcoal
2006

Following Page:
Splash
40" x 78"
Charcoal
1998

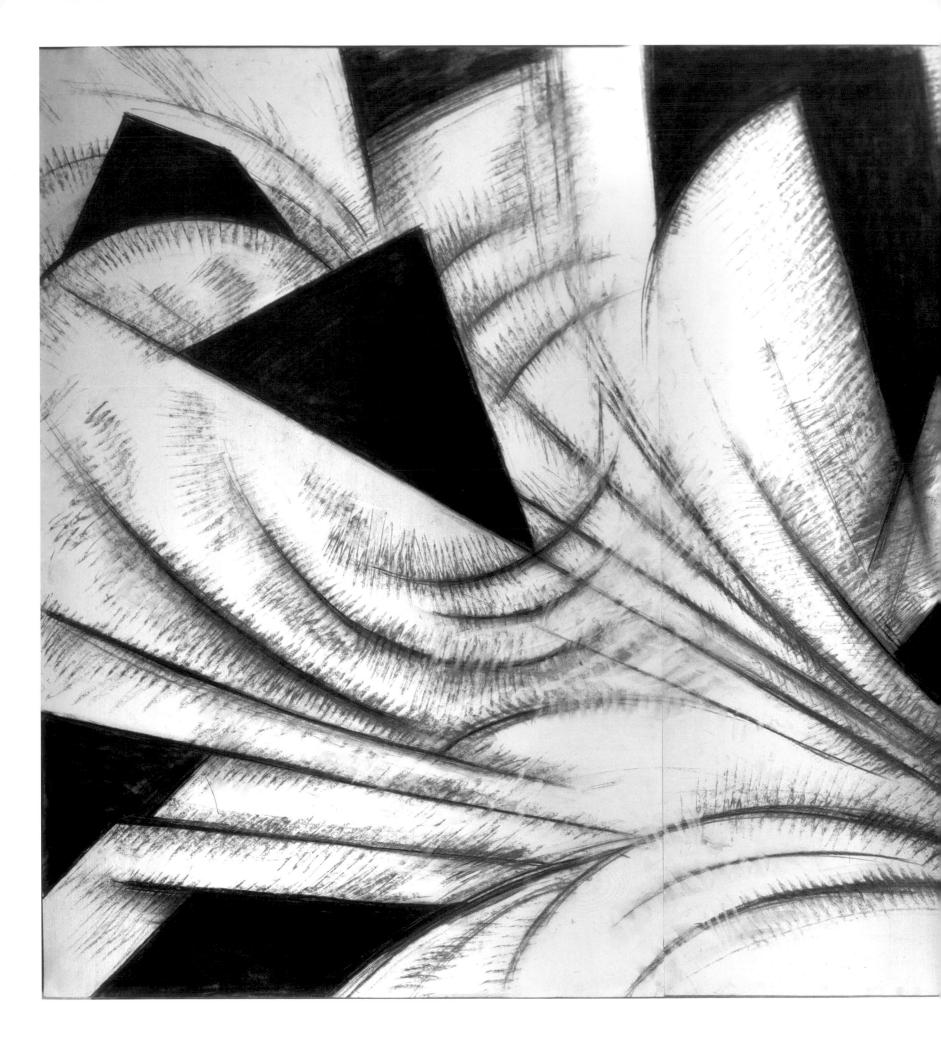

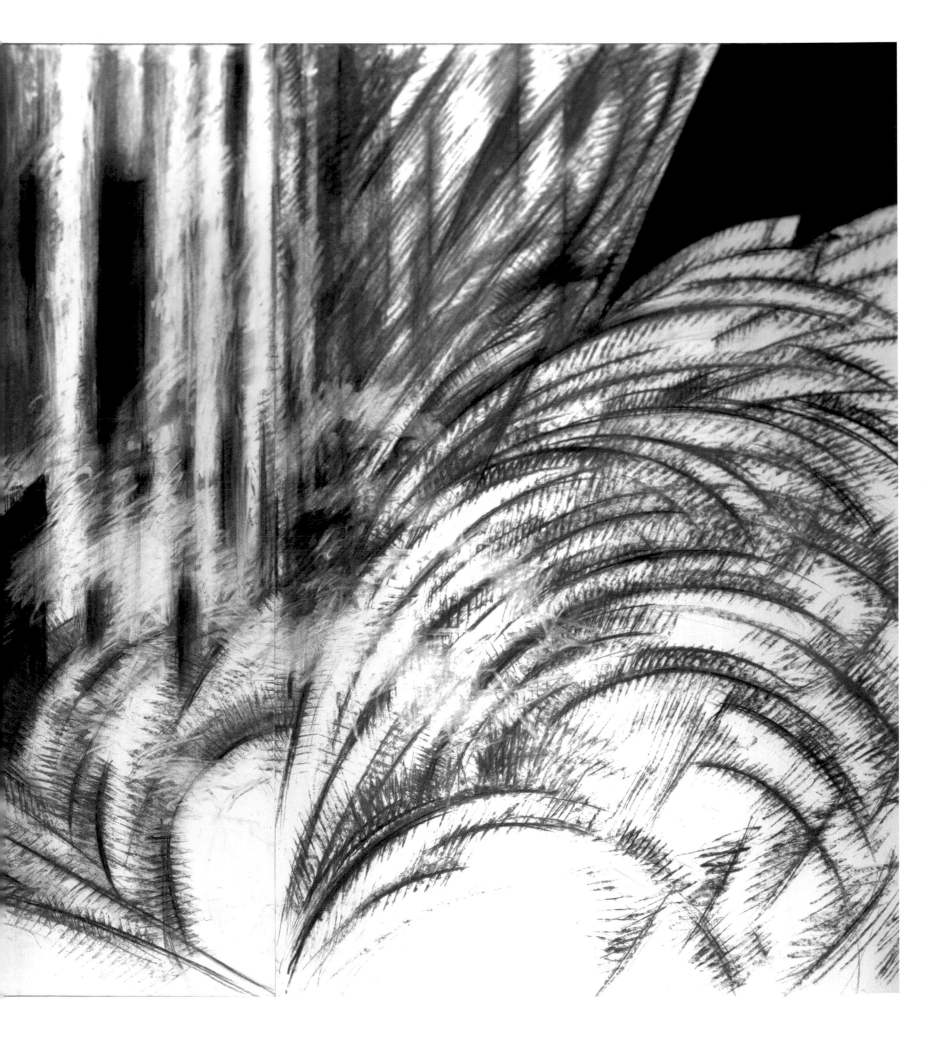

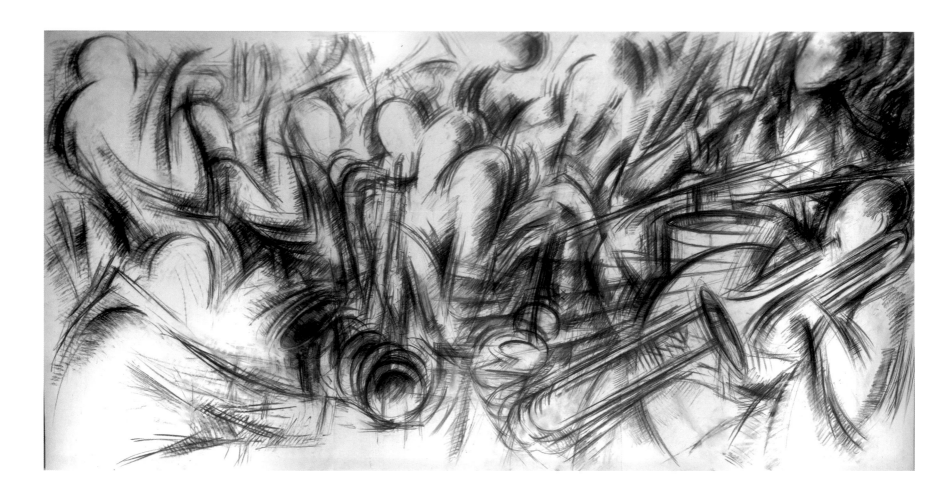

Session
40" x 78"
Charcoal
1996

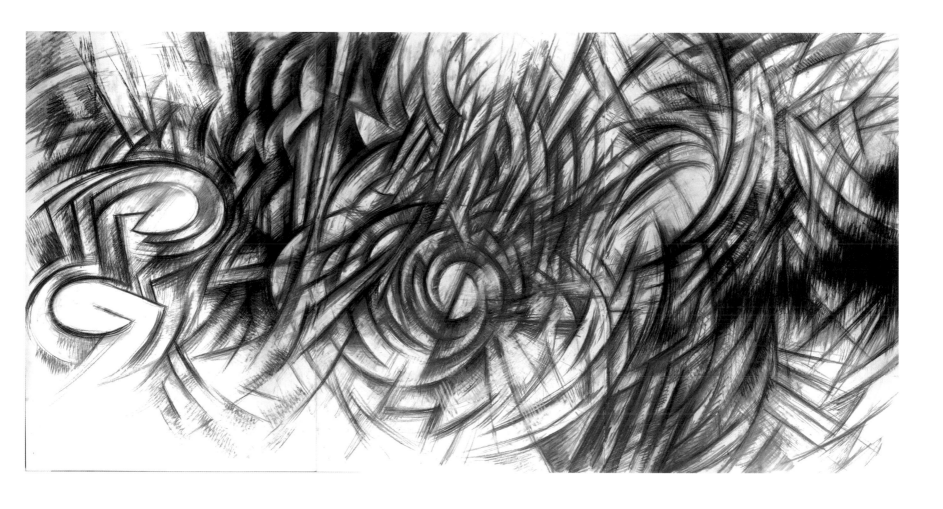

Jazz
40" x 78"
Charcoal
1997

Following Page:
War 1, 2, 3
(Triptych)
40" x 26" each
Charcoal
1997

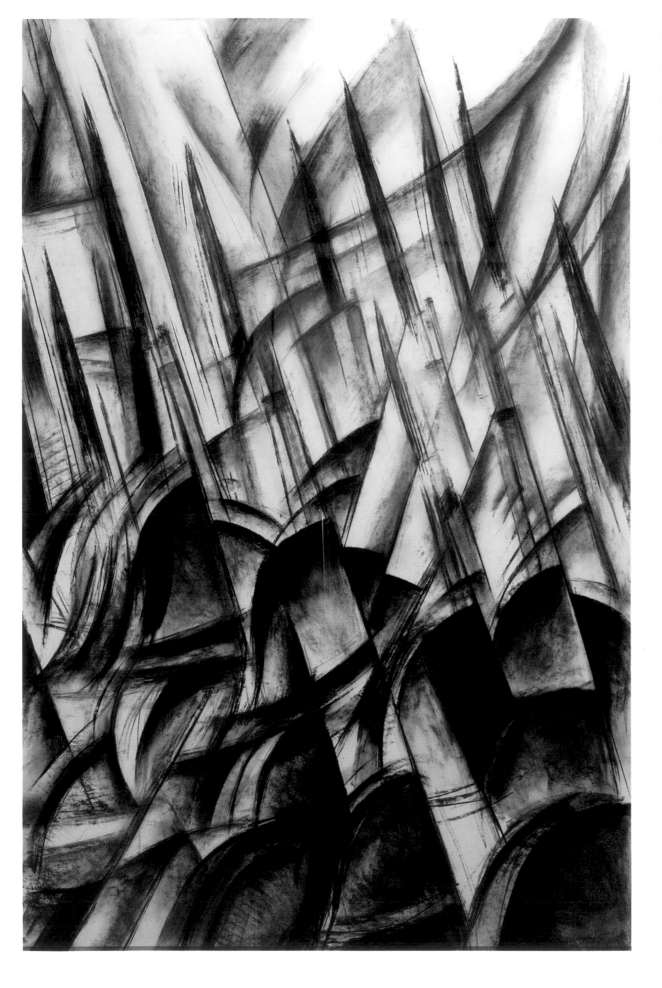
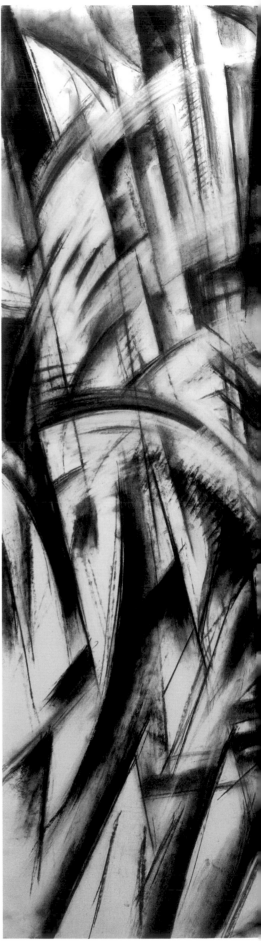

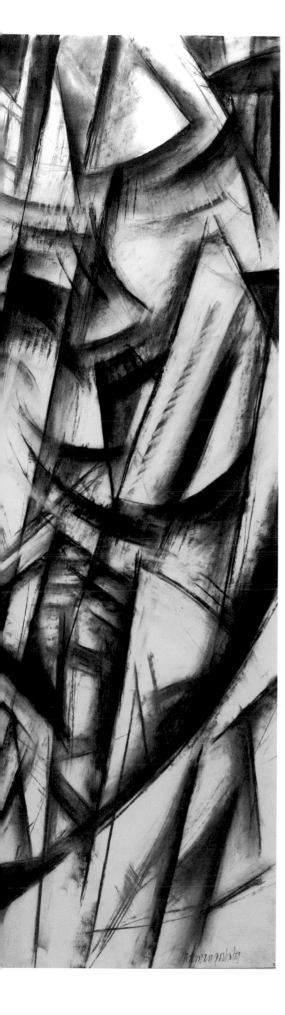
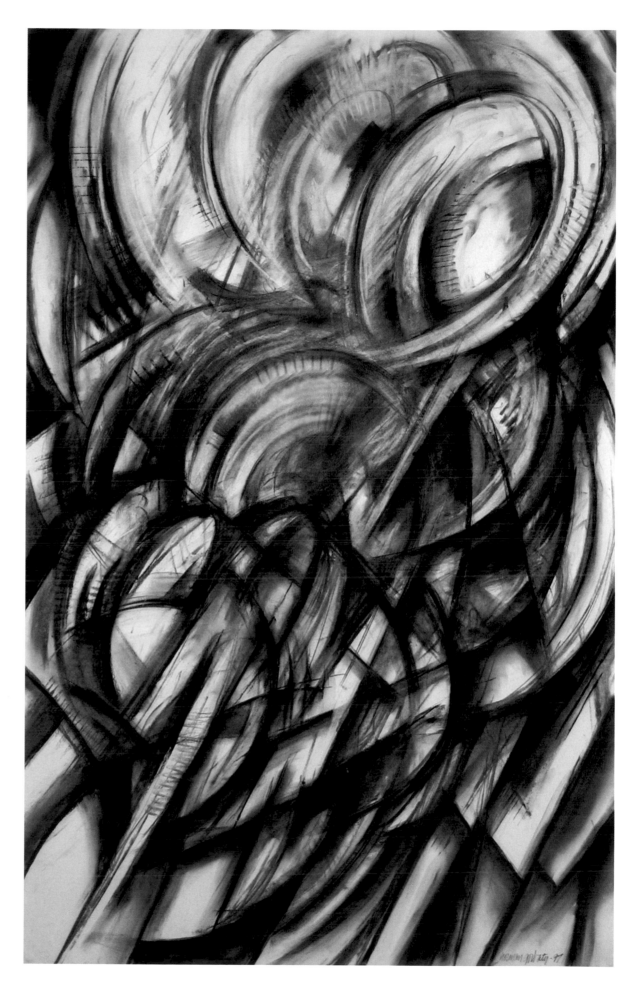

Tower
41 1/2" x 29 1/2"
Charcoal
1980

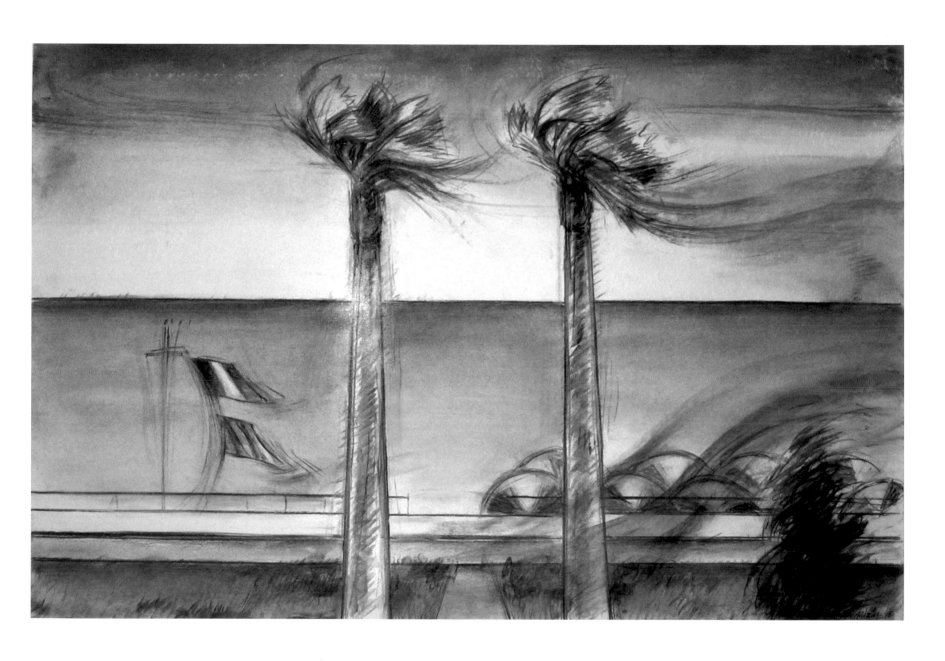

Riviera
26" x 40"
Charcoal
2004

Following Page:
Dogs Fighting
40" x 78"
Charcoal
2005

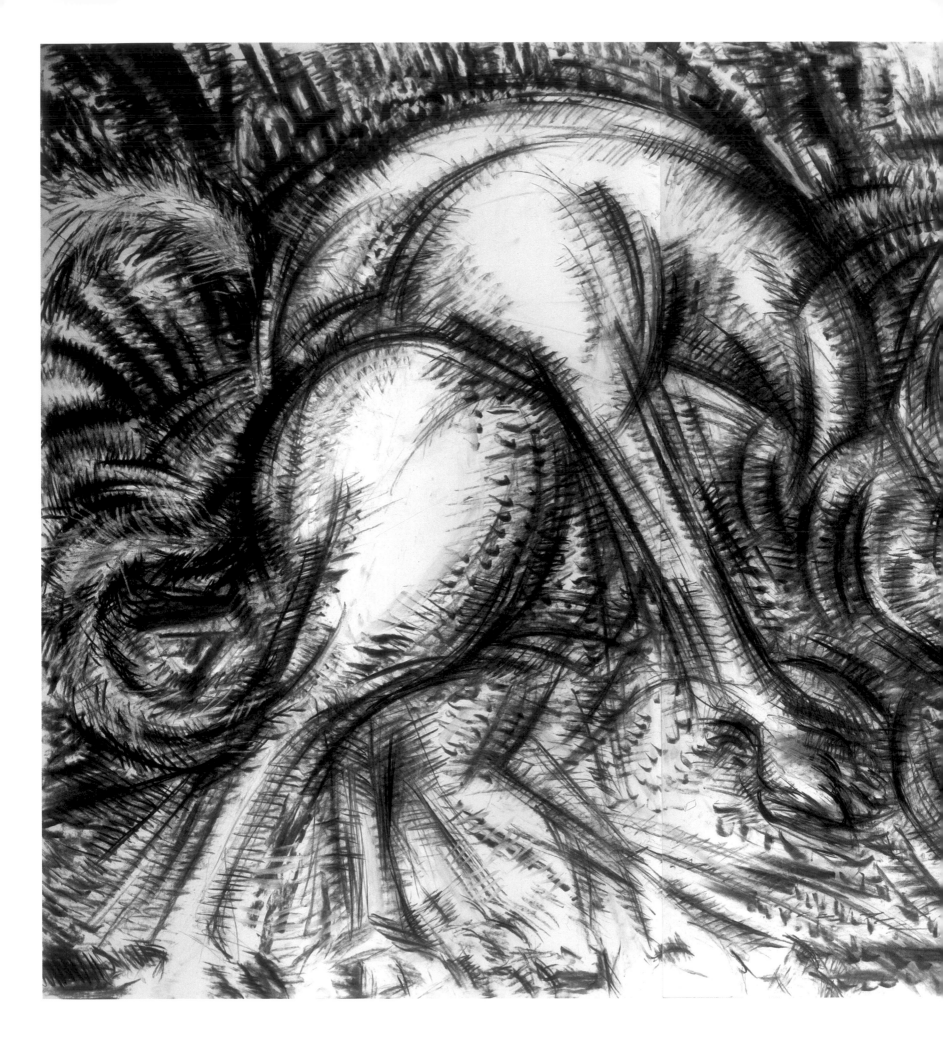

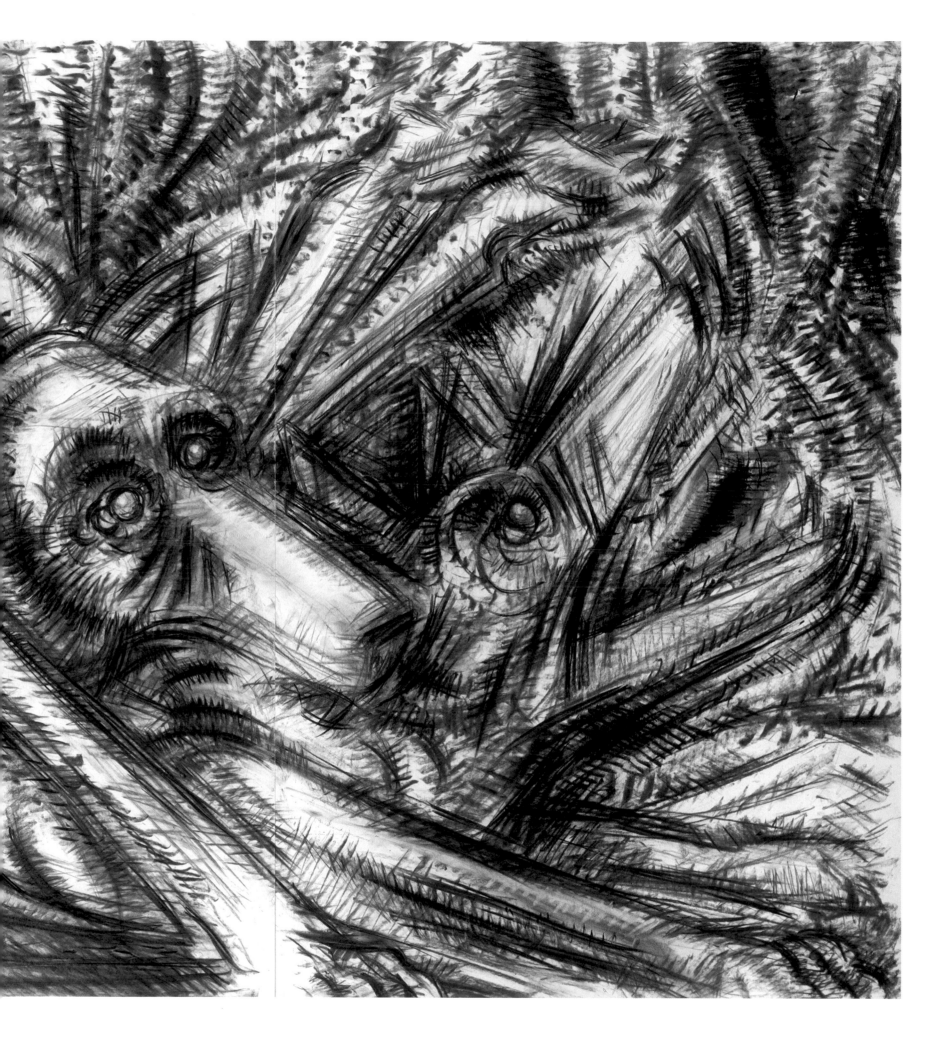

Scratching Dog No.1
30" x 23"
Conte Crayon
1999

Scratching Dog No.2
30" x 23"
Conte Crayon
1999

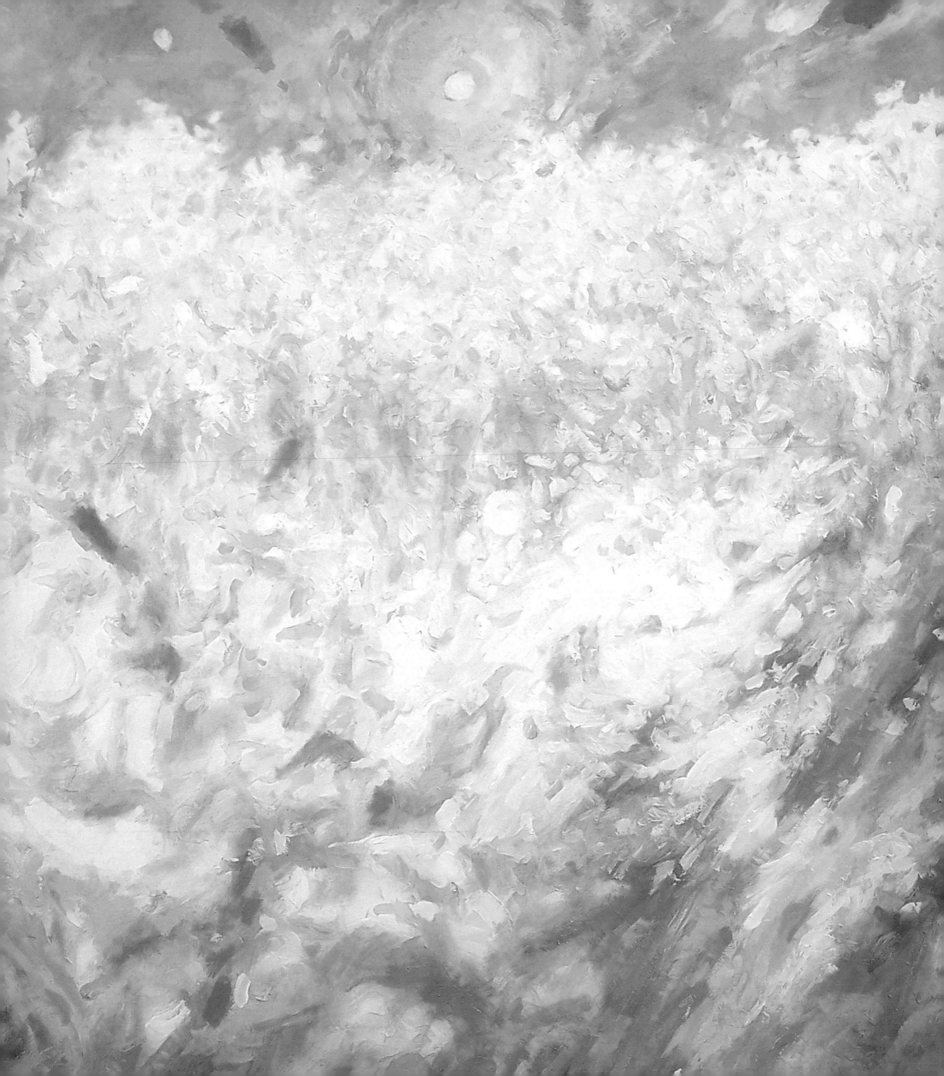

painting

is

never

ending

Painting is hard. I "push" paint around mixing new colors, making new color relationships, having colors say "how do you do" to each other. The defined edge is my enemy. The painting is never finished, it's always becoming. I could work one painting for a lifetime. Each stroke points me in a new direction. One could find ten or twenty painting directions under the surface of one piece. The process is so exciting, it engulfs me in the doing. It is a never ending search for I know not what because the goal is ever-changing.

Trees On Trees
36" x 36"
Oil on Canvas
2006

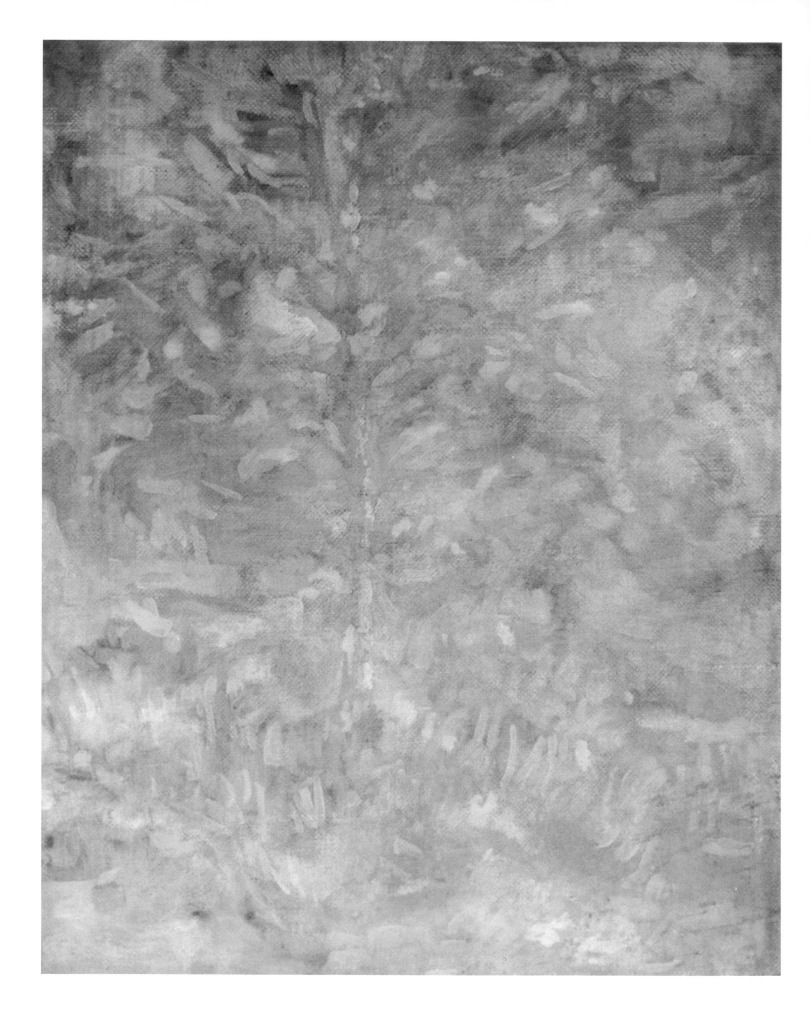

Yellow Tree
24" x 30"
Oil on Jute
1954

Field & Sun
18" x 24"
Oil on Canvas
1954

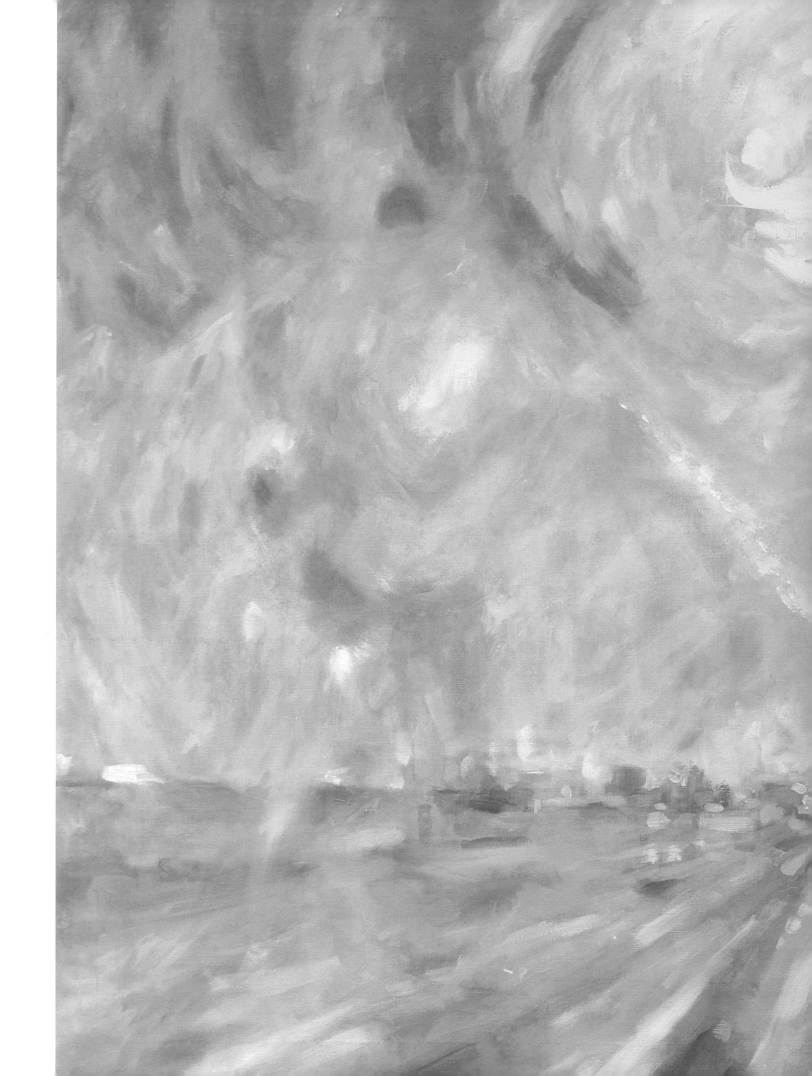

Into the City
35" x 50"
Oil on Canvas
1954

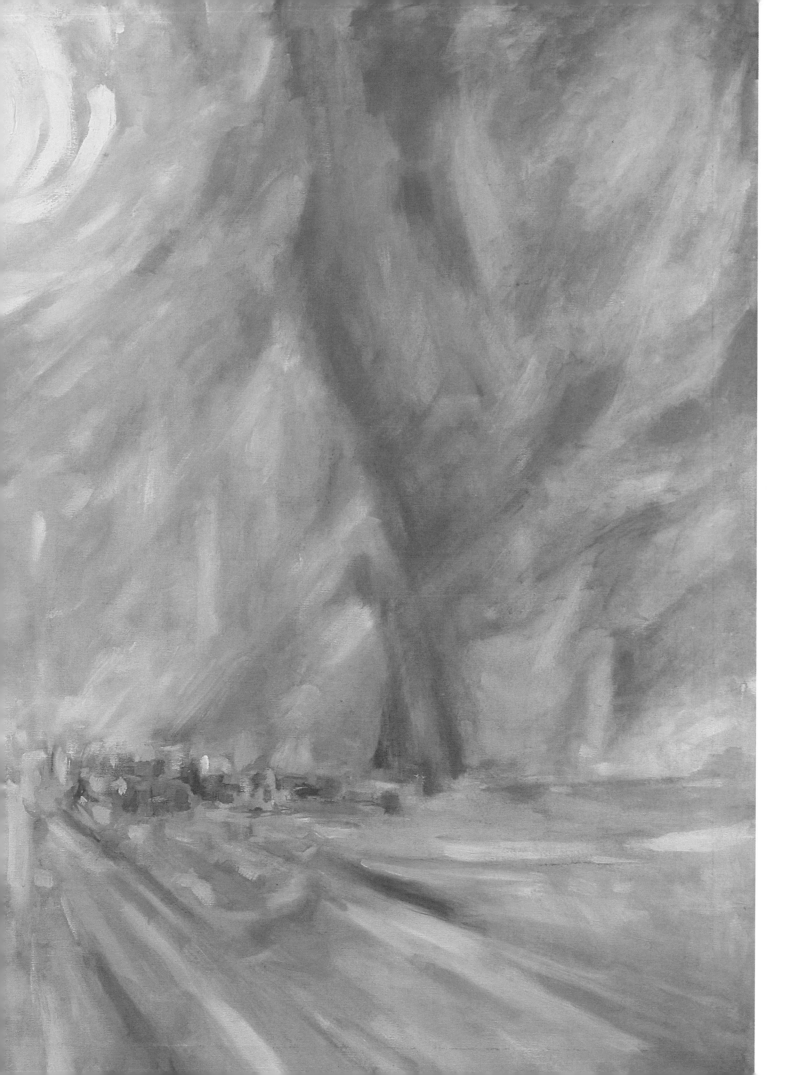

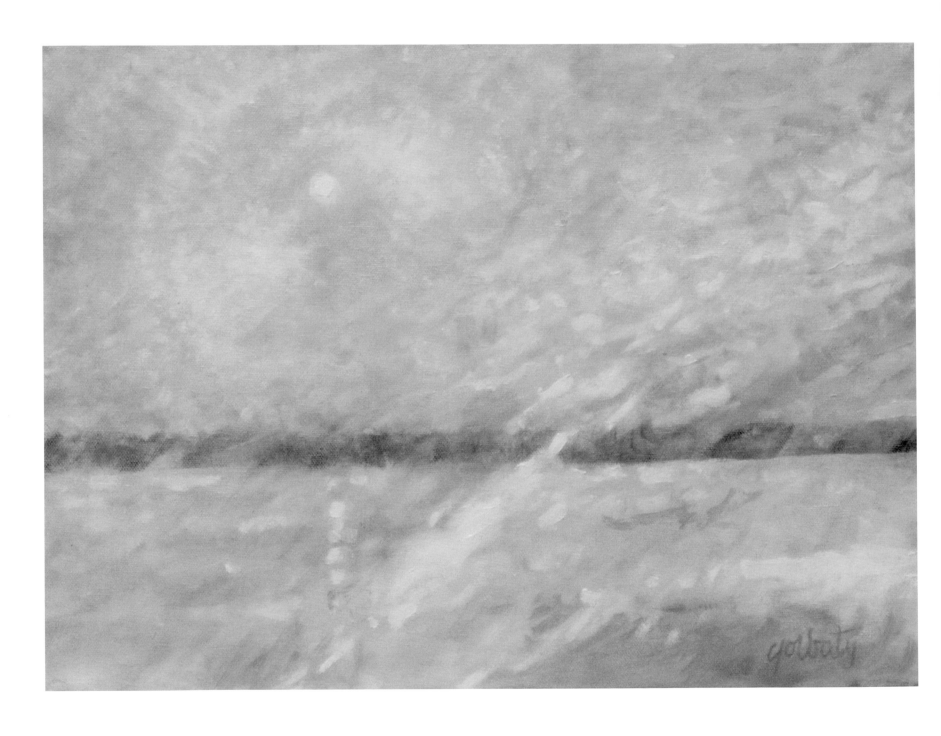

Winter

12" x 16"

Oil on Canvas

2006

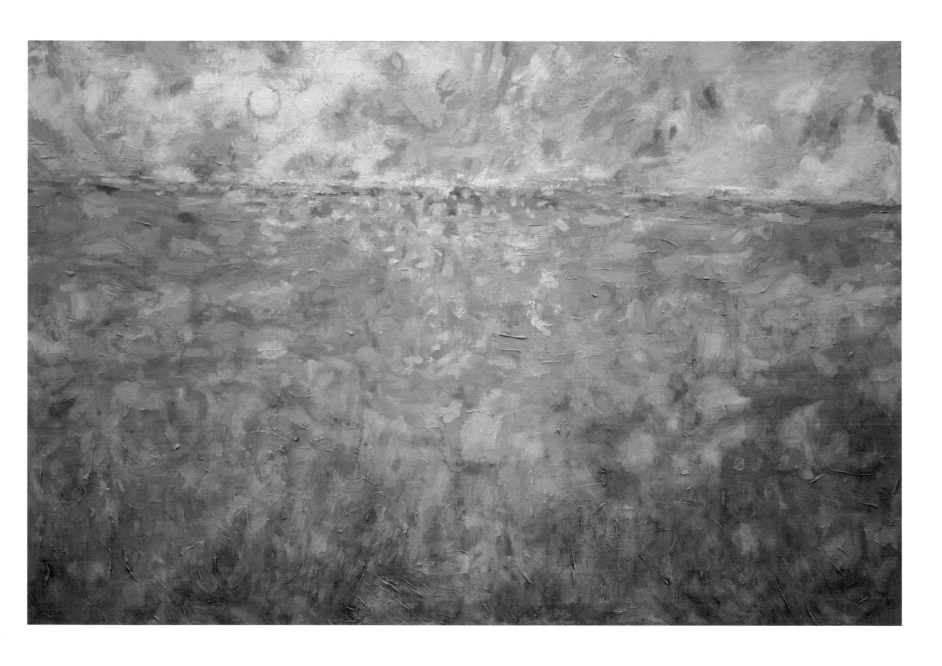

Sun Day
25" x 36"
Oil on Canvas
1954

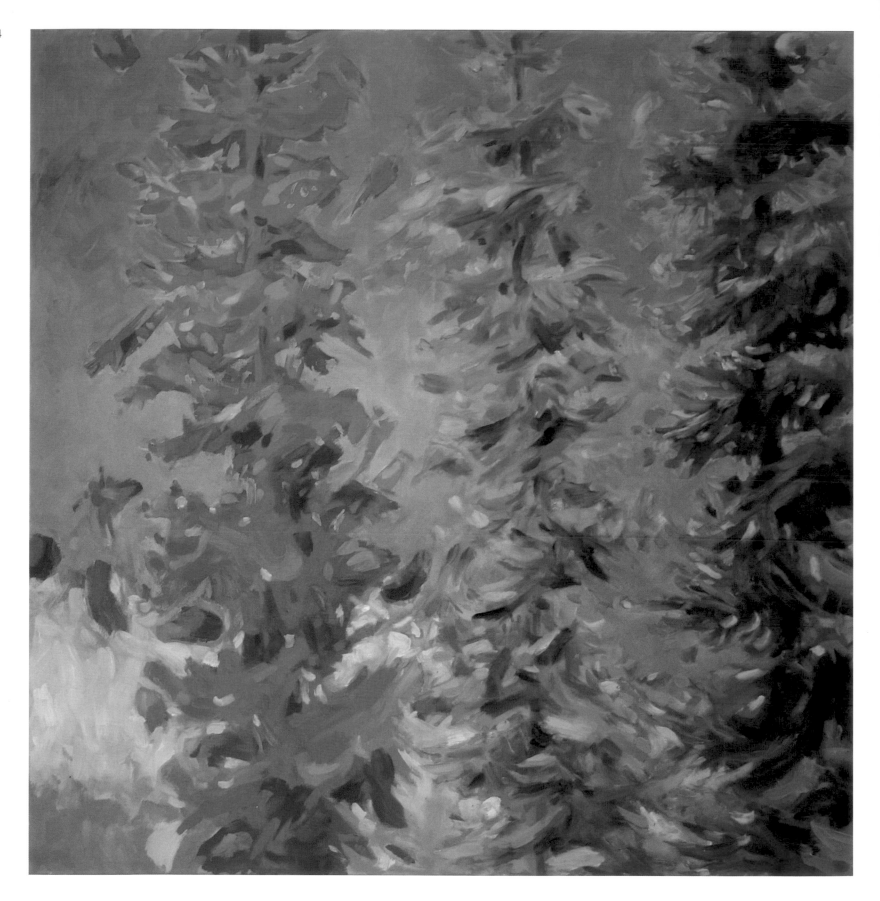

Three Trees
36" x 36"
Oil on Canvas
2006

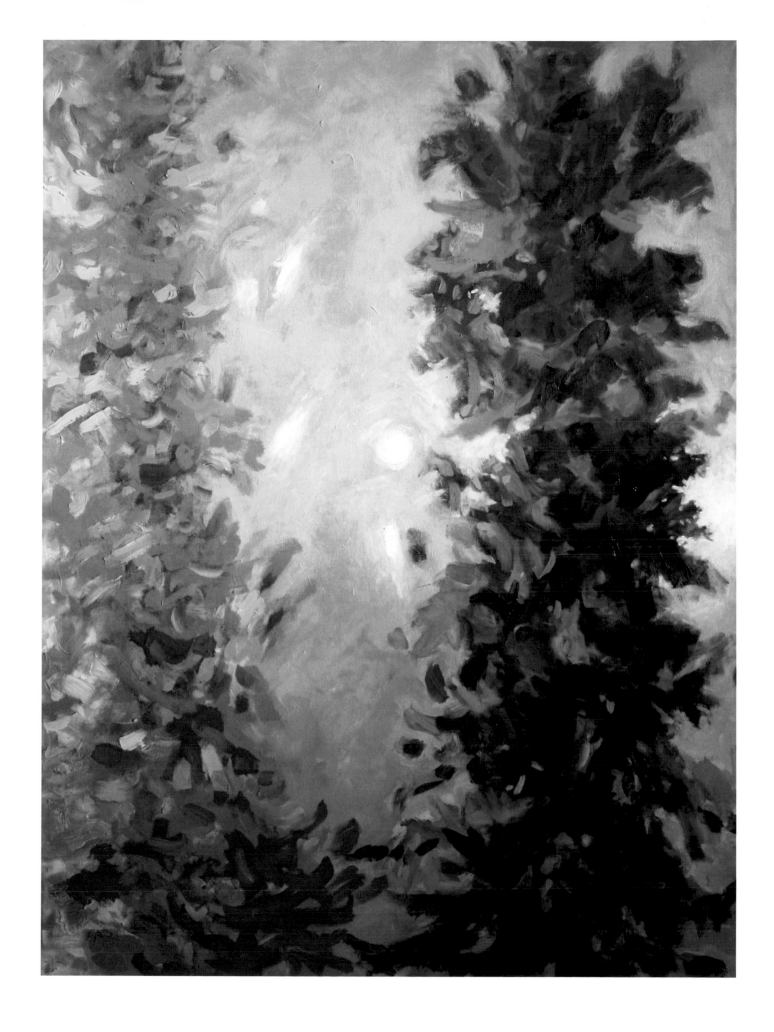

Trees Touching
40" x 30"
Oil on Canvas
2006

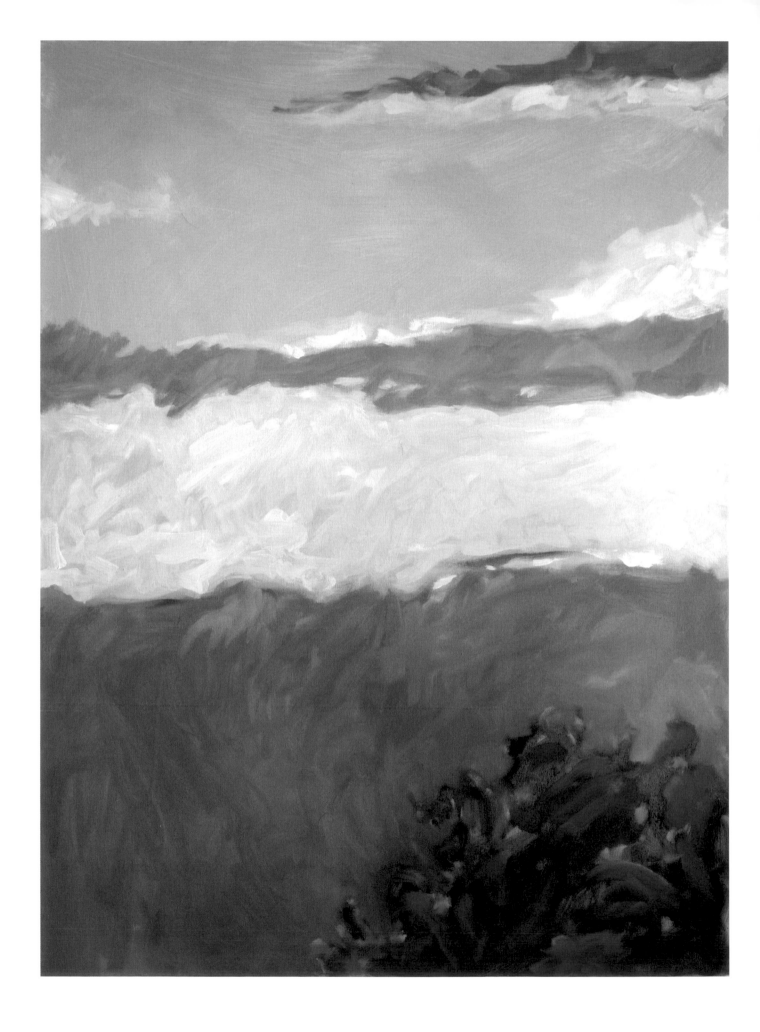

Purple Tree
40" x 30"
Oil on Canvas
2006

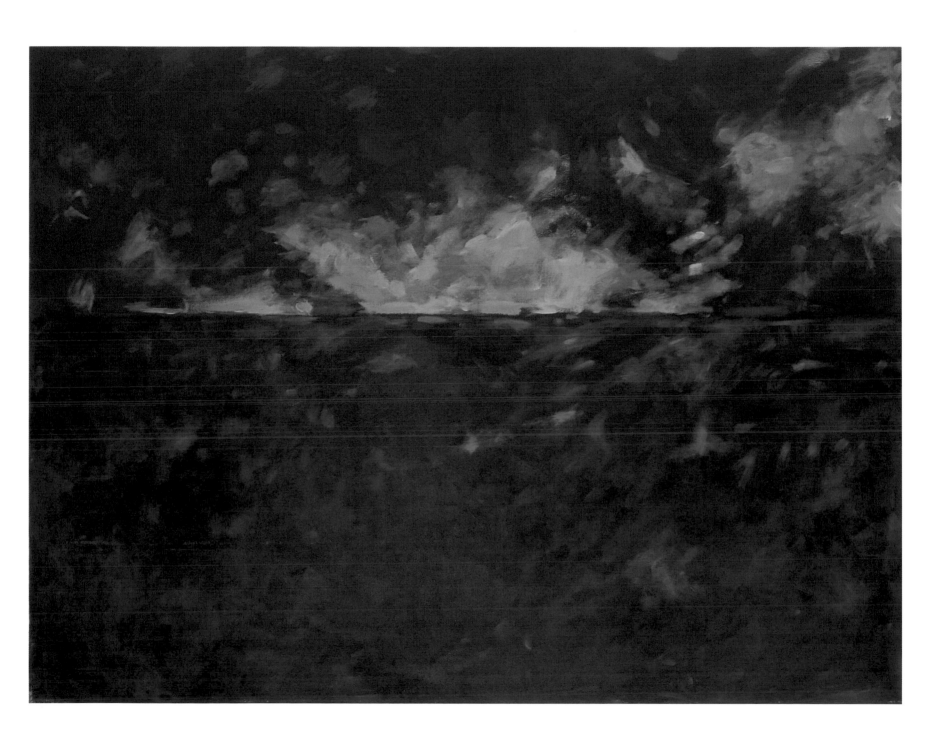

Flat Land No. 2
30" x 40"
Oil on Canvas
2006

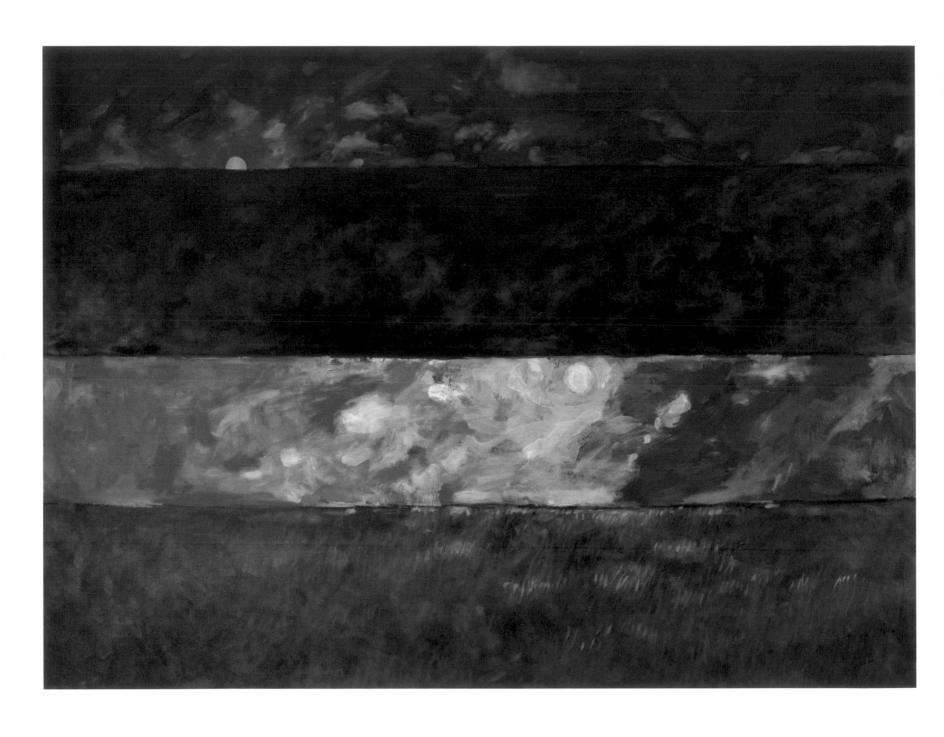

Time of Day
30" x 40"
Oil on Canvas
2006

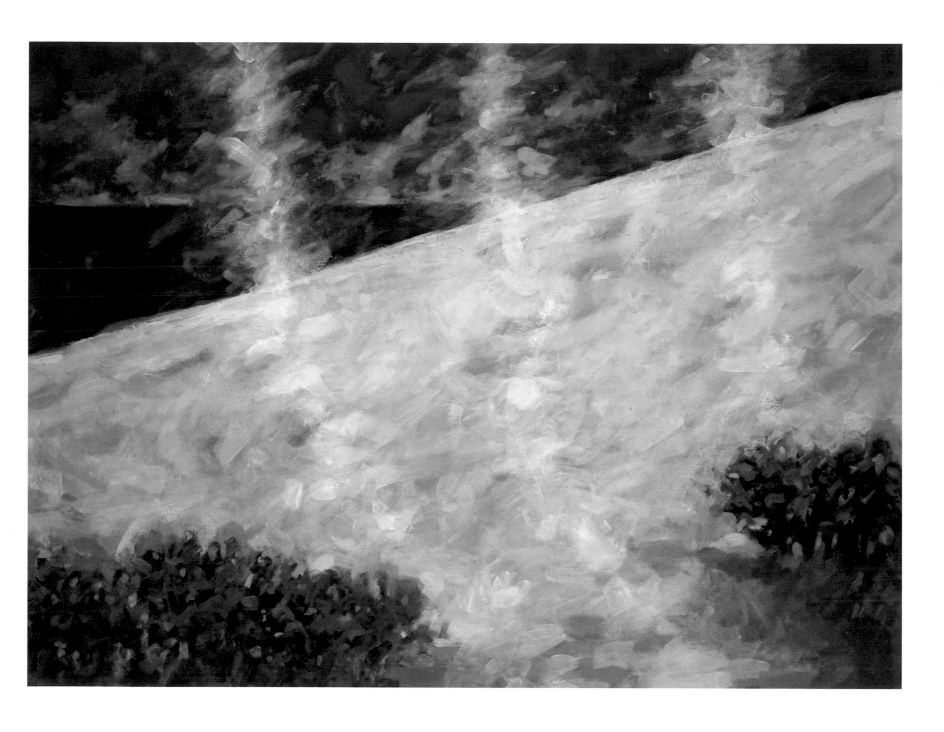

Hillside Seaside

30" x 40"

Oil on Canvas

2006

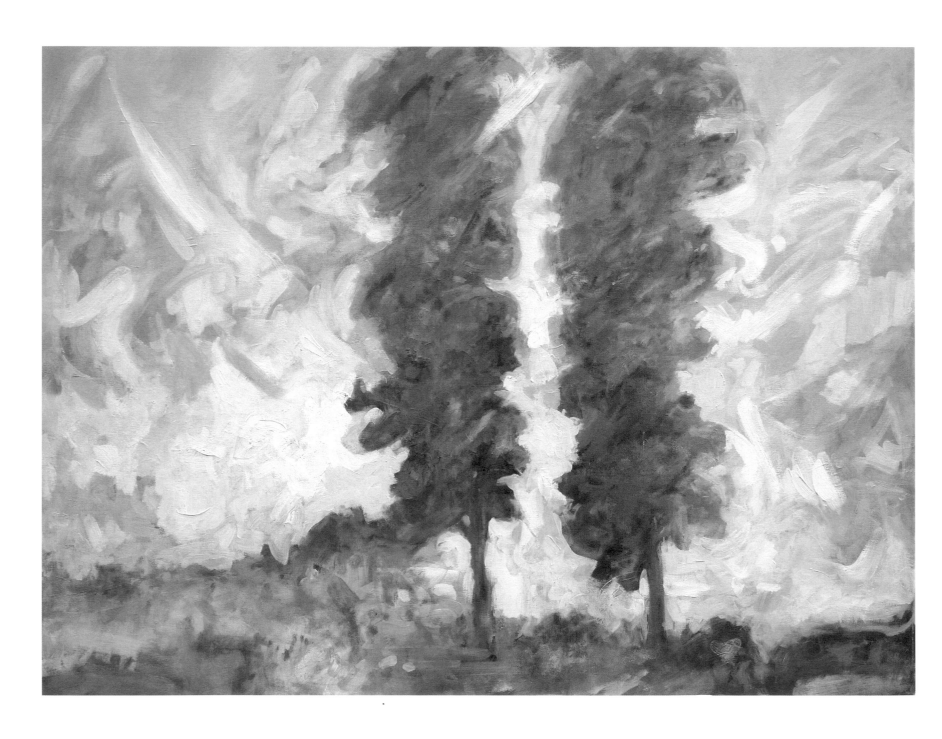

Morning
30" x 40"
Oil on Canvas
2006

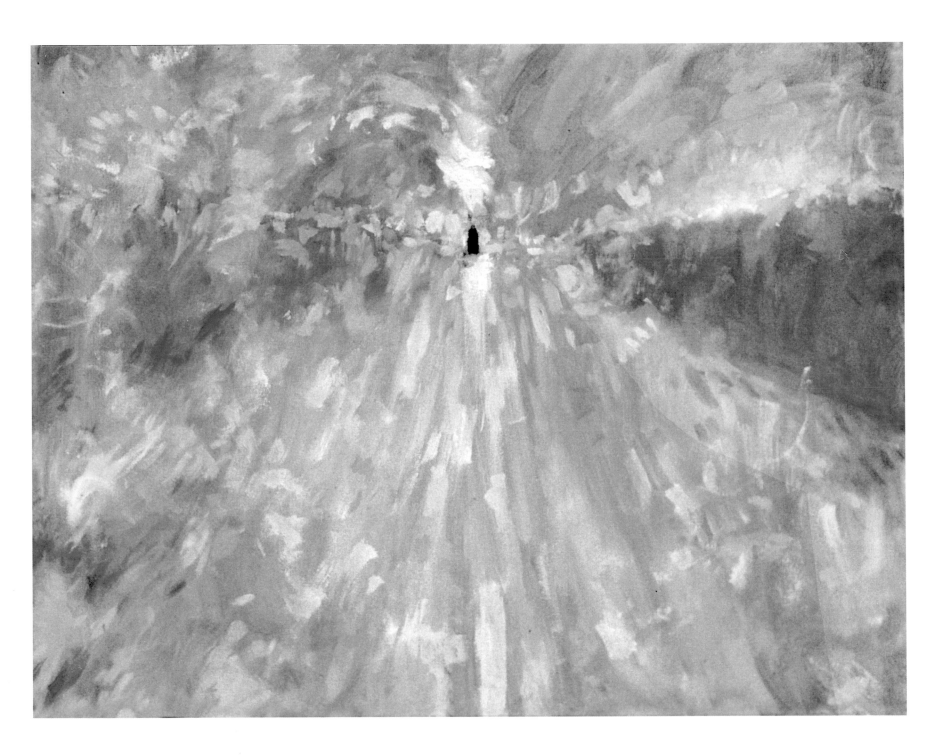

Train No. 3

19 3/4" x 24"

Oil on Canvas

2005

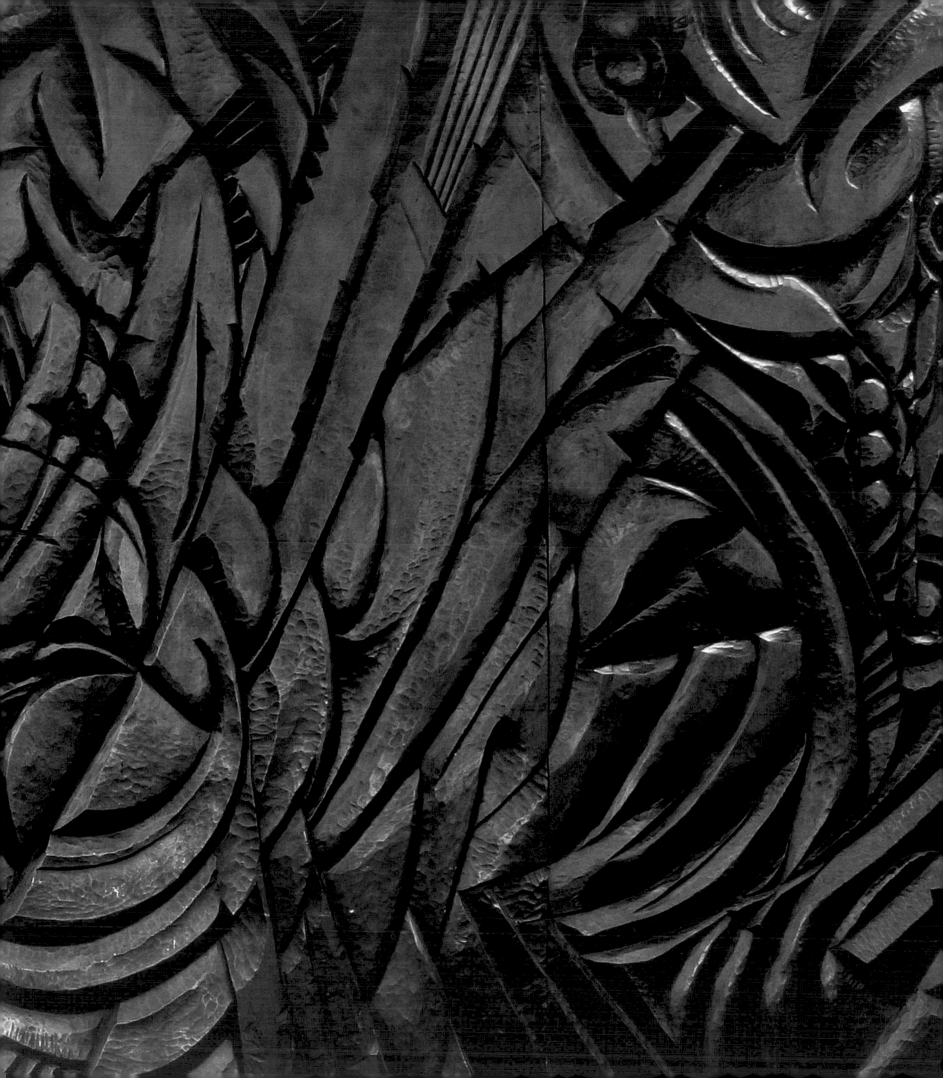

carving

bas

relief

is

drawing

Detail:
Jazz
84" x 180"/ 3 panels (84" x 60" each)
Ebonized Bass
2000

My father was a carpenter as were my three uncles and my grandfather before them. Til this day, I remember the "shop" where they worked, the smell of sawdust, of hot glue, the smell of burning wood from the pot bellied stove for heating and cooking. And still with me are the sounds of hammering, of saws cutting, of planes shaving and shaping and the laughter of men working. And the wood, all kinds of hardwood — oak, walnut, cherry, and the soft — poplar, fir and pine each with its own look and qualities for the making of things, speaking to you, telling you what it wants to be. The wood though dead is alive. It warps, expands, cracks, stretches. Its grain or change of grain, is something to contend with and accept. It gives life to the saying — "going against the grain." And the finishing to bring out the life of the piece — what oils, varnishes, waxes, finishes, or lack there of are wanted. I love the wood and the working of it. It talks to me, and so I appropriately answer it back. I go to the carving with a predetermined image that changes when interfacing with the wood. I feel the interaction of the tool with the wood and the specific eccentricity of the piece being worked on. The final result is from a partnership, a marriage with the wood. Carving bas relief in wood is very much a drawing process... drawing with the chisel as instrument, relying on light and shadows to define the resulting image. It is a magical doing in that

one defines objects in space on a relatively flat surface. It seems a contradiction that one draws with a chisel, an act of taking away to produce a line, a tone, a shadow. An image, unlike drawing, that changes with the change of light or movement of light or of the position of the viewer. To understand wood is to accept its diverse personalities and to allow them to come through.

In preparing this book I found myself referring to old sketches, thumbnails, scribbles; the notations that were the beginnings of an idea, a notion to be explored, to be remembered and referred to in the doing of a carving. In the sketches there was no attempt to "make art" – rather to be simple, bare, to note and only note an idea. These images are a search for what might be – a search for finding form. They are as much a part of what the work was about as what it would become. They are as unresolved as the "finished" carvings would be unfinished, a part of the doing process. I love these marks, these scribbles, these clues as to what the carving wants to be. Simple, lean, a hint, lacking the "fancy dress" of technique. I listen to these "five cent words". These simple "to do" marks seem unresolved but in truth, are totally developed in their lack of development.

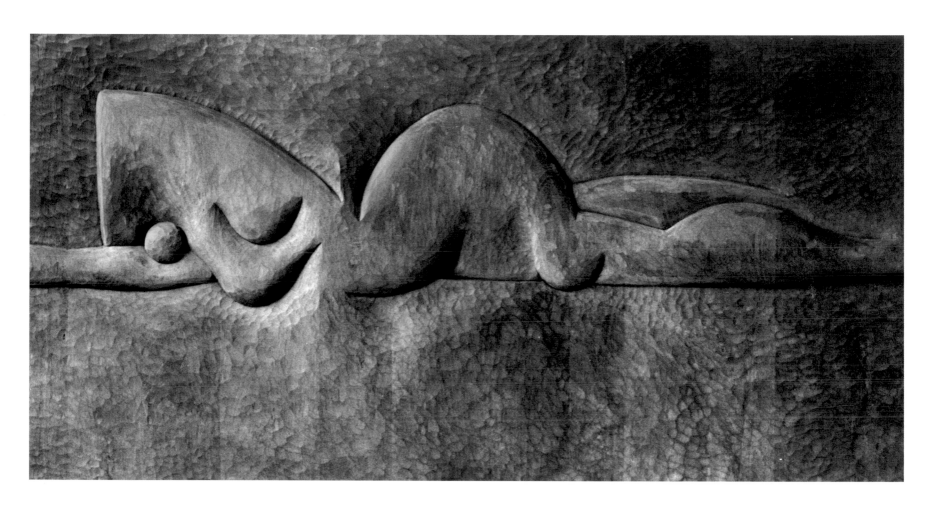

Reclining Nude No.1

36" x 72"

Oxydized Walnut

1995

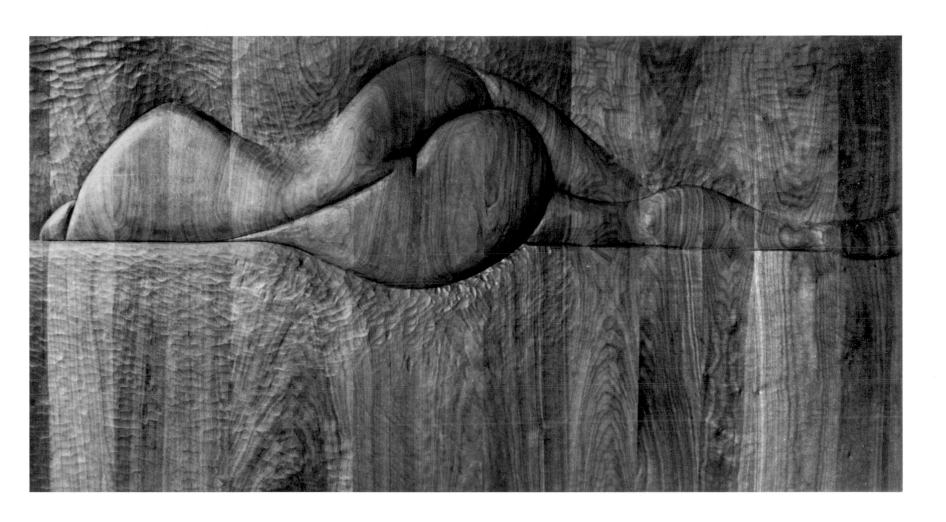

Reclining Nude No.3

36" x 72"

Walnut

1995

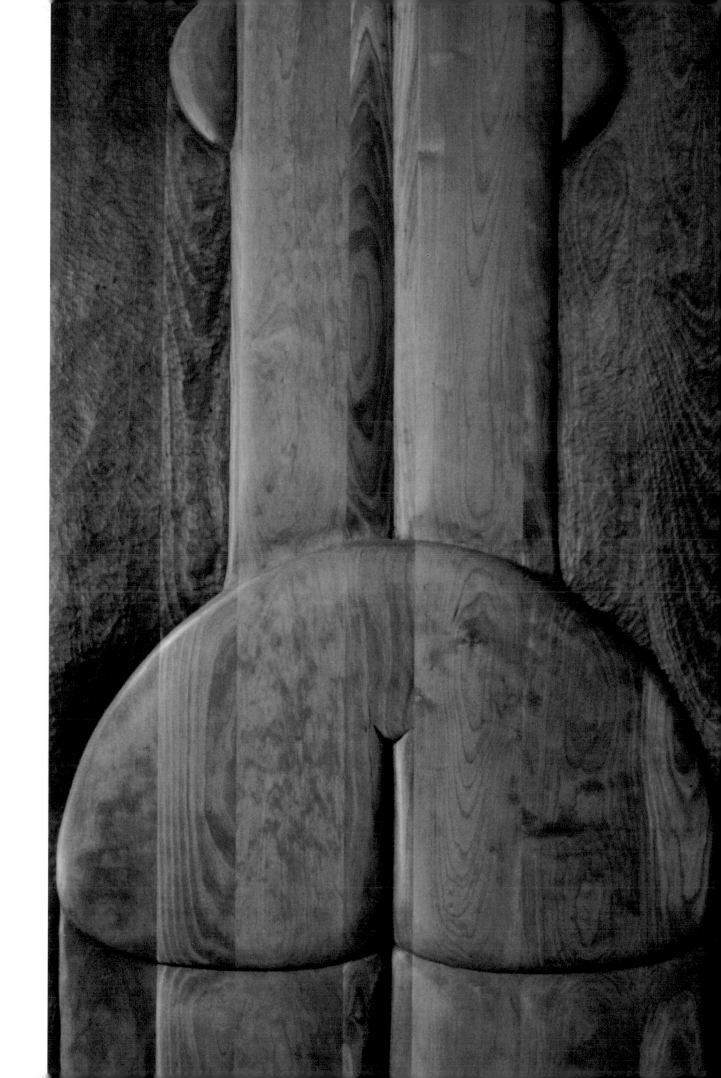

Big Fat Ass
72" x 42"
Cherry
1987

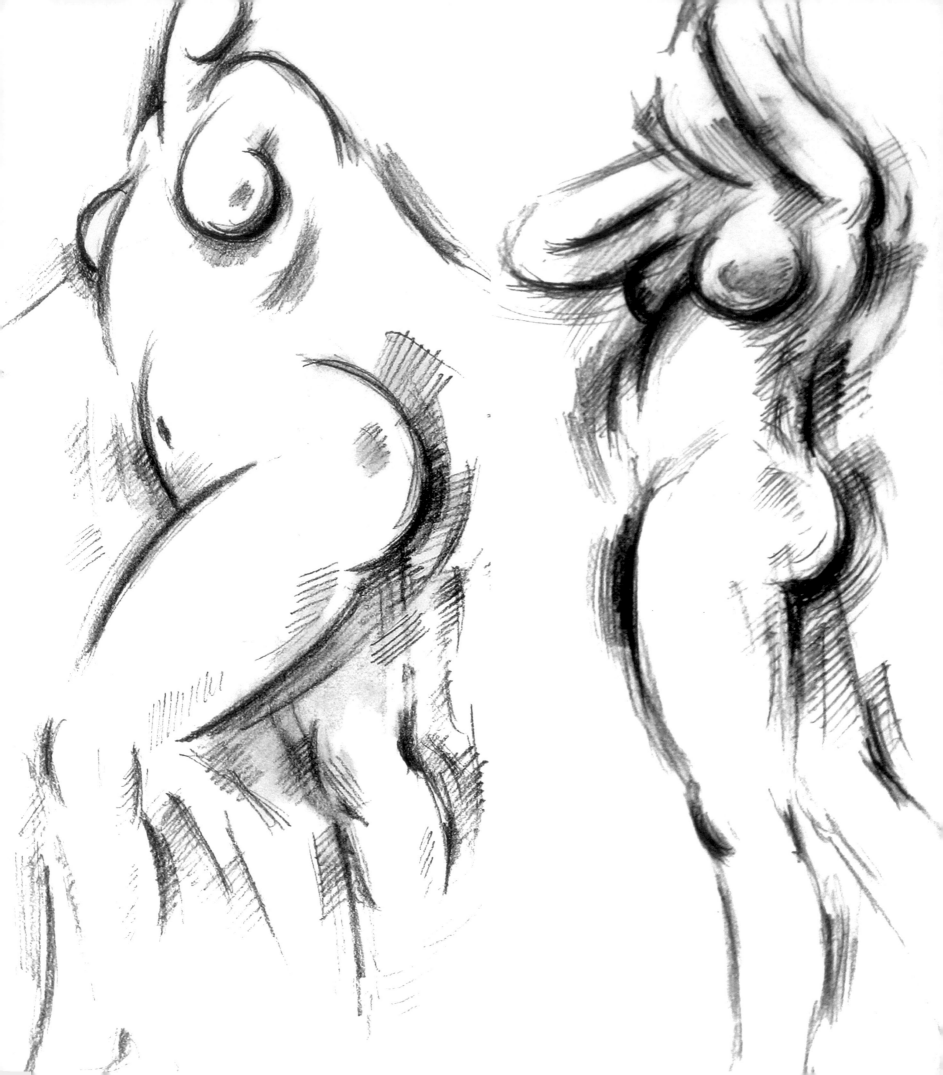

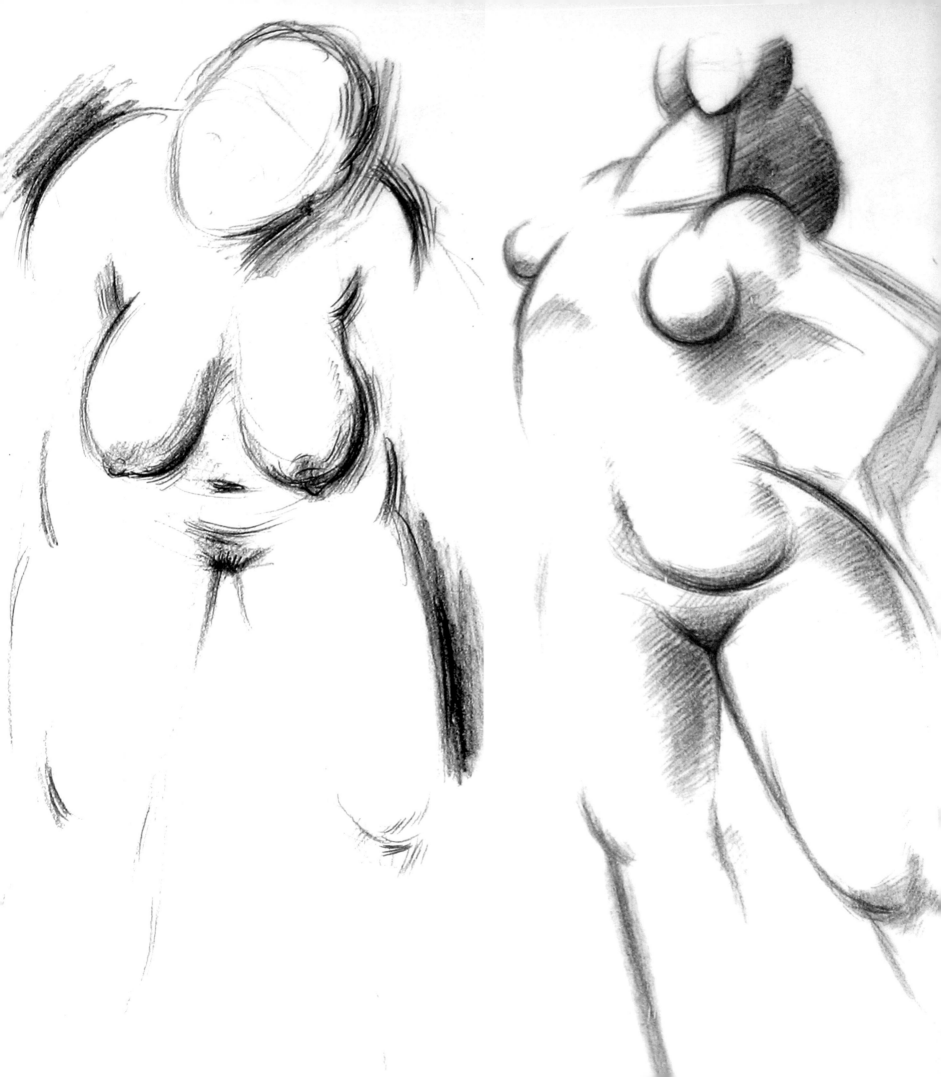

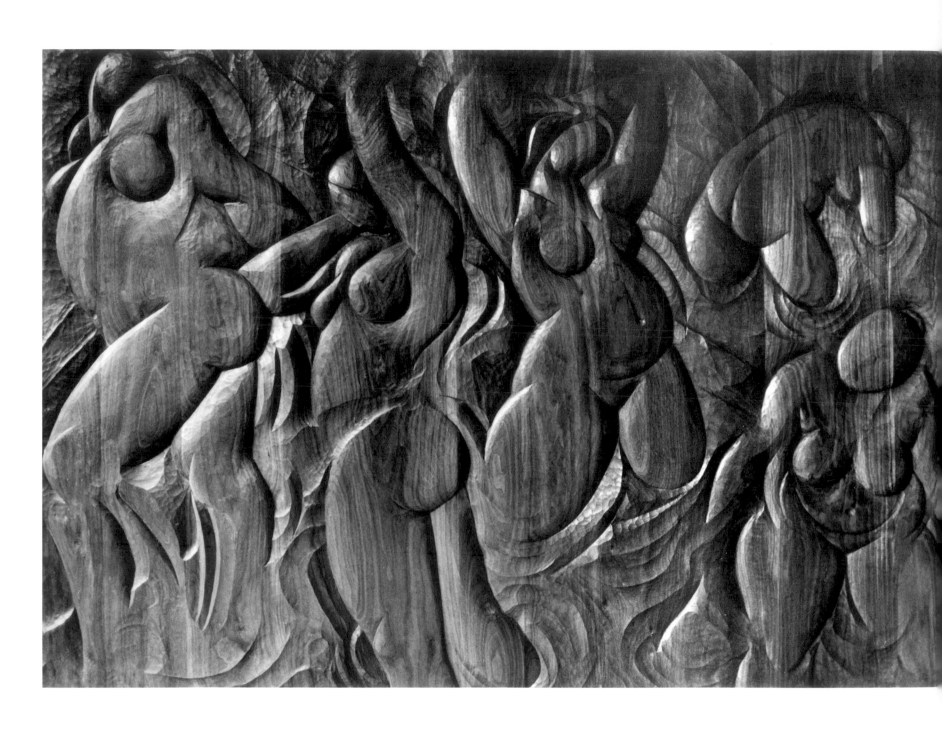

Seaside Girls No. 2
60" x 84"
Walnut
1990

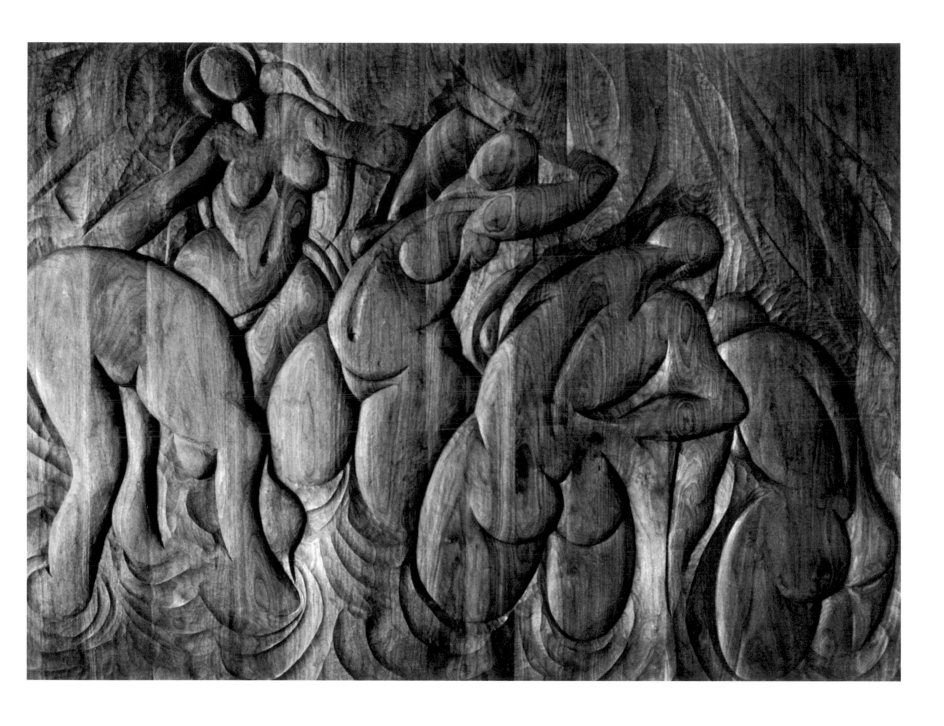

Seaside Girls No. 1

60" x 84"

Walnut

1989

CREATION SERIES

Where are we? Where do we come from? Where are we going? The eternal questions we ask ourselves. The passage of "from" to "to." From innocence to "reality." Creation— it's about breaking the rules and finding oneself in a different world— outside comfortable known borders. A world for which we are now responsible. Where we become the caretakers.

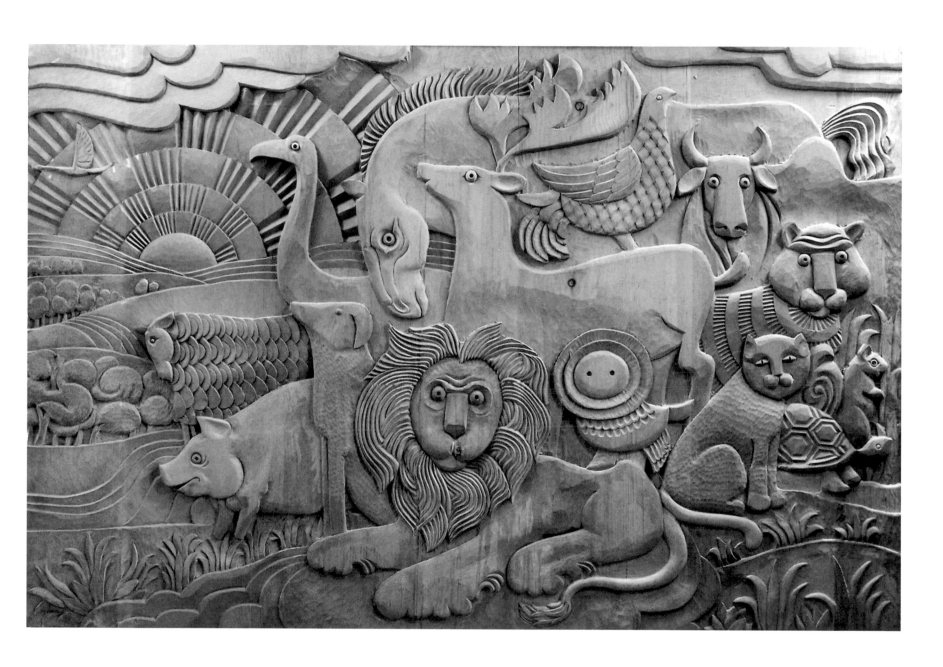

The Animals
48" x 72"
Pine
1973

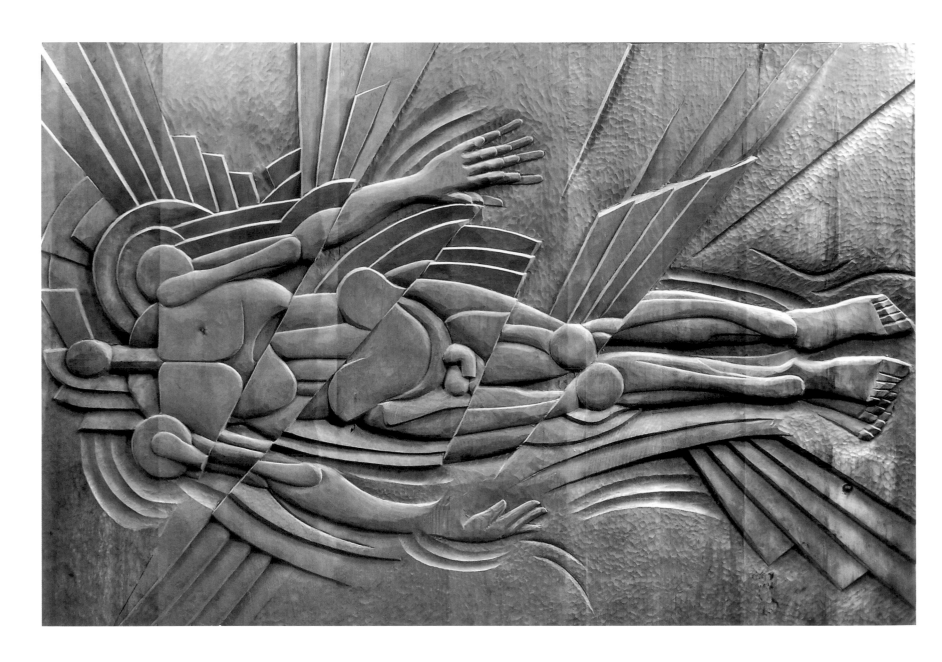

Creation of Adam

48" x 72"

Pine

1975

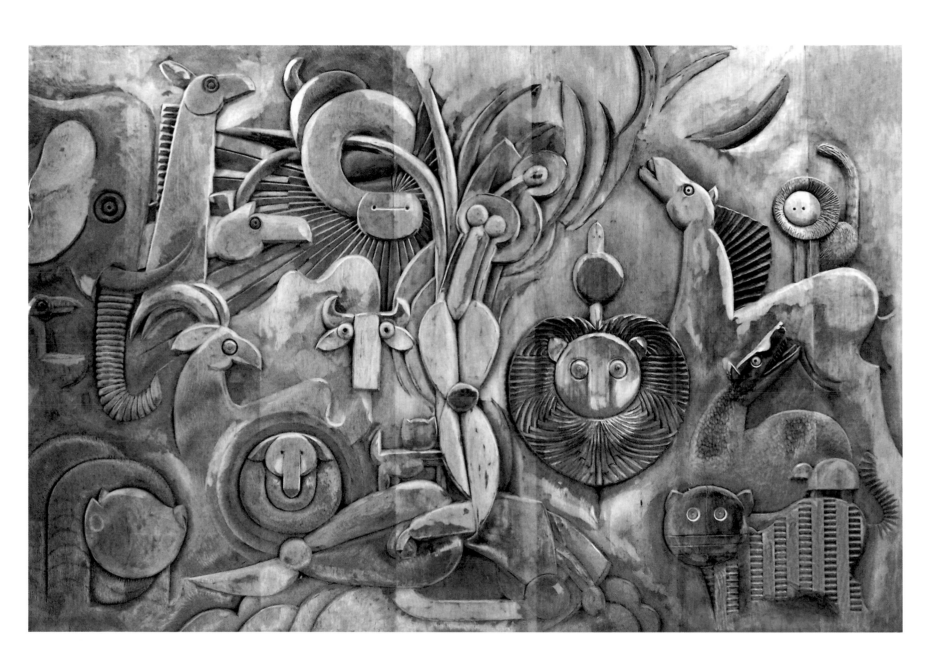

Creation of Eve

48" x 72"

Pine

1977

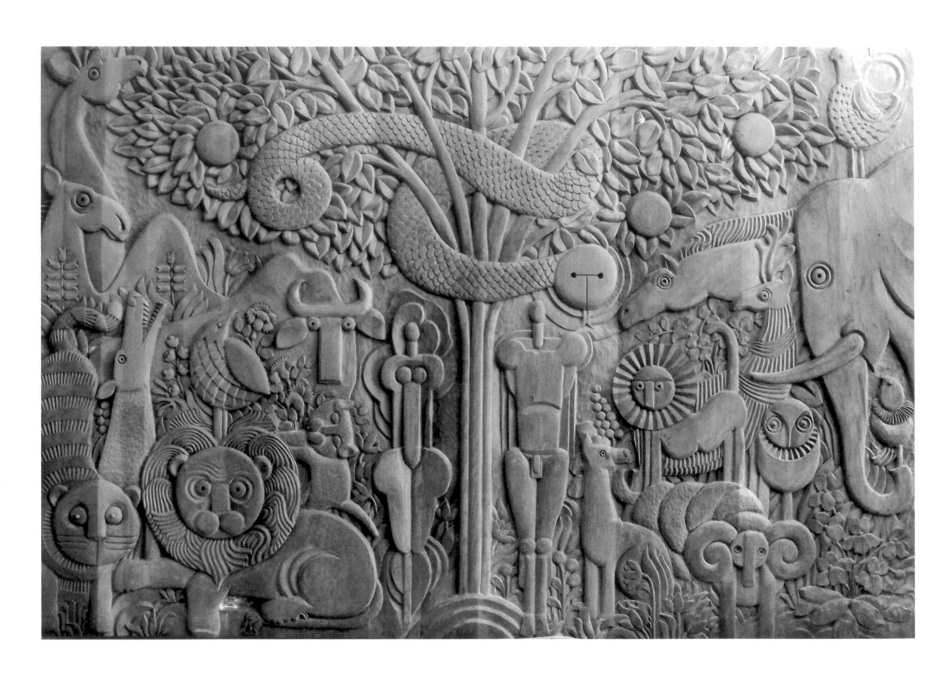

Eden
40" x 72"
Pine
1980

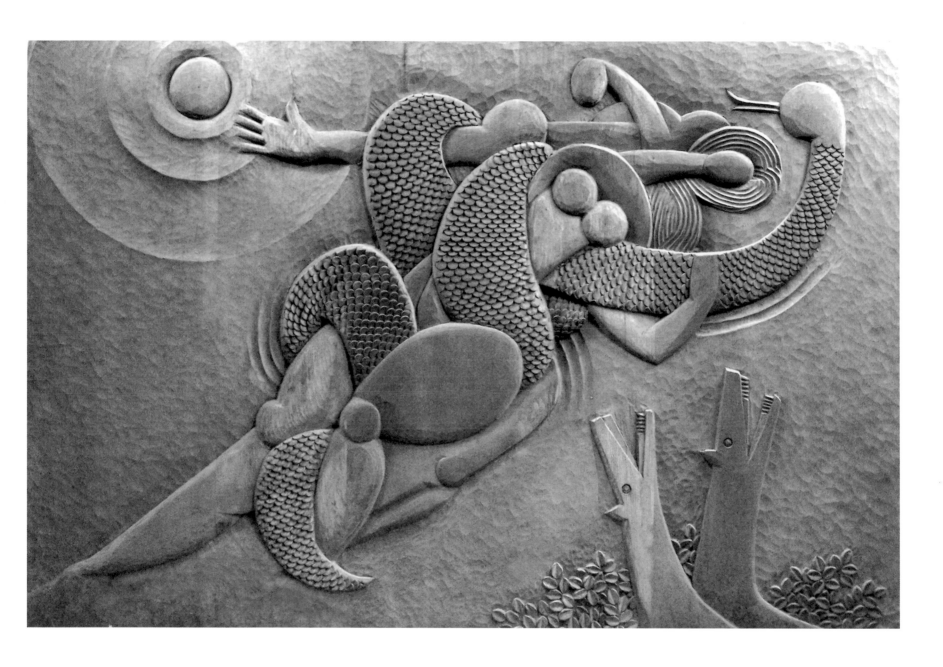

The Temptation

48" x 72"

Pine

1981

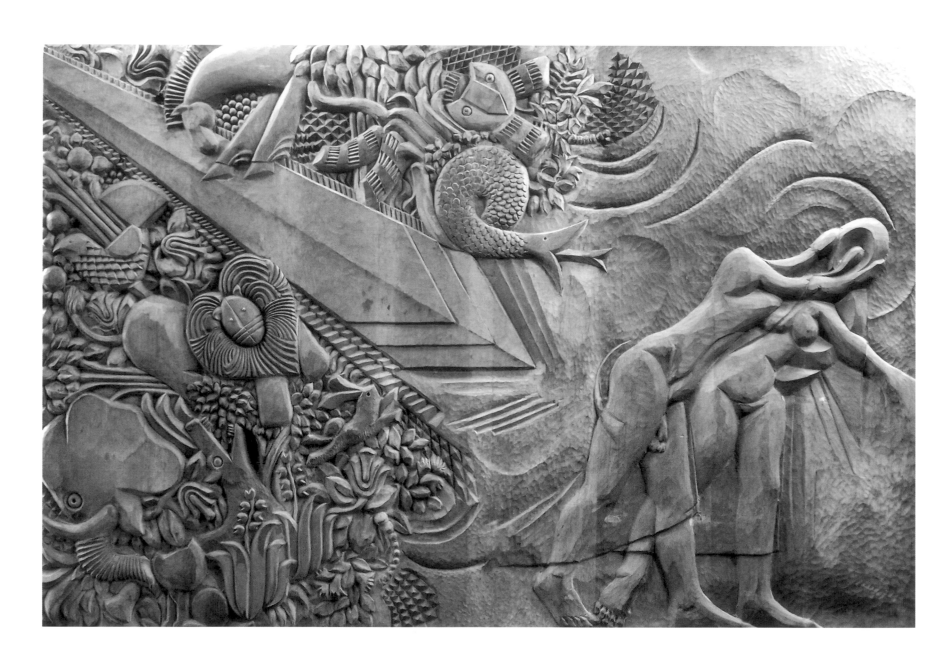

Expulsion
48" x 72"
Pine
1998

The "birth" of the first murderer. In a world, not Eden, where we are destined to live and make reply to problems we create. Where we are destined to be God-like as caretakers of the world.

Birth of Cain
24" x 24"
Basswood
1984

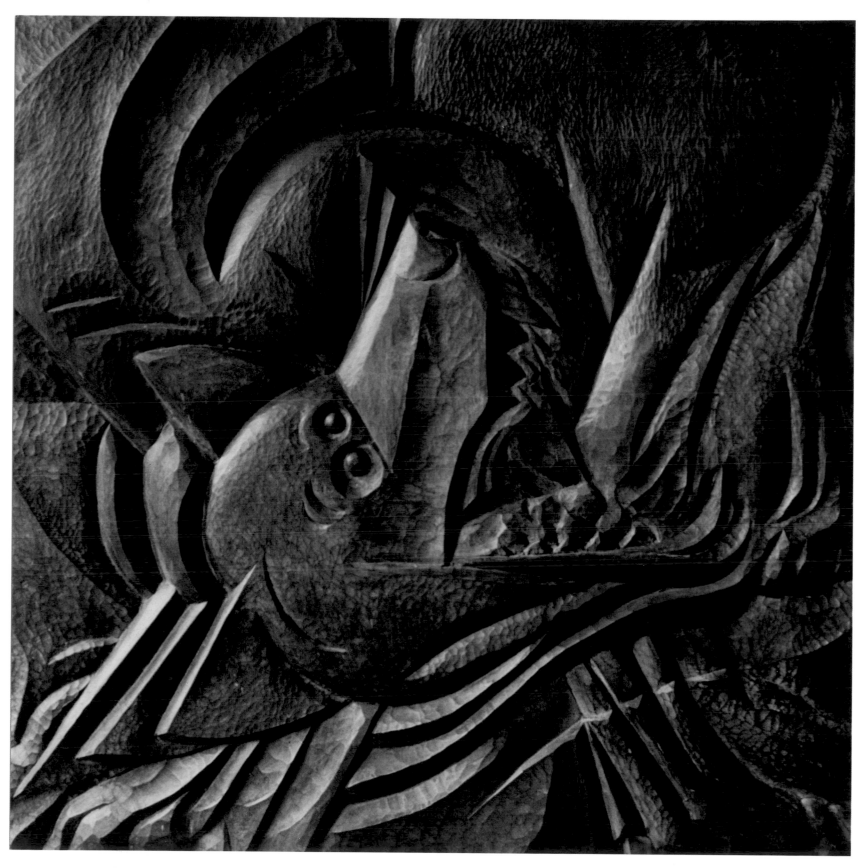

Dog Looking Up
36" x 36"
Ebonized Walnut
1994

Following Page:
Jazz
84" x 180"/ 3 panels
(84" x 60" each panel)
Ebonized Bass
2000

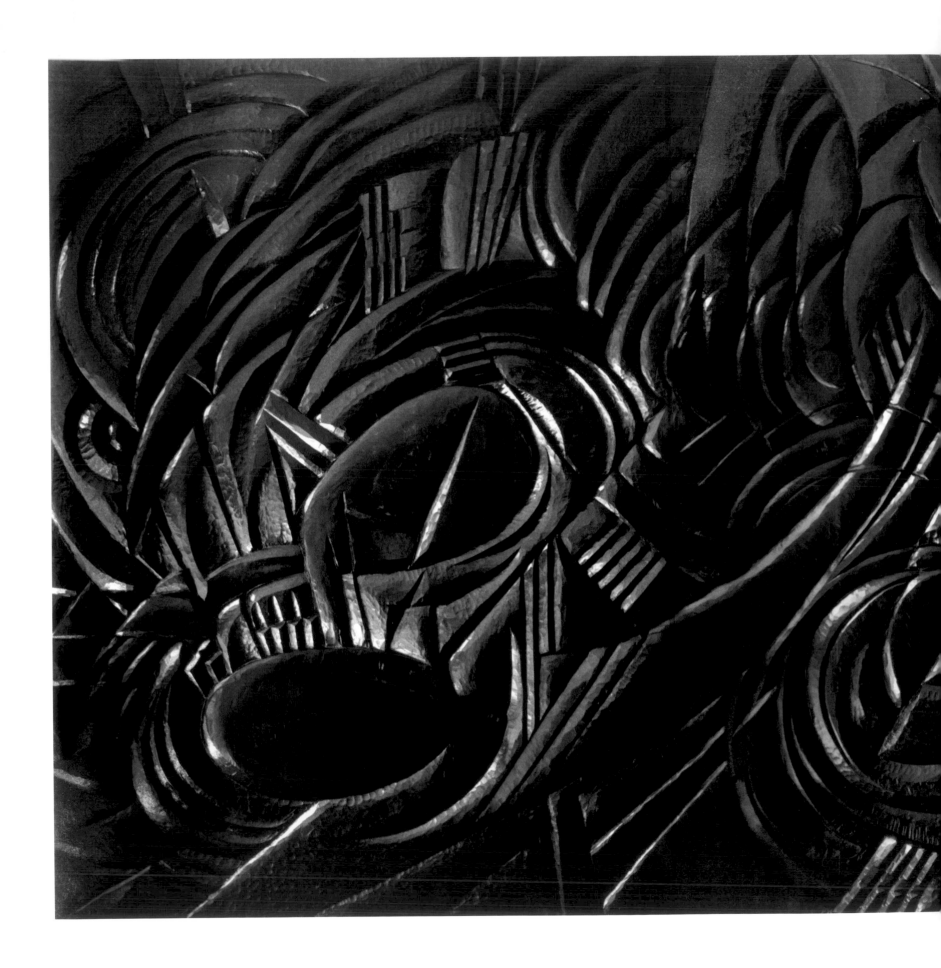

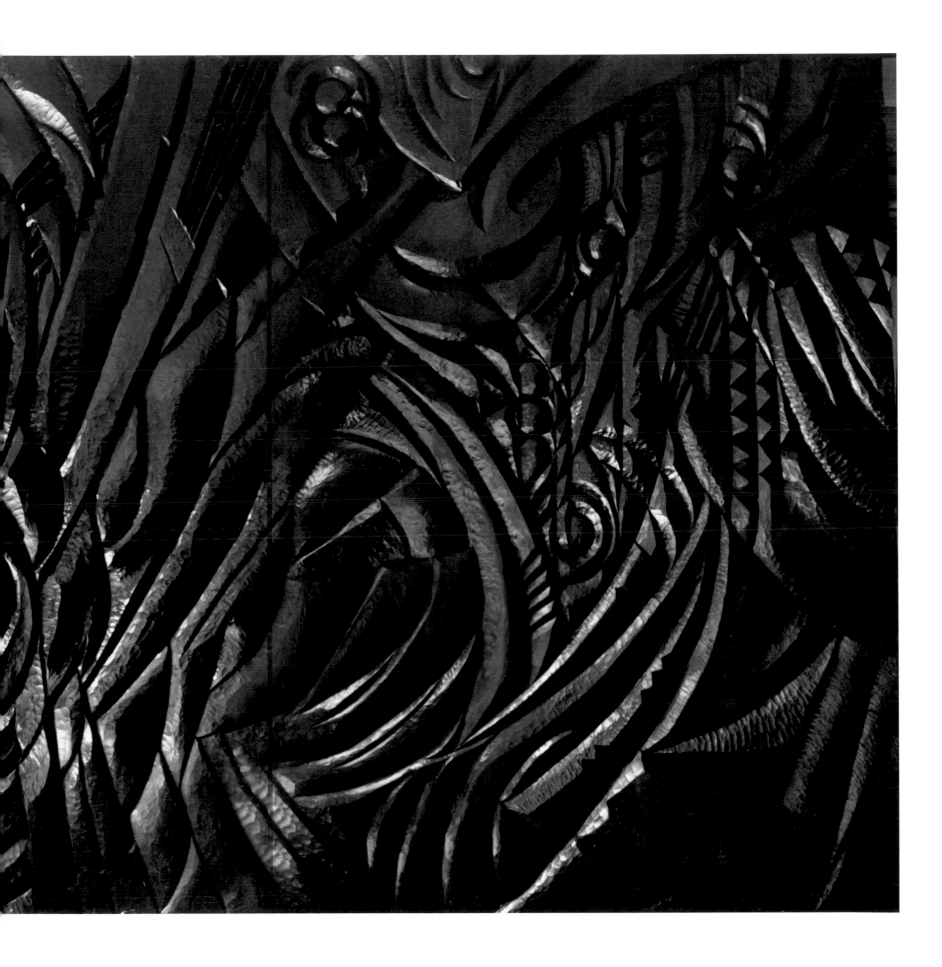

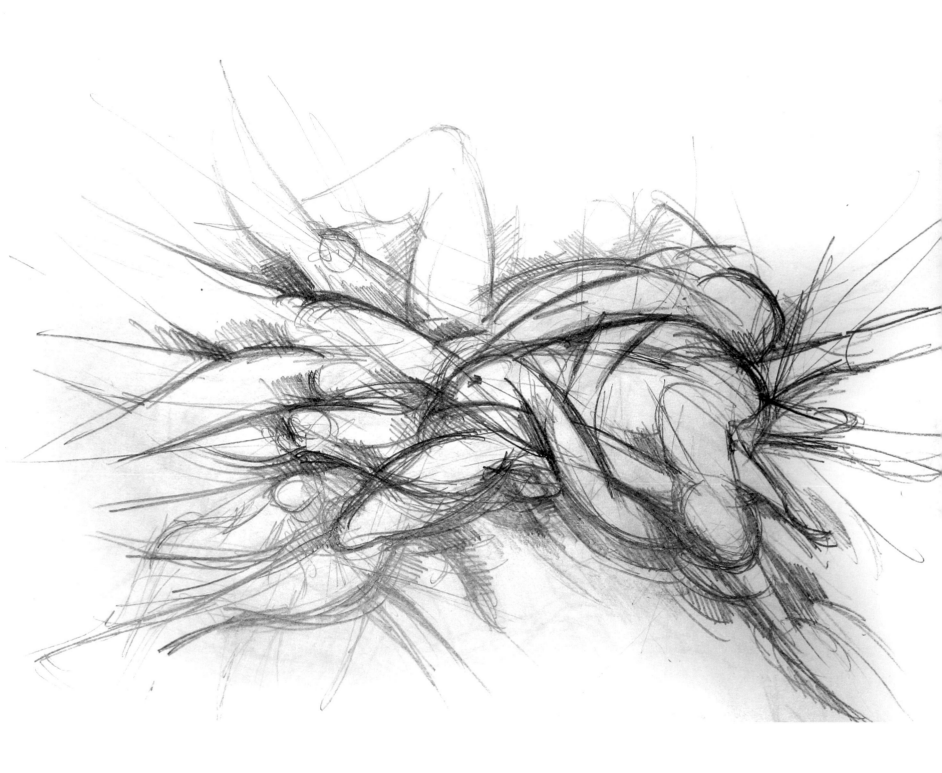

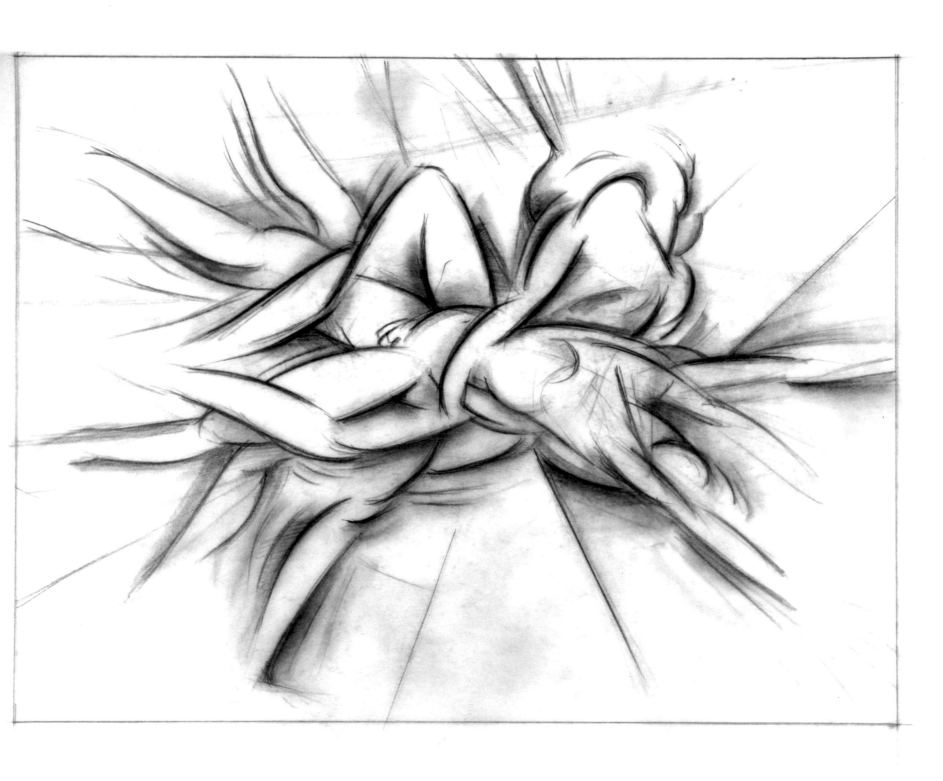

Jacob spent the night alone on the far side of the Jabbok River, and there he wrestled with an unknown presence, a man, an angel, God, until break of day. In the course of the wrestling as day approached, the man said, 'Let me go, for the day is breaking', and Jacob replied, 'I will not let you go unless you bless me'. The man asks Jacob's name, and when he is told, says that from now on your name is Israel, 'for you have striven with God and man and have prevailed'. In return, Jacob asks him his name, but is not told. The man simply blesses him, and Jacob calls the place where this happens 'Peniel', because there he saw God 'face to face'.

Peniel
72" x 96"
Bronze
1987

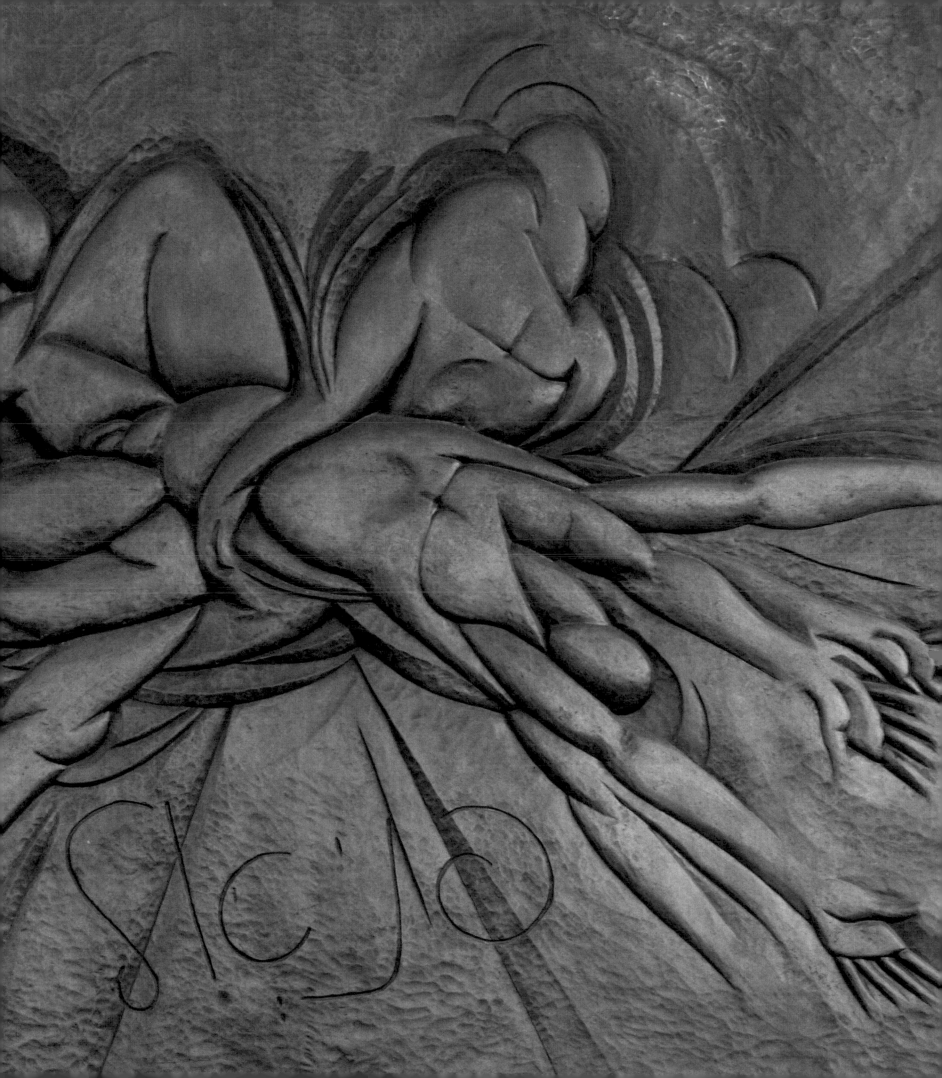

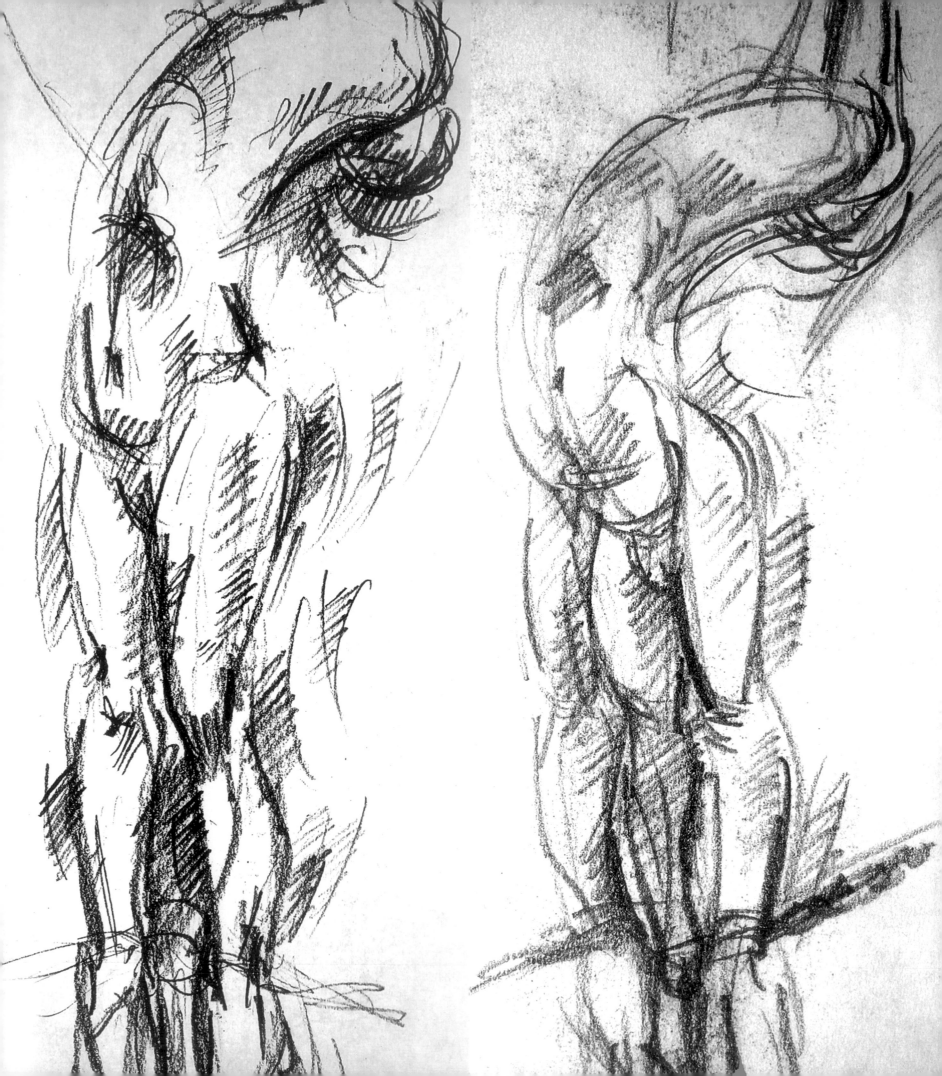

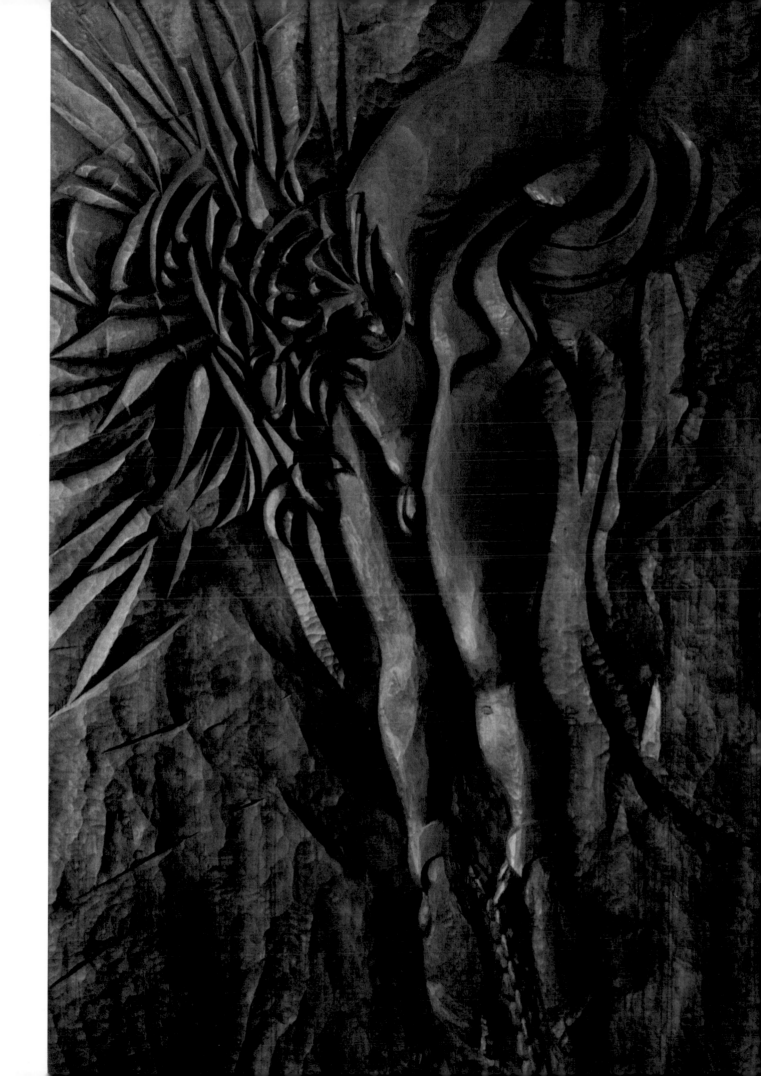

Prometheus

72" x 48"

Ebonized Bass

1989

making

three

dimensions

from

two

Years earlier, I did a series of drawings exploring the human form in two dimensions. More recently while reviewing these drawings in a "sculptural frame of mind" I realized I could do them in three dimensions as sculptures. I simply took the drawings to the shop and actually traced them out onto wood of varying thickness, cut them out and constructed them. Since my original model was in two dimensions, I was forced to think in three dimensions to make the figure stand, and by exploring the piece in the round to do unseen views that made visual sense to me.

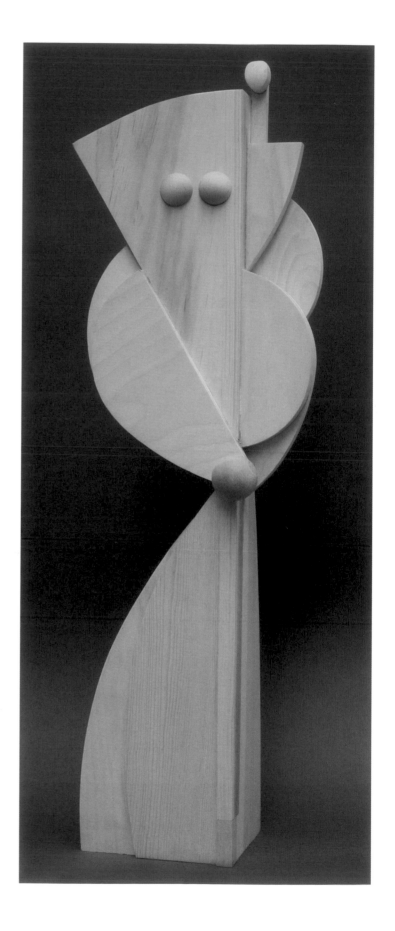

Female Nude
36 1/2" x 11 1/2" x 7"
Pine
2007

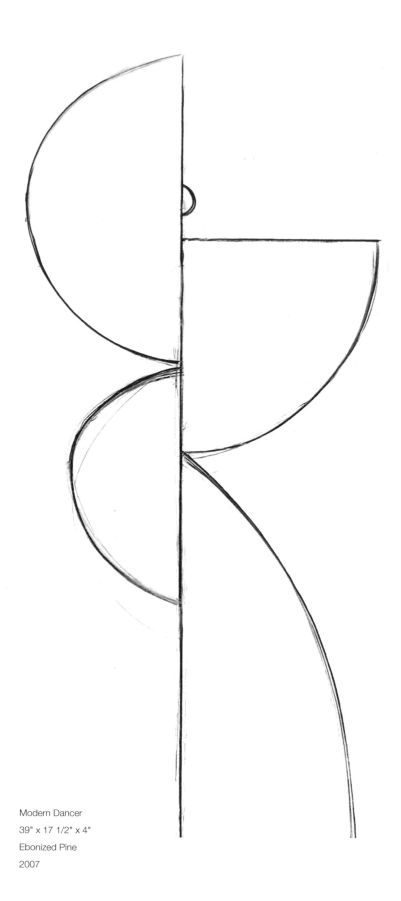

Modern Dancer
39" x 17 1/2" x 4"
Ebonized Pine
2007

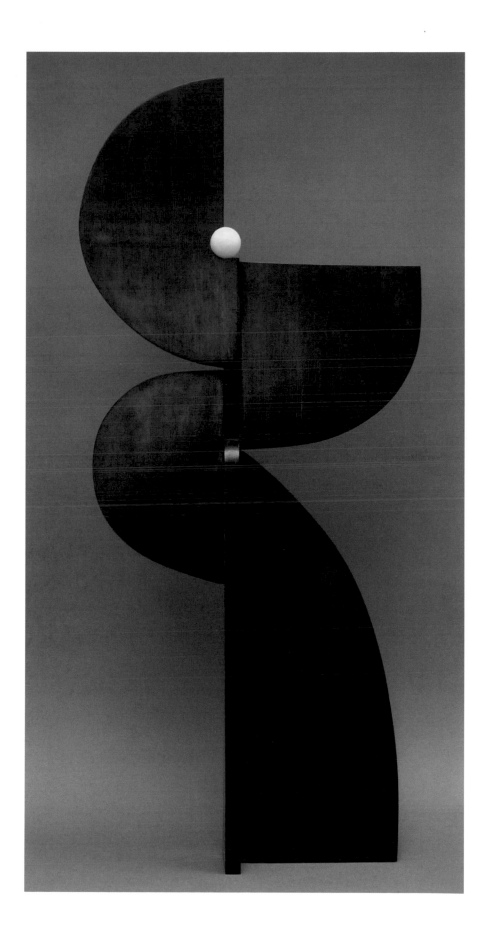

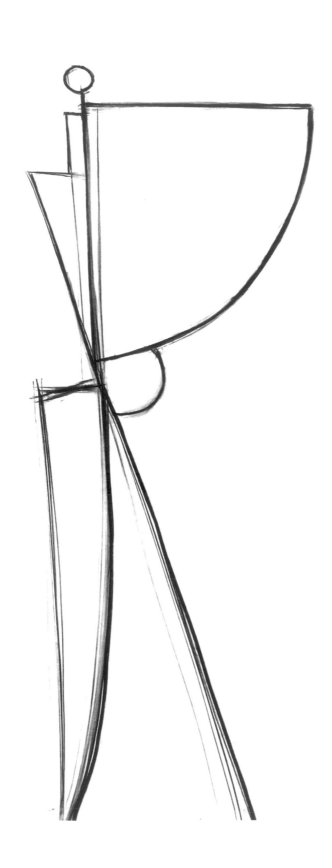

Goddess
38" x 16" x 8 1/2"
Ebonized Pine
2007

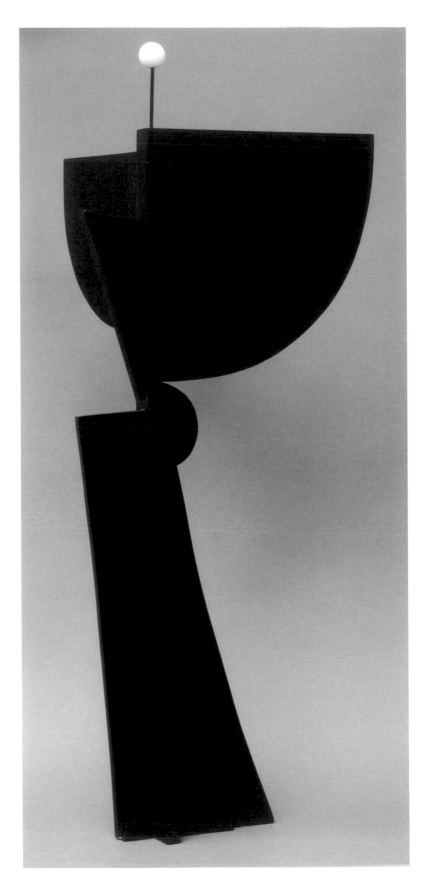

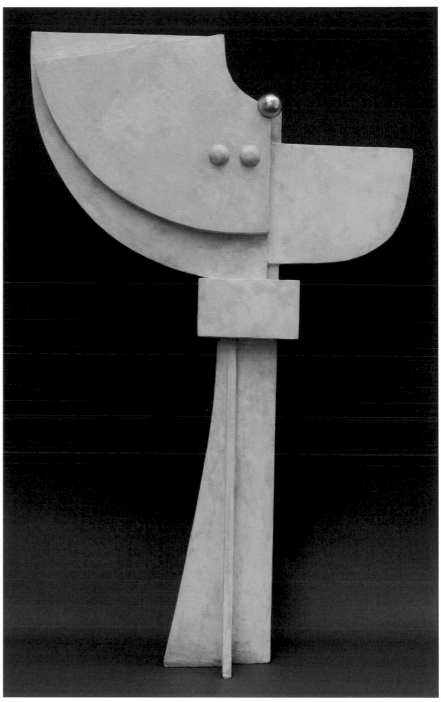

Eurydice

39 1/2" x 24 1/2" x 10"

Gessoed Pine

2007

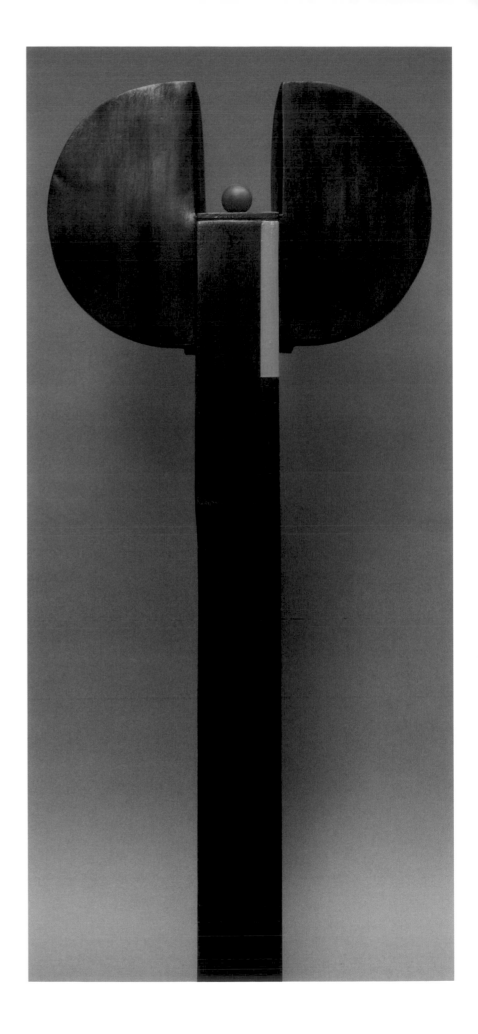

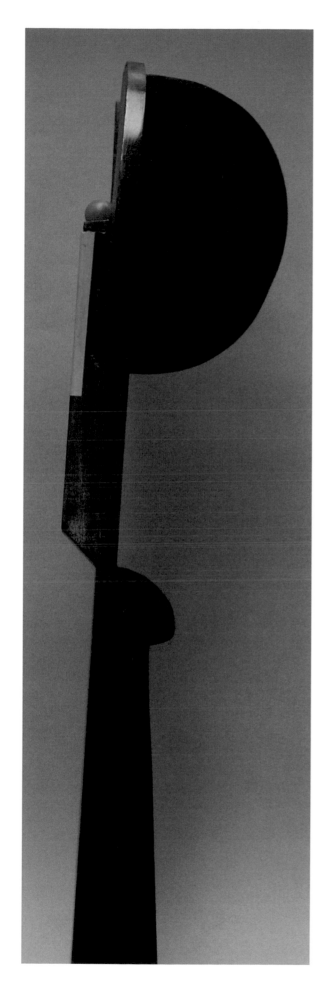

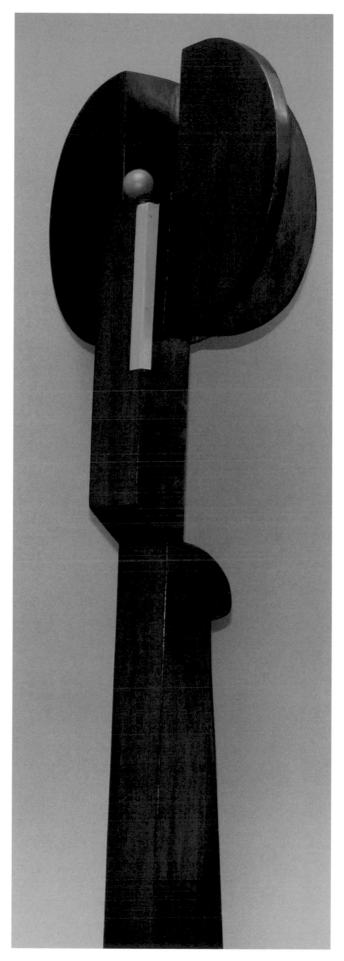

Spanish Dancer
39" x 16" x 7 1/4"
Ebonized Pine
2007

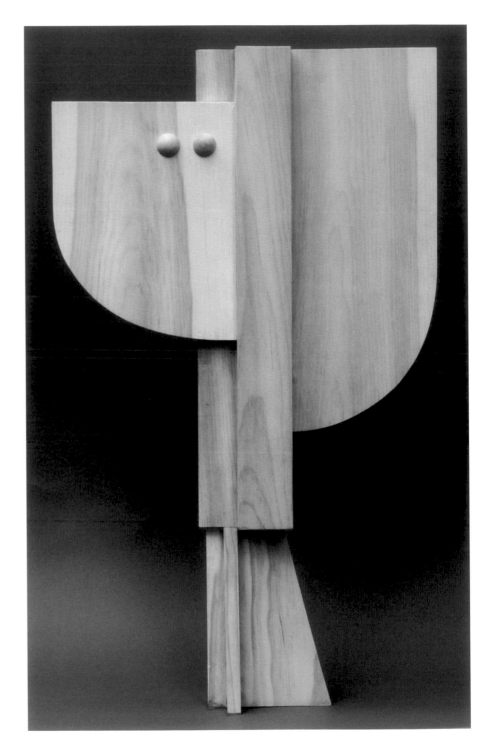

Female Figure

36" x 21" x 7"

Pine

2007

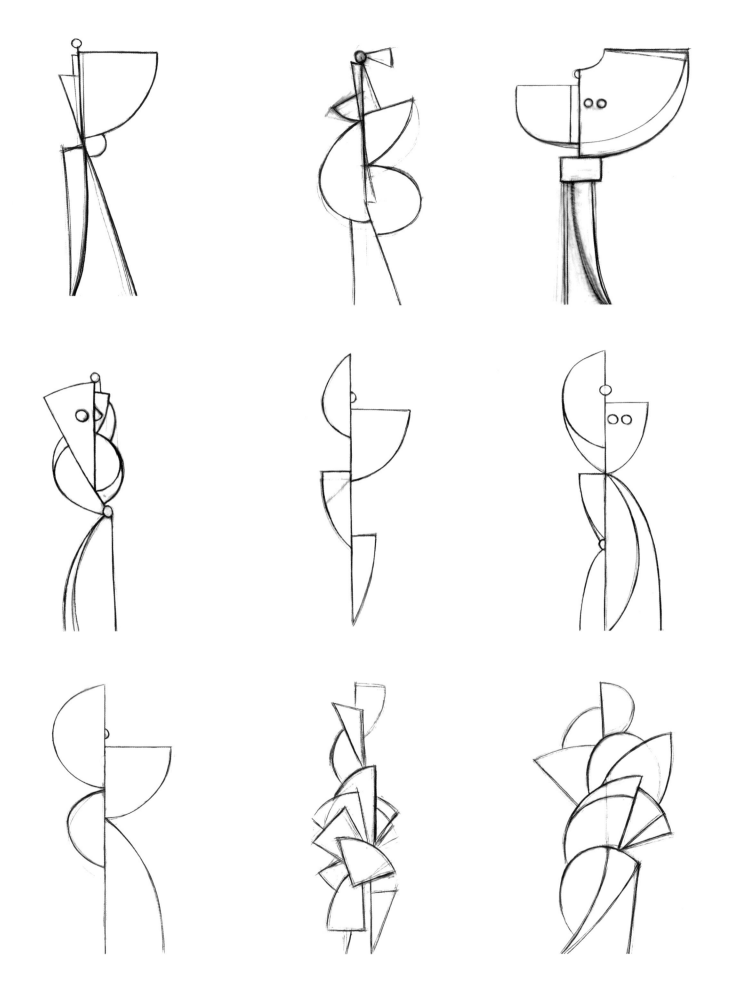

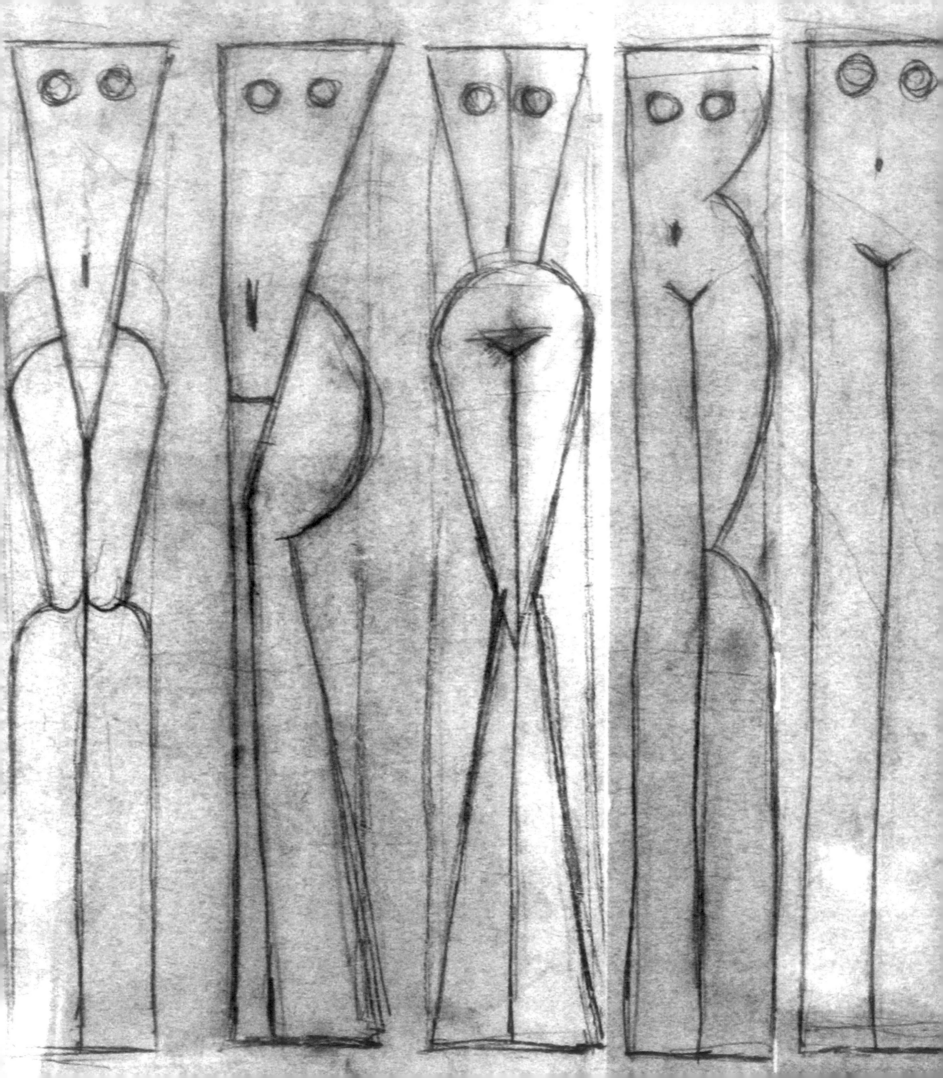

giving

backs

and

sides

to

bas

relief

Bar relief has its limitations. Like a painting or a drawing it is essentially two dimensional, flat, one sided. There is no back. One views it in one plane. How could I combine bar relief with carving in the round? My reliefs are carved from wood panels made by joining thick wood boards of varying widths to create the desired dimensions. The vertical "board" brings to mind ancient stele markings, Easter Island heads, obelisks, the standing stones of Stonehenge. If one took an individual board and stood it on end, a stele would result from which one could carve front, back and even the sides. The piece could be viewed in the round. Simply, I would honor the board shape, its boundaries would be my limitations. As I explore the shape I am pushed to be simpler and simpler. Doing these pieces is a continuous process. Each piece forcing a simpler more abstract next piece. Only the act of doing determines what the next piece wants to be – taller, narrower, simpler and so on.

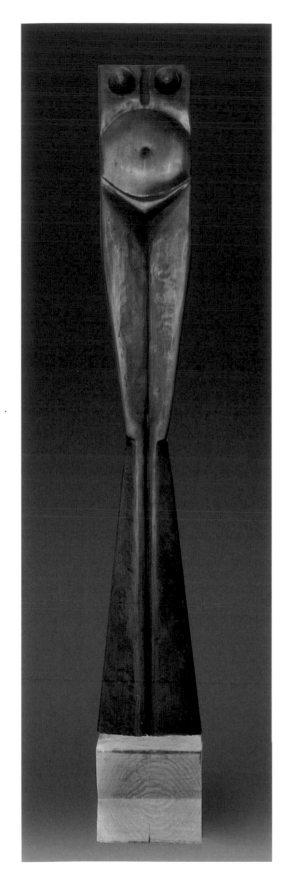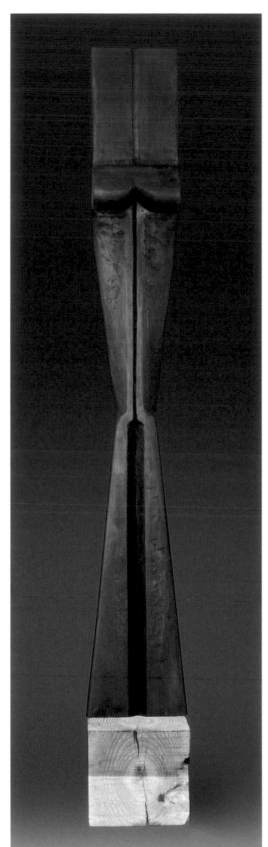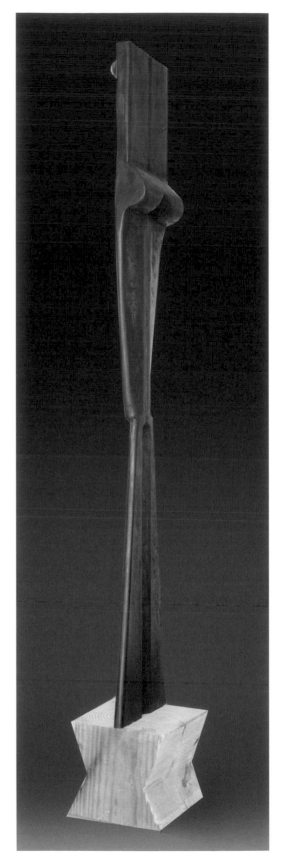

Thin Nude

82" x 10" x 11" with base

Basswood

2007

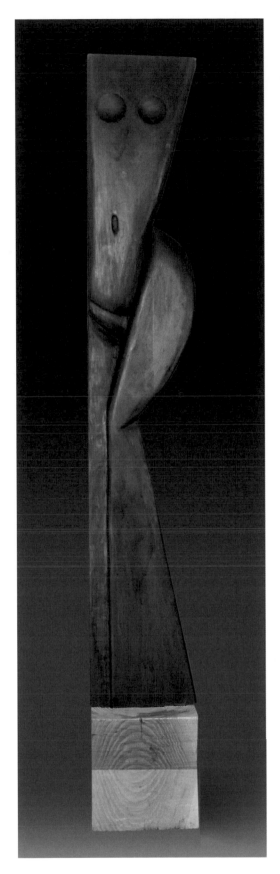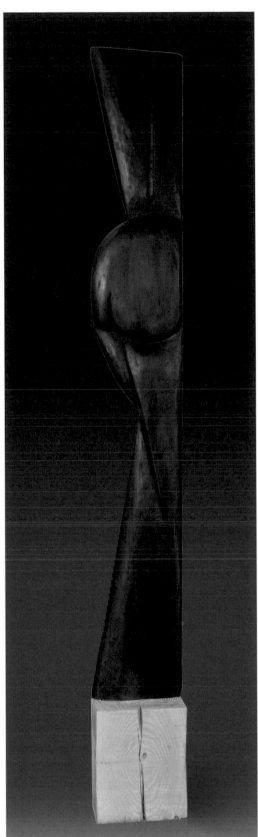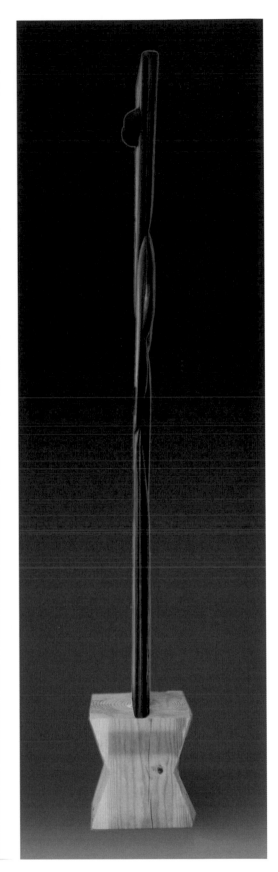

Dancer

82" x 12" x 11" with base

Basswood

2007

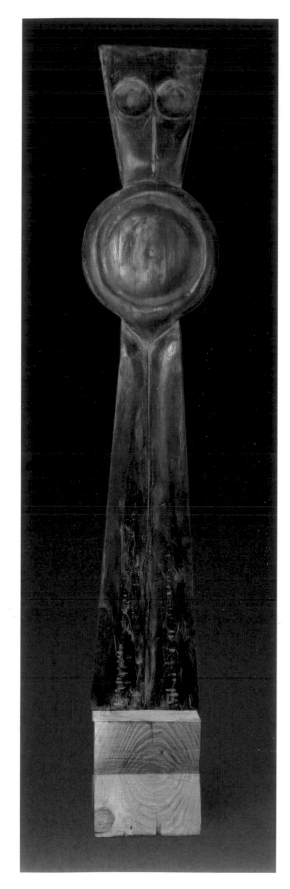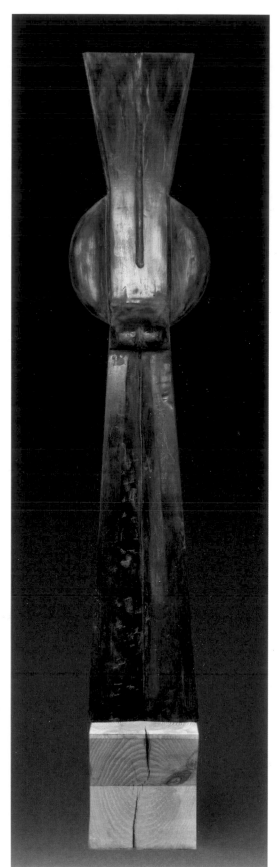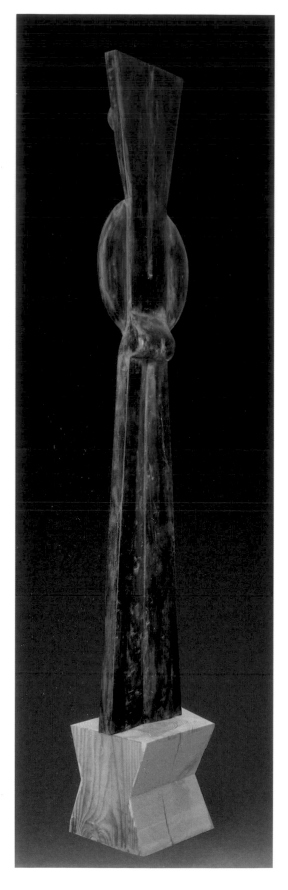

Pregnant Woman

82" x 15 1/4" x 11" with base

Basswood

2007

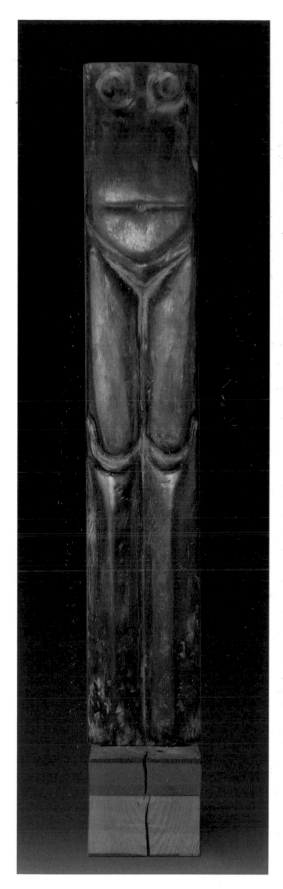
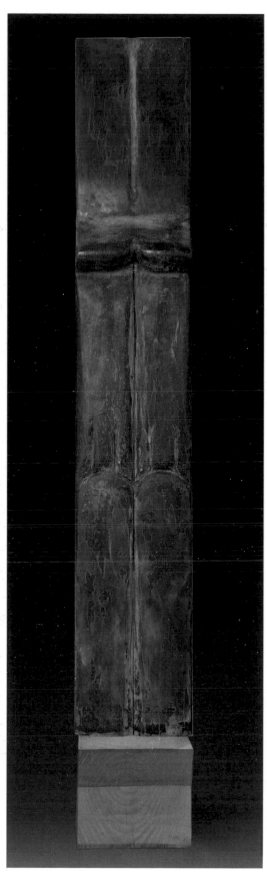
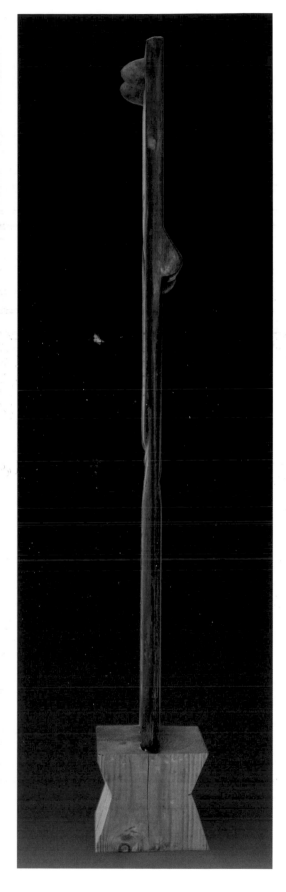

Board Nude

81" x 12" x 11" with base

Basswood

2007

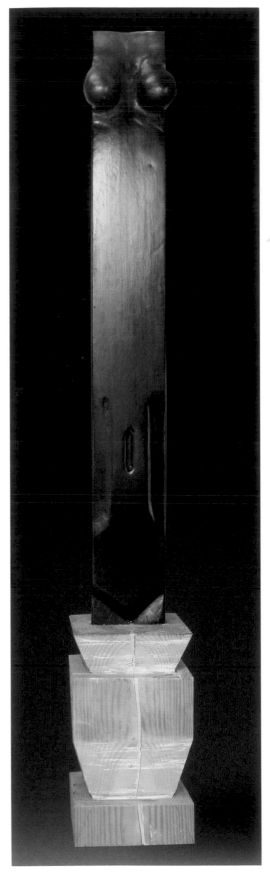
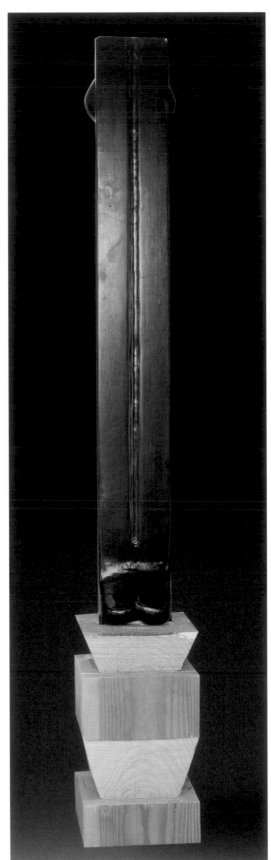
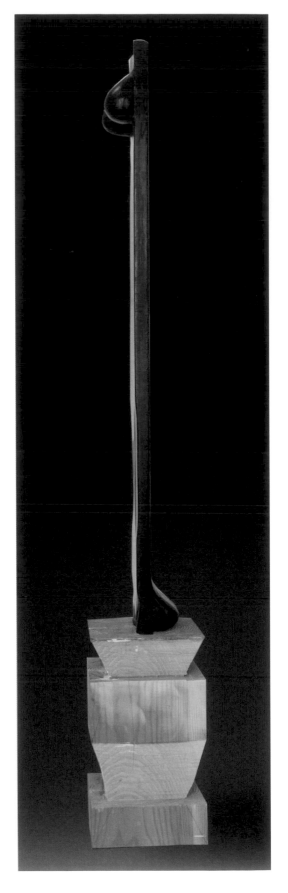

Female

77" x 11" x 11" with base

Cedar

2007

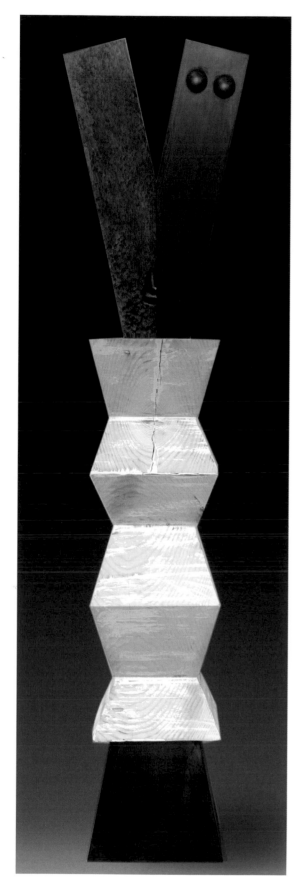

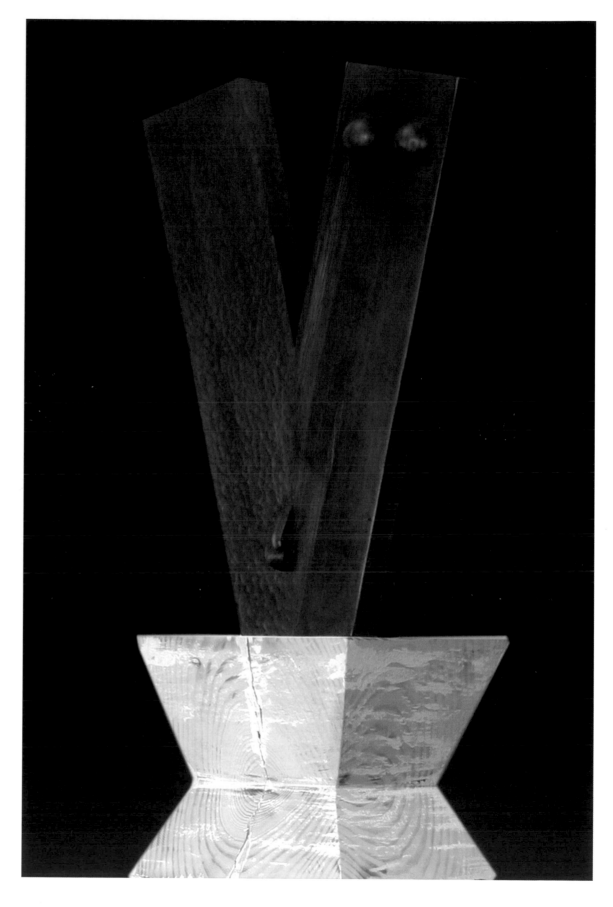

Eve from Adam

62 1/2" x 15 3/4" x 11" with base

Fir

2007

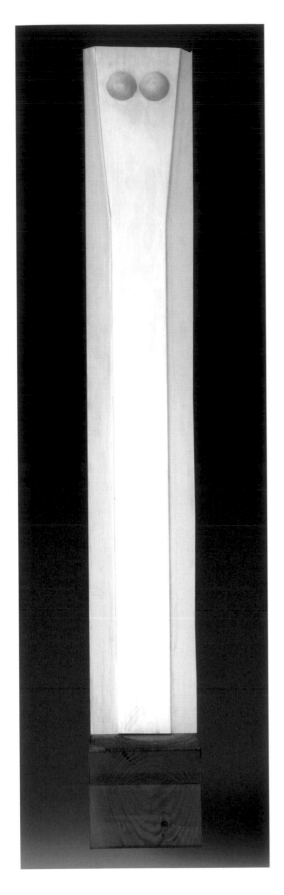

Eurydice

82" x 11" x 11" with base

Pine

2007

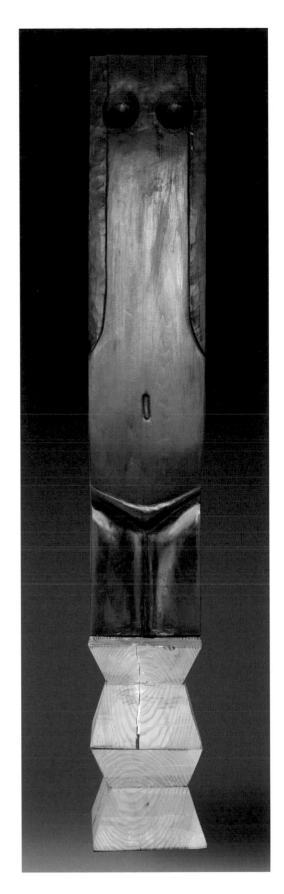
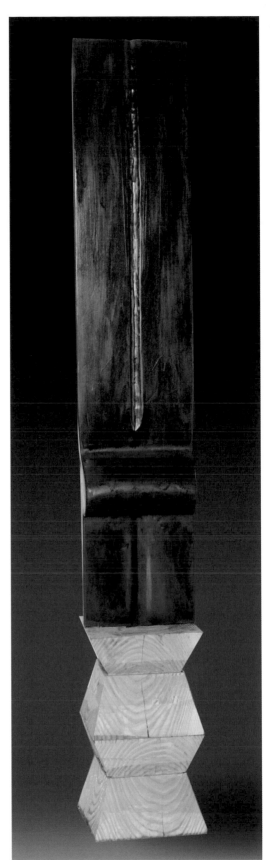
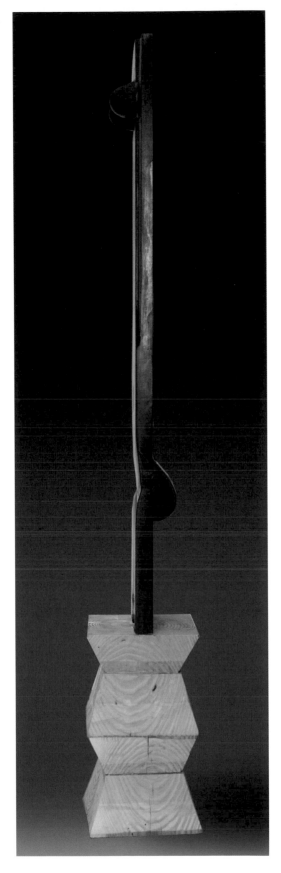

Mama

79" x 12" x 11" with base

Basswood

2007

what
i've
been
up
to

Date of Birth

Born 1932
Brooklyn, NY

Education

1953-1955 **Yale University**
School of Art and Architecture
M.F.A.
Teaching Fellowship

1952 **Yale Norfolk Art School**
Adjunct Course work

1949-1953 **Amherst College**
B.A.
Magna Cum Laude, Phi Beta Kappa
Simpson Fellowship

1951-1953 **Smith College**
Adjunct Course work

Employment

1955-1956 **James Eng Associates**
Designer

1956-1958 **L.W. Frohlich**
Designer

1959-1968 **Benton & Bowles, Inc.**
Vice president, Art Group Supervisor

1968-Present **Norman Gorbaty Design, Inc.**
President – Designer

Instructor

1955-Summer **Yale Norfolk Art School**
Instructor

1961-1970 **Cooper Union School of Art**
Adjunct Professor
Advanced Graphic Design

1971 **Silvermine School of Art**
Instructor
Graphic Design

Visiting Lecturer

Yale University

Minneapolis School of Art

University of Winnipeg

University of Maine, Augusta

Carnegie-Mellon University

Kansas City School of Art

The Pennsylvania State University

Union College

Collections

Yale University Art Gallery
New Haven, CT

Baruch College
New York, NY

Glucksman Ireland House
New York University, New York, NY

Mead Art Museum
Amherst College, Amhest, MA

Print Research Foundation
Stamford, CT

The Eric Carle Museum of Picture Book Art
Amherst, MA

National Portrait Gallery
The Smithsonian, Washington, DC

The Laterman Collection
New York, NY

Awards

Heisey Award

Yale-Norfolk Art School Fellowship

Graduate Assistant Fellowship Yale

50 Best Books Award – A.I.G.A.

Printing for Commerce – A.I.G.A.

Society for World Literacy

Design in Glass – Corning Glass

Simpson Fellowship – Amherst

Art Directors Club of New York

50 Best Ads – A.I.G.A.

Society of Illustrators

New York Employing Printers

Lithographers & Printers National Association

Commemorating the Warsaw Ghetto Uprising

Typmundus 20

American Television Commercials Festival

Society of Publications Designers

Award of Distinctive Merit

Trademarks U.S.A.

International Poster Competition

American Poster 64

A.I.Λ. Medal

Work Shown at

Museum of Modern Art

Brooklyn Museum

Springfield Art Museum

Pennsylvania University

Wesleyan College

Mead Art Museum - Amherst

Smith College Art Museum

Cooper Union

Kansas City School of Art

University of Indiana

Minneapolis School of Art

Maine State University

Typmundus 20

American Federation of Arts

New York Art Directors Club

A.I.G.A.

Tremaine Gallery at the The Hotchkiss School

The QCC Art Gallery

Film Title Design

Bananas *(Woody Allen)*

Everything You Wanted to Know About Sex *(Woody Allen)*

Sleeper *(Woody Allen)*

Little Big Man *(Elliot Erwitt)*

Gladys Knight and the Pips *(Bill Parrott)*

Contributing Designer for the Following Publications

Time Magazine

U.S. News and World Report

Fortune Magazine

CA Magazine *(Cancer Society Journal)*

Impact 21

Maine Magazine

Beverage World

Beverage Aisle

Money Magazine

Financial World

One Magazine *(Catholic Near East Welfare Association)*

Illustrations/Posters

Gorbaty's work as an illustrator has been included in countless magazines, annual reports, brochures, advertisements and numerous children's books. He has also designed posters for such clients as Museum of Modern Art, Walker Art Institute, The Smithsonian and Hoffman–LaRoche Ltd.

Bibliography

Print Making with a Sponn, Reinhold, 1960

Printmaking Methods Old and New, MacMillan Co. 1959

thank

you

Joy, my late "old beauty," for having endured me for over fifty years. For taking care of the life tasks that would have given me less time to "do" things. For having supported me in the doing and in her near successful effort to make me a mensch. For her love and support. I love her still.

My daughter Lisa and her husband Bill Haldane and my grand children Becky and Lizzie, for being there to help fill the void when Joy left us. Their stability, inclusion, concern and love kept me "a part of." I love and am proud of them as I would like to think they are of me.

Andrew Patapis, who worked with me, side by side for a lifetime in graphic design. We've shared the doing. His stability and calmness of character have sustained me. He is both a brother and son to me. His contribution in doing this catalog made it happen!

Frances Iger-Laterman and Bernard Laterman, who supported my work from the first.

David Fenster, master filmmaker, whose insightful film, that accompanies this exhibition, gets to the heart of who I am.

Hariet Eckstein, my companion whose encouragement to overcome self-doubt, whose faith in me has given me the strength and confidence to continue the doing. You were the rock that kept me going.

All the people that are too numerous to mention who were there for me, you know who you are. So do I.

ng

thank

you

When we began this project we had no idea of the enormity of the task. Thankfully, we found infinite energy, strength and patience we didn't know we had. We would like to acknowledge those who helped us get this far, those who were supportive along the way and those who were simply "good people". If we've left you out, please forgive us, you know who you are.

Brad Adab, Claire Aloisio, Vinnie Ambrosio, Ben Balcomb, Ben Bangser, Baruch College Hanging Crew, Andrew Beccone, Dick Bennette, Pat Blossom, Sam Bongiorno, Santo Bruno, Elizabeth Bullis-Weise, Miggs Burroughs, Kenneth J. Carifa, Eric Carle, Debby Carman, Bernard Chaet, Dr. Ray Chow, Nick Clark, Janis Conner, Thomas Del Spina, Hariet Eckstein, Mark Faigen, Baree Feherenbach, David Fenster, Joshua Findlay, Dr. Evan Fox, Tim Frate, Jimmer Furino, Roni Gilat-Baharaff, Joe Goddu, Myron Goldstein, Paul Goodman, Lorraine Grabel, Susan Greenberg Fisher, Jay Grimm, Lisa Haldane, Sylvia Herskowitz, Alvin Ho Young, Lisa Hoffstein, Glen Holcomb, Larry Hoy, Stan Hull, Ellie Jacobs, Mel & Paula Kaiser, Ivan Karp, Richard Klein, Roger Knoop, Meryl Krell, Arthur Kremer, Valerie Kressner, Marilyn Kushner, Naum Landaverde, Michelle LaRocca, Frances Iger-Laterman & Bernard Laterman, Debbie Levin, Gary Levine, Ken Lieberman, Bill Makky, Steve Makky, Dobra Marshall, Dr. Diana Mille, Haralombos Misirlakis, Terri Moore, Herb Myers, Chris Naples, Judy & Bob Natkin, Lois Neiter, Robert Newman, Bo Okyuan, Ellen Ozeri, Andrew Patapis, Susan Pava-Nusbaum, Michael Perrotta, Scott Richter, Joan Rosenbaum, Joel Rosenkranz, Abigail Runyan, Michael Satten, Lisa Scandaliato, Dr. Justin Schechter, Martin Schwat, Peter Scurlock, Cameron Shay, Chuck Silverstein, Derek Stanton, Patsy Star, Steve Stefanidis, Mark Steiner, Msgr. Robert Stern, Alan Stone, Peter Stone, Ruth Sussman, John Szoke, Dr. Robert Teltser, Gail Thier, Slavo Valko, Sarah Vallera, John VanAlstine, Mark VanAlstine, Anne vanStuelpnagel, Lucy Velasquez, Marguerite Vigilante, Kathleen Waldron, Cindy Winebaum, Reba Wulkan, Brian Young.

Special thanks to Erik Ferrone, Bernie Fox, Mary Gorman Hetherington, Charlie Noyes, Faustino Quintanilla, Jon Stillman.

bg / skg

Without the eyes and vision of Charlie Noyes and Faustino Quintanilla this exhibition and catalogue would not have been possible. It was their openness of mind that allowed them to recognize a true Modern Master.

We are grateful.

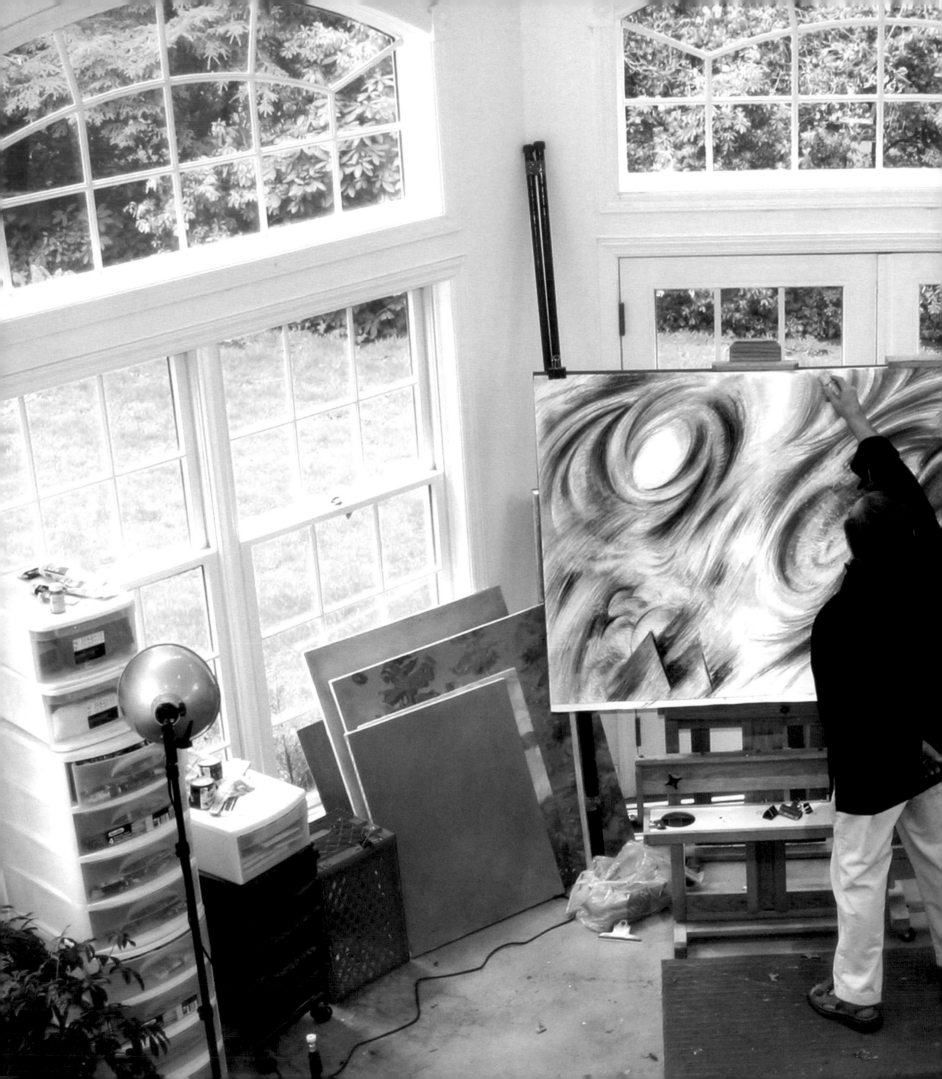

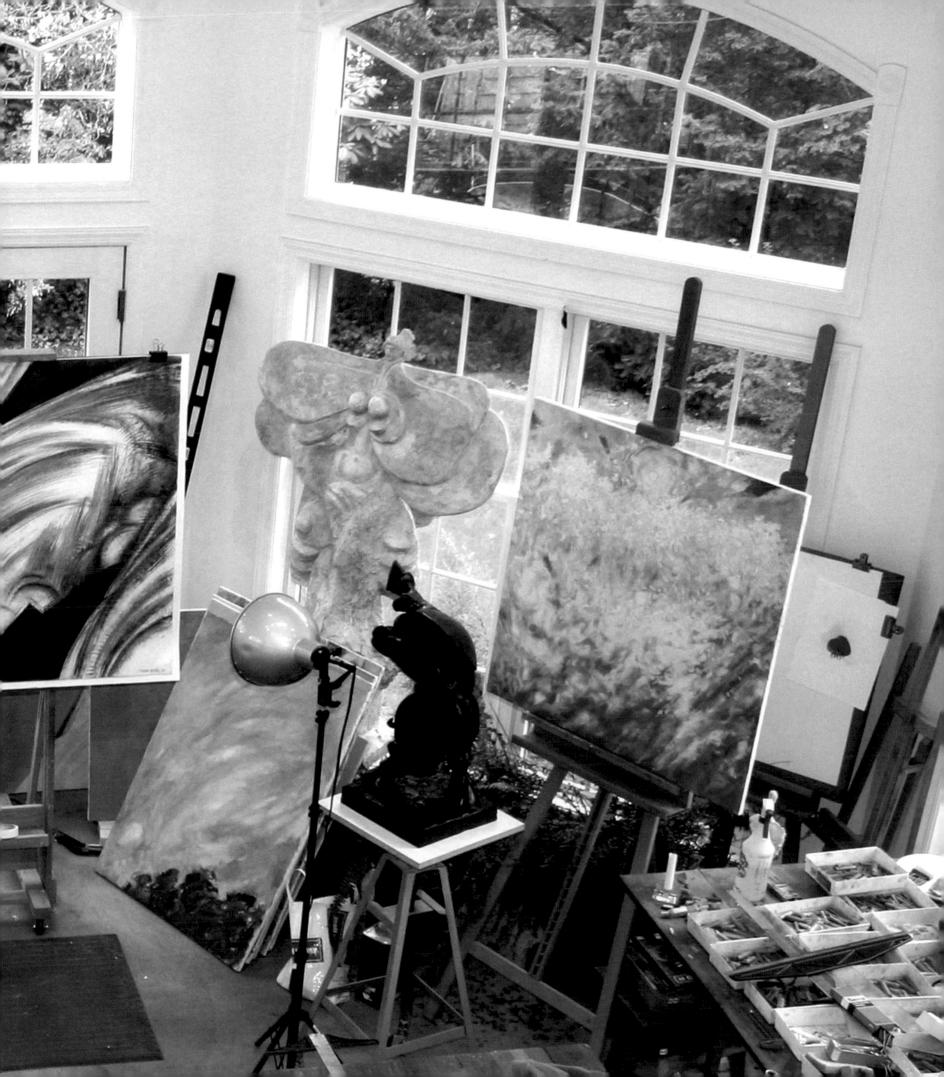

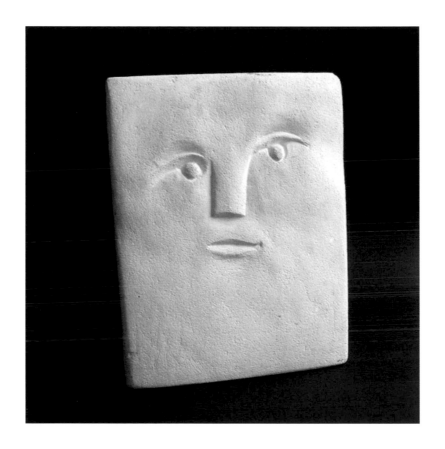

Joy

9" x 9"

Limestone

1970